THE LITERATURE OF PHOTOGRAPHY

THE LITERATURE OF PHOTOGRAPHY

Advisory Editors:

PETER C. BUNNELL
PRINCETON UNIVERSITY

ROBERT A. SOBIESZEK
INTERNATIONAL MUSEUM OF PHOTOGRAPHY
AT GEORGE EASTMAN HOUSE

THE TRUTH
concerning
THE INVENTION OF PHOTOGRAPHY

Nicéphore Niepce

His Life, Letters and Works

By VICTOR FOUQUE

ARNO PRESS
A NEW YORK TIMES COMPANY

NEW YORK ★ 1973

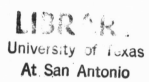

Reprint Edition 1973 by Arno Press Inc.

Reprinted from a copy in
The Newark Public Library

The Literature of Photography
ISBN for complete set: 0-405-04889-0
See last pages of this volume for titles.

Manufactured in the United States of America

———◆———

Library of Congress Cataloging in Publication Data

Fouque, Victor, b. 1802.
 The truth concerning the invention of photography.

 (The Literature of photography)
 Translation of La vérité sur l'invention de la
photographie.
 Reprint of the 1935 ed.
 1. Niepce, Joseph Nicéphore, 1765, 1833.
2. Photography--History. I. Title. II. Series.
TR140.N5F72 1973 770'.92'4 72-9198
ISBN 0-405-04907-2

THE TRUTH
concerning
THE INVENTION OF PHOTOGRAPHY

Nicephore Niépce

His Life, Letters and Works

By VICTOR FOUQUE

Translated by
EDWARD EPSTEAN

NEW YORK
TENNANT AND WARD
1935

TRANSLATOR'S NOTE

• • •

This translation is offered not to the casual reader or as a literary work, but to the student of the History of Photography. Fouque's work is followed closely, often retaining French construction and terms, when they do not offend the taste of the English language. If sentences seem to be obscure, especially in the letters of the brothers Niépce, they are so preserved because they were deliberately written by them in this manner in order to veil the information.

This work of Fouque, published in 1867, has served the writers of history as one of the most important sources of information for the period recorded.

I am indebted to my friends John A. Tennant of New York City and L. P. Clerc of Paris, for their kind and constructive criticism.

<div align="right">EDWARD EPSTEAN</div>

New York, 1934.

THE TRUTH
concerning
THE INVENTION OF PHOTOGRAPHY

Nicéphore Niépce

his Life, his Endeavours, his Works
from his Correspondence, and other unpublished Documents

By VICTOR FOUQUE

Correspondent of the Ministry of Public Instruction
on Historical Works, Member of many Academies
and learned Societies, etc.

"Sic vos non vobis,	*"So, what is yours, is not*
"	*for yourself,*
"Tulit alter honores,	*"*
VIRGILIUS	*"It brings honors to another."*
	VIRGIL

PARIS
Library of Authors and of the Academy of Booklovers
rue de la Bourse, 10
CHALON-SUR-SAÔNE
Bookshop of FERRAN, rue de l'Obélisque
1867

THE TRUTH

concerning

THE INVENTION OF PHOTOGRAPHY

• • •

NICÉPHORE NIÉPCE

PROLOGOMENA

{PREFACE}

It is evident, incontestable, that if an error is published, it is soon, without preliminary examination, accepted and adopted by everyone as the truth. In that case, each emulating the other, the preachment, the repetition, the propaganda and, with the aid of public indifference, it becomes, in a manner, indelible. It is also very difficult, if not impossible, to eradicate it entirely. For, as Henri Martin discreetly said, "the refuted error, twenty times confounded, lifts up its head twenty times again." This is easily understood. It does not matter much to the public that it is Pierre in preference to Jacques who has discovered a certain thing, provided it profits thereby; it asks no more! Photography is a deplorable and regrettable example of this.

Indeed, open the biographies, the dictionaries, open most of the works treating on Photography, and you will read there that this wonderful art was invented by *Daguerre!* "That is evident," remarks the reader: "since Photography is called *Daguerreotypy,* that Daguerre is its author." In fact, he, who does not know the basis of a matter, cannot reason otherwise; and he does not take the trouble to inform himself whether he is wrong or if it is not so.

In spite of all that has been said to the contrary, against the usurpation, in spite of all that has been written for more than a quarter of a century on photography and its real inventor, Joseph-Nicéphore Niépce, the error persists today, and we have recent examples of it in credulous writers who insist, without seeking to become enlightened, on attributing to Daguerre the invention of this art, one of the finest, the most useful and most marvelous scientific discoveries of this century! They maintain and defend their opinion either in their journals or in their books, with as much energy as obstinacy, and they see the matter with such acrimony and passion and so fervently as to convince their readers. We have, on many occasions, just as many talented

writers have done and only on some pages, tried to show the falsity of their arguments, but in vain;, we have failed against their systematic obstinacy!

God forbid, however, that we should wish to lessen Daguerre's merit! But his part concerning Photography is fine enough, without according to him what by right belongs to Joseph-Nicéphore Niépce. We wish only to render to each that which is justly due him. *Suum cuique.*

To this end, we go a step further, but in a more thorough manner than we have done previously, in order to establish, to verify with certain, authentic and incontestable proofs, by means of a number of documents, mostly unpublished, which are in our possession, the priority of Joseph-Nicéphore Niépce in the discovery of Photography, a priority at any rate recognized by Daguerre himself, in an authentic document, recorded, composed of four pages in-folio, autographed by him alongside of Niépce, which document we reproduce completely, by the photographic process, in order to convince the incredulous.

We further state why Photography, invented by Nicéphore Niépce, strangely carries the name of Daguerre instead of that of its inventor: in this regard we will explain the facts, remaining obscure even today. We will also relate the particulars of the life of our illustrious fellow-countryman; we will state the struggles, the joys and the many disappointments that he sustained; the experiences, the studies, the trials and the persistent work to which he devoted himself before attaining success.

For this purpose we will draw on the numerous autographed letters of Nicéphore Niépce and those of his brother Claude, entirely unpublished, which are in our hands. This correspondence comprises: 1st, *Sixty-six* letters by Nicéphore Niépce, addressed to his brother Claude, at Paris, written between March 21, 1816 and August 16, 1817, and mailed at Chalon-sur-Saône;

2nd, Also *one* letter addressed to his son Isidore, then at Côte-Saint-André (Isère), and dated at Gras, May 26, 1826;

3rd, Two other letters from him, dated Paris, August 27, September 2 and 4, 1827, addressed to Isidore Niépce, at Chalon-sur-Saône;

4th, A later letter from Nicéphore Niépce, written at Kew, near London, November 5, 1827, and addressed, as the two preceding letters, to Isidore Niépce, at Chalon;

5th, *Thirty-one* letters from Claude Niépce, addressed to his brother Nicéphore at Chalon, dated Hammersmith, from October 29, 1818 to December 5, 1825, mailed at Hammersmith, a small English town, four miles from London; altogether *one hundred and one unpublished letters* in which are related, and noted, the trials, the experiments and their results, of Nicéphore Niépce, relating to Photography, and of which we give numerous extracts.

We add to these letters and the above-mentioned document, the *unpublished Note* addressed to the *Royal Society of London,* December 8, 1827, by Nicéphore Niépce, at the time he presented his designs and heliographic plates to that scientific body and of which we also give a copy. We have among other documents, the manuscript of the *Notice sur l'Héliographie* (the primitive name of Photography) dated November 24, and December 5, 1829, and containing the processes, and Nicéphore Niépce's manner of operation, and having at the bottom of the last page this passage written and signed by Daguerre: *"Received from Monsieur Niépce the copy of this present note, Daguerre."* In addition to the full and verbatim copy of this *Notice,* we reproduce photographically the last page which contains this declaration autographed by Daguerre.

All these documents have been found by Isidore Niépce among the numerous papers of his father (relegated for more than thirty years to a garret), after numerous and persevering searches, constantly urged by us; and they have graciously been placed at our disposition by the son of Nicéphore Niépce, to whom we beg to offer our keen and sincere appreciation.

The contents of this volume are divided into four parts.

The first comprises, among other diverse subjects, the biography of Joseph-Nicéphore Niépce, from his birth up to 1813; also the history of the works, mechanical and others, to which he devoted himself during this early period of his life, either alone, or together with his brother Claude.

The second part concerns itself with the history of the invention of *Heliography,* the original name of *Photography,* and the events and facts connected with it until the death of Nicéphore Niépce.

In the third part we have explained why Nicéphore Niépce's invention is called DAGUERREOTYPE instead of having been named NIEPCEOTYPE, following the name of the inventor.

Finally, the fourth part contains a genealogical note and history of the different branches of the honourable Niépce family.

Our intention to publish this book is not new, since it began more than ten years ago. The delay in publishing it calls for a brief explanation.

In 1855, the municipal administration of Chalon-sur-Saône, desirous of erecting a monument, on one of the public squares, to the memory of Joseph-Nicéphore Niépce, born at Chalon, appointed a commission *ad hoc,* of which we had the honour to be Secretary. The authorization for opening a public subscription, the proceeds of which would be used for the erection of the proposed monument, was requested from the Government. The municipal council, at its session of June 27, 1855, voted the sum of 5,000 francs to serve as a nucleus of the above-mentioned subscription; the sum was voted again on March 27, 1857. Several of the notables added the promise of their support more or less considerable sums of money. But these marks of sympathy for our famous countryman remain without effect to this day; the repeated applications to the Government had no result, although they were not absolutely refused.

As long as we hoped that the Government would reverse its decision, we had deferred the publication of our book, intending to publish it at the time of the dedication of the proposed monument. Having now arrived at a point where we despaired of our hopes, we decided to offer our work to the public. Possibly it may be a stimulant for urging anew the authorization to open the subscription so ardently desired by the friends of Nicéphore Niépce, in order to render him the justice due him! Let us hope that the hour for the amends will not strike too late.

We also hope that this book will sufficiently serve to correct the error which has unjustly attributed to Daguerre, for more than a quarter of a century, the imperishable work of Nicéphore Niépce!

FIRST PART

· I ·

We are about to write the history of the invention of *Photography* and that of its famous inventor, Joseph-Nicéphore Niépce. For a long time artists and eminent writers, one after another, have described and explained with indubitable talent the progress of this marvelous art, and they have given to the whole world the practical use, the clever and easy application of this process. Therefore, we need *not* occupy ourselves with the numerous methods adopted and used by photographic artists. Surely, the task that we have taken upon ourselves to combat the error which has persisted with impunity for more than a quarter of a century, has already been enough of a bane to us, without surrendering ourselves again, unseasonably, to scientific and artistic demonstrations; therefore we refrain from discussing a subject which is too difficult for us.

If, from the rue Saint-George, we enter a narrow vaulted passage which runs under a part of the house which is No. 19 on this street, where the rue de l'Oratoire begins, we find ourselves as soon as we have left the sombre vault, facing a house which is No. 9 (¹) on the same rue de l'Oratoire.

We find in this house a ground floor, a first story with an attic above. The main entrance of the building looks onto a closed court, adjoining the rue de l'Oratoire by a large wall with a carriage entrance and alongside of it another small entrance. In the court, there is a building facing the residence which serves as a coach-house and stable.

The front of the house opens on to the court by three openings in the ground floor; five windows with shutters on the first floor, and two other windows, commonly called skylights, in the attic. In addition to this on the rue de l'Oratoire the ground floor had

a place for a shop made in July 1830; over this shop there is a window which gives light to one of the rooms on the first floor, and over this another small window which admits daylight to one of the attic rooms. The construction of this house dates back to the middle of the seventeenth century. It had belonged in turn to members of the Bourgogne Parliament, to the Clergy of Chalon, to various administrations of this town, to lawyers, merchants, and, as will be seen from what follows, to men of learning.

It was built, at least in part, by "Noble Pierre d'Hoges, counsellor of the King and grand falconer of Chalonnois" who had been mayor of Chalon from 1650 to 1658. (2)

His daughter, Anne-Charlotte d'Hoges, who inherited it from her father, bequeathed it in her will to Pierre Legoux-Maris, counsellor of the King at the Bourgogne Parliament.

This latter in turn sold it to Antoine Bernard de Massol, chevalier, counsellor of the King in his councils, president of the court of Comptes de Bourgogne and Bresse, and to Dame Jeanne-Marie Berbier de Dracy, his spouse and "consort."

These, by the deed acknowledged by Bordet, notary, February 4, 1676, "surrendered, ceded and sold in perpetuity to the Reverend Master Nicolas Jornot, priest canon of the collegiate church of Sainct-Georges of the said Chalon, acquiring also in perpetuity for him and his own, a house which had been constructed during the lifetime of the aforesaid Sieur d'Hoges, not entirely completed, which has not yet been plastered or whitewashed so far, on the outside or on the inside; the two lower rooms and garrets have not been floored, nor have any fastenings, or doors, as far as the lower chambers, the upper part and garrets, nor have any glasses been put on the window frames in all the windows of the above-mentioned building, nor likewise any openings nor skylights in the attics; the said building is situated on a small street behind rue Sainct-Georges of the aforementioned Chalon, called la rue des Prestres de l'Oratoire, consisting of two rooms with fireplaces, two upper rooms, also with fireplaces, three service cabinets, and the attic; an addition for a wood-house, with the garden, with outbuildings in it. . . In consideration of the price of two thousand five hundred livres, payable forthwith. . . "

After Canon Jornot, this unfinished residence became the prop-

erty of "Messire Antoine Anne Beuverand de La Loyère, doctor of the Sorbonne, priest canon and grand-archdeacon of the Church of Chalon, where he resided."

By the deed received from Reverdy, a notary, on April 24, 1740, the aforesaid "by his goodwill, sells to sieur Bernard Niépce, Counsellor to the King, controller of the garrisons and pensioners of Bourgogne and Bresse, residing at Saint-Loup-de-Varenne, by these presents acquires a house situated in the rue des R. P. de l'Oratoire of this town, otherwise rue Saudon . . . Said house joining on the east the street mentioned above and on the west the garden of M. de Rully, on the north the house belonging to M. Dupon, and on the south that of the said Reverend Fathers of the Oratoire This present sale was made "for the sum of five thousand one hundred livres"

Twenty years later, in 1760, at the death of Bernard Niépce, mentioned above, his eldest son, Claude Niépce, inherited this house. This, again much later, at the death of the latter, became the property of Joseph-Nicéphore Niépce who gave it in 1825 to his son M. Isidore Niépce, as a marriage portion; he sold it, in April 1830, to sieur Muard, a locksmith, for ten thousand francs; today the house belongs to M. Guichard-Potheret, wine merchant and president of the Chamber of Commerce of the department Saône-et-Loire, member of the Légion-d'Honneur.

If, at the risk of annoying the reader, we seem somewhat long-winded in discussing the origin and the various circumstances connected with this house, it is because our principal hero, Joseph-Nicéphore Niépce, inventor of Photography, was born in this house on March 7, 1765.

In order to avoid a confusion of names and persons, we add a genealogical and historical note on the large and honourable family Niépce, which forms the fourth part of this book; the history of the branch of the family from which the inventor of Photography is descended cannot be traced back farther than Bernard Niépce who, as we noted above, bought, in 1740, the house which we have described.

This Bernard Niépce, who was born in 1671, and died at Gras September 13, 1760, was married to Anne Nodot; to them were born:

1st, Mademoiselle N. Niépce, married to Nicolas de Marcenay, esquire, living at Chalon;

2nd, Claude Niépce, who became an advocate to the Court, counsellor of the King, receiver of taxes of Chalon-sur-Saône. In addition to these offices, Claude Niépce exercised the function of manager for the Duke de Rohan-Chabot, whose confidence he had earned by his honesty and loyalty; he died at Dijon, about 1795, having earned the esteem and regrets of all those who had known him.

Claude Niépce married Anne-Claude Barrault, eldest daughter of the celebrated advocate of that name (³) and of demoiselle Besault, of Dijon. Anne-Claude Barrault contributed, when marrying Claude Niépce—who was already rich—a dowry of three hundred thousand livres. The issues of this union are:

1st, Victoire Niépce, who married M. Maillard, and who died childless in Paris;

2nd, Claude Niépce, born August 10, 1763, one of the principal persons of this book;

3rd, Joseph-Nicéphore Niépce, born March 7, 1765, in whose memory this book is written;

4th, Bernard Niépce, born in 1773, died a bachelor at Geneva, September 7, 1807.

Bernard Niépce and Anne Nodot also had a third child, a son, whose Christian name was the same as that of his father and of whom we shall speak in the fourth part of this book, as a member of the branch of Niépce de Saint-Cyr.

We will not repeat here the absurdities recited of Nicéphore Niépce's birth because, just as his glory has been contested after his death, so it was also denied that he was born at Chalon-sur-Saône. In order to cut short every sort of discussion in this respect, here is a verbatim copy of his birth certificate, as inscribed on the register of the Church of Saint-Jean-de-Maizel (⁴) of Chalon, deposited in the archives of the parish.

"Joseph, son of M. Claude Niépce, advocate at the Court, counselor of the King, receiver of taxes of Chalon-sur-Saône, and of Dame Claude Baraut (sic) his wife, born yesterday, has been baptized today, March 8, 1765; his godfather was Joseph Betauld, advocate at the Court, living at Beaune; his godmother Dame Claude Thérèse de Courteville, wife of Mons. Bernard Niépce, *ecuyer contrôleur ordinaire des guerres,* living at Chalon, whose names are subscribed together with my own, the curé and that of the aforesaid father, as witnesses.

"Amiens, curé; Niépce, Betauld, de Courteville-Niépce."

Joseph-Nicéphore Niépce and his older brother Claude were brought up with most particular care and a great deal of solicitude by their father, who also gave them as preceptor a learned man, the reverend Abbé Montangerand. In addition to the lessons under the paternal roof, the young Niépces had instructions from their neighbors, the Pères de l'Oratoire (5), scholars, whom everyone knew of great merit and vast erudition, who were accused, wrongly, of being somewhat liberal thinkers.

However that may be, thanks to the enlightened solicitude of their father, thanks also to the limitless devotion of their venerable teacher and again to the persistent and intelligent instruction which they received from the Pères de l'Oratoire, the two brothers, especially Nicéphore, made great and rapid progress in languages, science and literature. Young Bernard joined the studies of his older brothers later and, like them, became a studious and educated boy.

Brought up also with affection under the eyes of their parents, of a respectable family, these boys enjoyed a fine character and were timid and satisfied with their own company; they did not mix with their school-fellows nor did they take up their time with the games and usual amusements of children of their age. They seemed to be born to struggle with their minds and intelligence. Nicéphore and Claude spent their leisure time in constructing small machines out of wood, equipped them with wheels and gears, having no other tools than table and pocket knives. These machines, or rather specimens of handicraft, functioned very well to the great joy of their makers. They even produced the mechanism of a rising and falling crane.

Isidore Niépce, son of Nicéphore, told us one day: "I found, a long time ago, in hunting around in the attic of the house in the rue de l'Oratoire, remains of small machines made by my father and my uncle; and when I saw the products of their first work they created in me an intense emotion and recalled to me with joy the happy period of their youth during which they devoted themselves to these peaceful amusements, which were a kind of prelude to the serious work to which they consecrated all their thoughts, their energy, their fortune, and I may even say their lives."

Nicéphore and his younger brother Bernard were destined

for the service of the church but, since their studies were completed before the age required for ordination as priest, Nicéphore entered the field of teaching and taught one of the classes of the House of the Pères de l'Oratoire at Angers; he was very devout and of pure morals, which he continued to be all through his life. But the revolutionary tempest, which had rumbled for some time, burst into the open and carried in its terrible and irresistible wake the monasteries and their inmates.

Niépce therefore was forced to choose another career than that for which he was destined since his infancy. He exchanged his modest ecclesiastical habit for an attractive military uniform and on May 10, 1792 he was admitted to the rank of sub-lieutenant in the 42nd Regiment of the Line—heretofore called Limousin.

Appointed lieutenant in the second battalion of the 83rd Demi-Brigade on the 16th Floréal, year I of the Republic (May 6, 1793), he took part in the campaign of Cagliari (Sardinia) ; in the same year, 1793, he was with the army in Italy and took part in brilliant and glorious exploits.

He was appointed aide to the adjutant-general Frottier on the 18th Ventose, year II (March 9, 1794).

While at Nice, our hero became dangerously ill of an epidemic which found many victims in the army and among the inhabitants of the town. He owed his recovery to the affectionate and intelligent care of Mme. Roméro, the owner of the house in which he lived, and that of her charming daughter, Marie-Agnès. This dangerous malady required great solicitude and constant devotion and his recovery took a long time.

Nicéphore Niépce found himself greatly enamoured with the daughter of his hostess; she was born, in fact, to charm, of a figure taller than the average, clever, very graceful, high-spirited, and of perfect colour and rare distinction. Nicéphore believed that he could not give her any better proof of his appreciation for the preservation of his life than by offering her his heart and hand. The young lady gladly accepted his offer and on "the 17th Thermidor, year II (August 4, 1794), the Citizen Joseph-Nicéphore Niépce, aide to the Staff of the Army of Italy, aged 29½ years, son of the late Claude and de Barrot (sic) (Claudine), living at said Chalon, was united in marriage with the Citizeness Agnès Roméro, aged thirty years, daughter of the late

[10]

Ignace and of Françoise Beuden, widow for eight months of Jean-Louis Mignon, advocate, born and living at Nice." ([6])

Nicéphore, whose health had greatly suffered by his severe illness and whose sight had been greatly impaired, was compelled to quit the army in which he had shown himself so apt and zealous. And so when he signed his final papers, General Kerveguen, in appreciation of his esteem and regard, added the following flattering words to his discharge: "I lose in you the most brilliant lustre of my staff!"

However, on leaving the military service, Niépce did not terminate his service to France; on the 30th Brumaire, year III (November 21, 1794), three and a half months after his marriage, the authorities of the city of Nice were reconstituted in the persons of citizens F. J. Litter, Turreau and Cassanyes, — Representatives of the People, sent by the National Convention to the armies of Italy and the Alps, — "Nicéphore Niépce, formerely aide to Adjutant General Frottier" was appointed member of the "Commission of the District of Nice, to be, — the said Representatives — surrounded by many of the leading citizens known as patriots, in order that they may render service and teach morality, efficiency, and the civic obligations of the individual." ([7])

The poor condition of his health, however, soon forced him to resign this appointment.

Returning to private life, he leased a charming country house at Saint-Roch, a village situated at a short distance from Nice, where he installed himself with his sweet and devoted wife. There, due to the quiet life and freedom from the confusion of public life, due also to the pure and balmy air which he breathed, and the beautiful and reviving climate of Nice, Nicéphore soon completely recovered good health. His happiness was soon increased by the unexpected arrival of his dearly beloved older brother, Claude, from whom he had been separated for a long time.

Claude, like Nicéphore, had given himself to the service of his country. As a volunteer, he embarked at Toulon on December 19, 1791 on the Flute "Dromadaire", commanded by the naval lieutenant Sebire. After two years at sea, having taken a few days' rest, he reembarked at the port of Boulogne, on the 4th Floréal, year II (March 23, 1794), still as a volunteer, on

the frigate "Modeste" commanded by Captain Domergue. After several months at sea he left the service and joined his brother Nicéphore at Saint-Roch, as related above.

Most of Nicéphore Niépce's biographers have called his brother Claude a "great traveller". With the exception of the two campaigns at sea in the service of the State which we have mentioned, and his crossing the Channel from Calais to Dover in 1817, when he left France to live in Great Britain, Claude Niépce, as will be seen later, spent all his life in mechanical engineering at Nice, Chalon, Paris and in England. He cannot, therefore, be properly called a great traveller. He was certainly a very ingenious and expert mechanic, which is enough!

The disturbance of the war and the internal conflict which desolated and ruined France interested the two brothers Niépce very little. They also remained complete strangers to the intrigues of the different parties which fought for power and they gave themselves wholly with sincere and devoted affection to the sweet and most tender pleasures of friendship during their long stay at Saint-Roch. While the country around Nice was given over to anarchy and constantly overrun by armed bands, spreading terror and consternation among the people, the Niépces, by their prudence and the good fortune of being able to turn aside from the storm which rumbled about their heads without cessation, managed to escape the depredations of these malefactors, known under the name of *Barbets*.

The following extract of a letter from Nicéphore, addressed to his younger brother Bernard at Chalon, will give an idea of the excesses committed by this band of brigands:

"Concerning the *Barbets*, they have not belied the reputation which they have gained during six years of robbery and murder; and without the firm hands of the Austrians, who were not regarded very highly and who were badly led, the unfortunate town of Nice would have groaned under still greater misfortunes than those which they have experienced.

"I have not heard that the Austrians have shot down the *Barbets;* they had assassinated a man by the name of V... (sic), who lived in this town and they have robbed several houses, among them that of the wife of General Miollis. But the difference of opinions is only a pretext and the real J... (sic), according to them, are those who have the money"

[12]

Apropos of these *Barbets*, the brothers Niépce had an adventure one day, not so romantic, but which gave them a little excitement. The people at Saint-Roch, having learned that their village was about to be raided by a band of *Barbets*, became frightened and hurriedly took refuge in the town of Nice. Although strongly urged to follow their example, Claude and Nicéphore refused to leave their home, relying on their good reputation, their well-known loyalty and, in short, their regular and modest manner of life, for exemption from any attack. So, with a free conscience, they continued in their work and usual occupations, without worrying about the *Barbets*.

But on the evening of this day, full of agitations, and while they were strolling in their garden, inhaling with delight the fresh and balmy air, they found themselves at the turn of the path suddenly confronted by an unknown person.

This person with a mysterious air and distinguished manner approached them and addressed them politely: "Be assured, gentlemen, I know you. I am the chief of the Barbets. Nothing will happen to you; you may remain here without fear."

Claude and Nicéphore, in return, as astonished as they were touched by his language, equally strange and reassuring, thanked the robber chief for his courtesy and good intentions. After a short conversation in a charming manner, the man disappeared through a small door which opened on to the dry bed of a mountain stream called Paillon, through which he had entered the garden, leaving the brothers somewhat bewildered by this totally unforeseen apparition.

Although both of the brothers Niépce possessed most happy and lively qualities, we must confine our attention particularly to Joseph-Nicéphore; because the only purpose of this book is to render to him the glory which has been unjustly given to another.

The new ideas born of the Revolution of 1789 had only further developed his already high ideals and his natural goodness; he remained religious, notwithstanding the acts of impiety which he had so often witnessed. His mind was sound and his training solid and complete. Endowed with unlimited charity, his beautiful soul was reflected in his words and actions. He thought much more of his neighbors' welfare than of himself and his own interests.

[13]

We cannot recount here the many examples of the boundless beneficence of Nicéphore Niépce; but this story, however edifying to the reader, is outside the proper subject of this book and so, apart from the history of the invention of photography; therefore, much to our regret, we must abstain from recounting the charitable deeds of our illustrious countryman.

We have seen them, Claude and Nicéphore, living quietly amid the turmoil of the world, having no part in the grave events which were constantly taking place before their eyes. The charming retreat at Saint-Roch replaced everything and made up their universe. There, in the company of Mme. Niépce, they passed the days in peace, following their tastes and their scientific work. They cultivated at the same time their flowers, literature and the arts, and time passed for them all too quickly.

On the 15th Germinal, year III (April 5, 1795) the calm and unmixed happiness which they enjoyed was increased by the birth of Nicéphore's son — Jacques-Marie-Joseph-Isidore Niépce — who was the object of the most tender affection, solicitude and devotion of his father and mother, as well as his uncle, who loved and cherished him as if he had been his own son.

It was during their stay at Saint-Roch that the brothers first conceived the idea of applying automatic motive power to the propulsion of a boat, without the help of sails or oars. The difficulties encountered only increased their courage and perseverance, augmenting their ardour and desire to overcome the obstacles which constantly surrounded them.

Unfortunately, the lack of capital, that powerful and indispensable agent in all undertakings, caused them, alas, many failures, due to the scarcity of money and the difficulty they found in procuring it in the troublous times in which they lived; and their numerous experiments suffered from this financial scarcity.

Nevertheless, the favorable results already obtained in these experiments, although they were still incomplete, acted as a stimulant which kept alive the sacred fires which animated them, and they continued to try new combinations.

Notwithstanding their tranquilly happy existence at Saint-Roch, however, their thoughts ever turned to the distant home, because for them the adage *"ubi bene, ibi patria"* was not the true expression of their feelings; they impatiently awaited the day when they would be reunited with their dear mother and younger brother,

Bernard. But it was still necessary to await, under the glorious skies of Nice, the time when order would be completely reestablished in France before they could return to their native town. It was on June 23, 1801 when Nicéphore, his wife and son, together with Claude fulfilled their desire by entering their beautiful house in the rue de l'Oratoire at Chalon, where they again had the joy of embracing their venerable mother and their brother Bernard, from whom they had been separated for more than ten years.

After Claude and Nicéphore had recovered from the fatigue of their trip and definitely established themselves in their old home, where they enjoyed all the intimate pleasures of family life, they devoted themselves anew to their predominant taste for industrial science and the arts.

At this time they were more interested in achieving glory, in order that their name might be remembered by posterity, than in making money from the product of their inventions and work.

Urged by these noble sentiments, they worked with zeal to complete and improve the engine which they had conceived and worked on during their stay at Saint-Roch. After many experimental combinations and trials, their machine finally attained that state of perfection which they had sought so long. On April 3, 1807, following their application of November 15th of the preceding year, they were granted a patent for this invention which defined and guaranteed their absolute rights in this fine creation for a period of ten years. This patent was granted by decree of Emperor Napoléon, dated Dresden, July 20, 1807, countersigned by Hugues B. Maret, Secretary of State, and in addition also by Cretet, Minister of the Interior.

This machine, which they called *Pyreolophore,* had a motor of great power of which the principle was the sudden action of fire on air and the violent rarefication of this fluid.

There are persons still living at Chalon who remember very clearly having seen, on a clear moonlight night, a boat equipped with a *Pyreolophore* on the Saône, and on the Battrey Pond situated in the woods of Charmée, near the property of the inventors at Saint-Loup-de-Varenne, near Chalon.

The brothers Niépce had submitted their machine for approval to the Académie des Sciences which appointed a commission to examine it. The result of this examination was the very remark-

able and very favorable report by MM. Berthollet and Carnot, read at the session of December 15, 1806; it is printed in the memoirs of the Institute (⁸) and we give some extracts of it here.

"The combustible agent ordinarily employed by MM. Niépce is lycopodium (⁹) which possesses easy and great powers of combustion; but since this material is costly they have replaced it largely with pulverized coal, which they mix according to requirement with a very small portion of resin, which was quite successful, as we have convinced ourselves by several experiments.

"In the apparatus of MM. Niépce, no part of the calories is dissipated in advance. The moving force is an instantaneous product and the full effect of combustion is employed to produce the explosion which serves as the motive force.

"During another experiment, the engine was placed in the prow of a boat which was 2 feet wide and 3 feet high, tapering down to the water; it weighed about half a ton and moved up the Saône, propelled solely by this motor, with a speed greater than that of the opposing current of the river; the quantity of combustible employed was about 120 grains per minute, and the number of revolutions about twelve or thirteen per minute."

The Imperial Government offered a competition for plans of a workable hydraulic machine to replace that of Marly's antiquated machine which, as is well-known, pumps the waters of the Seine to Versailles. The brothers Niépce decided to take part in the competition and made a model of a pump according to their ideas, both very simple and ingenious, which they called *Hydrostatique,* by means of which water could be raised to a great height with a much smaller loss of water than by other machines of the same kind. This pump as well as the *Pyreolophore* obtained well deserved commendation from the Institute and many scientists of renown.

The following letter dated December 31, 1807, from Lazare Carnot, member of the Institute, is evident proof of the great esteem which this famous scholar had for the works of Claude and Nicéphore Niépce.

"I have received, Messieurs, the letter which you did me the honour to write to me on the 24th of this month. It seems that the result proves the necessity for substituting a combustion engine for Marly's machine. I am very sorry that you have been unable to engage in this earlier, especially in using the principles

of the *Pyreolophore* motor. You will always be acclaimed for the invention of this engine, for which mechanics have always hoped and aspired.

 "I do not know that I am able to form a clear idea of your new engine so that I might give a formal opinion of it. You use neither wheels or levers, which is a great advantage but, on the other hand, there are pistons and valves, which necessarily destroy at least partly the effectiveness of the motive power, and the hammer which intervenes in the mechanism confutes the name *hydrostatic* pump by which you call your machine. But names mean nothing. I advise that you make exact experiments to prove the capacity of this engine before offering it to the public; it is the only way to overcome objections, especially if you want to establish the comparison of your product with the hydraulic ram with which at present we are so well acquainted. The experimental examination which has been made demonstrated that the model at least is a very good engine. But, of course, we do not know whether it will be just as good in the large size. However, this we will soon learn because the Government has furnished the funds for making the experiments on a larger scale. M. Montgolfier has no doubt of the success after the new improvements, which he proposed, are made and which consist principally of an air chamber, which has for its primary purpose to minimize the violence of the shock which destroys much of the force and dislocates the machine.

 "Accept, Messieurs, the assurance of my regard and attachment.
 Carnot."

 On the 20th of May, 1807 Nicéphore received the following letter from Mâcon: "Monsieur, the Société des Sciences, Arts et Belles-Lettres de Mâcon (¹⁰) at its session of May 19th, has elected you as a corresponding member. We meet not only prompted by the desire of reviving a taste for study in our town, but also for the fruitful occupation of interesting ourselves in the prosperity of the department as far as it relates to the arts; we, therefore, feel the necessity of associating with us cultured men who have the same interests in view and the same desire. We do not regard this in the light of offering you a title which in itself would not be a flattery, but with the desire to bask in your light. We certainly hope that your tastes will lead you to find it worth your while to correspond with us, and we

shall receive with appreciation all the works which you will be good enough to address to us, no matter what the subject may be. "I have the honour to be

"The Secretary, Cortembert, D.-M."

During the continental blockade and for the purpose of substituting a homegrown product for one essentially tropical, the Imperial Government encouraged the growth of woad (") as a substance yielding, by extraction, a dye which could profitably replace indigo.

Whenever a matter of the public weal was concerned, one did not vainly appeal to the patriotism of the brothers Niépce. Thus, since 1811, they had devoted themselves to the extraction from woad, which they had cultivated, of a colouring "starch" which is very beautiful and could be compared with that of the finest indigo; they had sent samples of it to the Minister of the Interior through the Prefect of the Department of Saône-et-Loire. A few days later, the Prefect forwarded to them the following letter from the Minister dated Paris, September 17, 1811: "Monsieur, I hasten to send to the commission in charge of the examination of home-grown substances suitable for dyeing, over which Senator Comte de Chanteloup presides, the samples of indigo-pastel which MM. Niépce brothers have sent you and which you have sent us with your letter of the 2nd inst. I shall inform you of the commission's opinion as soon as it has reached a conclusion. Meanwhile will you be good enough to express my appreciation to MM. Niépce-Barrault for the zeal with which they have taken up their experiments for this new industry.

"The chief of the second division, in the absence and by authority of His Excellency: Fauchat."

Later, on the following November 28, MM. Niépce addressed a report to the same Minister through the Prefect of Saône-et-Loire, giving the results of their observations and experiments in the culture of woad and the manufacture of "indigo-pastel."

The Minister addressed the Prefect, on December 7, 1811, in the following letter:

"Monsieur, I have read with interest the observations of MM. Niépce-Barrault which you sent me on November 28th, for the best season to cut the leaves for woad and the method of extracting the coloured starch without the intermediary of a preci-

pitant; as you say, their report is very good and a new proof of the intelligence and zeal which animates them. Will you be good enough to inform them that I am transmitting their report to the commission charged with the examination of all matters of this nature; they have made examinations in several places and will determine whatever is proper to fully establish the theory of the manufacture of indigo-pastel, and whatever is necessary to perfect the process. Receive

"Montalivet."

It is likely that woad brought no great profit to those who engaged in its cultivation because the Government, in order to encourage its growth, issued a decree on January 14, 1813 offering a bonus ([12]) for the producers of this colouring matter. Roujoux, Prefect of Saône-et-Loire, sending the ministerial order of March 31st of the same year to the brothers Niépce, which fixed the bonus quota allowed for the fabrication of indigo-pastel and enumerated the necessary conditions for obtaining it, wrote to them on the following April 24th:

". . . . I have informed his Excellency of the zeal and trouble that you have taken in the cultivation of woad, a devotion of which the Minister has taken note and for which he has instructed me to express to you his satisfaction; you will please let me know of your success, so that I may make my report."

On the 29th day of that month Nicéphore, in his name and that of his brother, replied in the following words to Roujoux: "The experiments which we have made for the last two years had for their object the determination of the exactness of the results which had been obtained in different parts of the empire. While we have succeeded in extracting a starch of good quality, the quantity has been so small that it is impossible for us to look favorably upon the establishment of a factory for the production of indigo in our Department, or at least in the community in which we live. During this time we have devoted ourselves to work of another nature. As soon as these are finished we intend to follow them, during the good weather, with some plans for the manufacture of indigo-pastel which might contribute to the improvement of the art. We hope that they will prove useful and worthy as some return for the flattering interest which you have been good enough to take in our early success."

In another letter, Nicéphore again writes on the same subject:

[19]

"Since it was a question of the extraction of indigo from woad, we were naturally very anxious to participate in the researches of which the results seem to be connected with the prosperity of commerce and the industrial arts. These researches took a great deal of time but they were not fruitless along the lines which interested us most; because the samples of this matter which we addressed to the Minister of the Interior brought us impressive and flattering encouragement. We have been urged by no other consideration than that of the public good."

Nicéphore Niépce made good the promise which he had made to the Prefect, and devoted himself anew to the cultivation of woad and the manufacture of indigo during 1813 and the years following, together with his other works no less important and useful, among which we must mention the manufacture of beet sugar and Giraumont starch ([18]). To this must be added his artistic works, which will be seen directly in the second part of this book, and this, notwithstanding the mental anxieties caused by the seriousness and magnitude of the events happening day by day, and which struck so sadly at the hearts of most of the French people.

The cultivation of woad indigo, we speak as a witness, has left many traces in what comprised at that time the beautiful estate of Niépce in Gras, commune of Saint-Loup-de-Varenne. The garden surrounding the residence of the family, the fields, even the edges along the main road extending for several kilometres were lined with woad plants, in more or less numerous groups or by isolated single plants, which have grown like weeds for more than half a century, without any cultivation.

SECOND PART

· II ·

Nicéphore Niépce had his heart in the right place. He loved his country too well not to have been profoundly humiliated in seeing it twice in succession invaded by foreign armies, and not to be sadly affected by the misfortunes which overwhelmed France in 1814 and 1815.

Although during this time of unrest he devoted himself incessantly to his favorite work, it was only after peace and security were definitely reestablished that he could seriously renew his labours and scientific researches in the world of the unknown. In the meantime, while devoting himself with his brother Claude to the mechanical arts, he applied himself by preference to his chemical experiments, the results of which must transmit his name to remote posterity.

Lithography had just become naturalized in France. Discovered in Germany at the end of the eighteenth century by Alois Senefelder (14), it was brought to France, first in 1802, by its inventor, but without success, and later, about 1813, by Count Charles-Philibert de Lasteyrie-Dussaillant. (15) In 1812, the Count went to Munich, in order to study this new art there; but he was forced to return to France because of the distressing events of the Russian campaign. After the Restoration, in 1814, he returned to Bavaria, engaged workmen there, bought materials used in lithography and returned to Paris, where he established the first and finest lithographic establishment of that time.

Anything new easily arouses interest in France. From the first moment of its appearance, lithography was hailed with veritable enthusiasm, and it soon occupied the mind of everyone. Each vying with the other wished to possess the tools and apparatus

[21]

for studying and practising this art. It was an infatuation perhaps without precedent.

Nicéphore Niépce followed the current and soon became deeply interested in Lithography which, like everything marvelous, moved him strongly. Far removed from the great industrial centers, however, it was difficult for him to find the proper kind of stones and to obtain the things primarily necessary and indispensable for his future lithographic work. The town of Chalon, especially at that time, was of little or no help to him in this regard. He had to use his own fertile imagination, replacing the apparatus which he lacked, made *ad hoc* by his own invention and which he himself put together.

"In 1813—M. Isidore Niépce, son of Nicéphore, wrote us —on February 26, 1867—my father made proofs of engravings and reproductions of designs similar to Lithographs, lately imported to France and which he admired greatly. The broken stone for the repair of the highway from Chalon to Lyons and which came from the quarries at Chagny, seemed to him, by the fineness of their grain, capable of being used to advantage in Lithography. We chose the largest, which my father had polished by a marble-cutter of Chalon; I made various designs on them, then my father coated them with a varnish which he mixed; then he etched my designs by means of an acid.

"But my father found that the stones did not have a sufficiently fine grain nor were they even enough, and he replaced them by polished pewter plates, on which he engraved musical scores; he tried various varnishes of his own mixture on these plates, and printed on them engravings which he had previously varnished in order to make the paper transparent; he then exposed the whole to the light from the window of his room: Here was the beginning, imperfect, if you please, of *Heliography*.

"My father spoke of his researches only to his brother and to me. When he wrote to my uncle, he was very reserved with regard to his works, fearing that his letters might be lost or opened. As for me, I helped in his experiments almost every day, and took part in his work."

Various combinations and many experiments similar to those mentioned in this letter were multiplied ad infinitum, with more or less success, during the years 1813, 1814 and 1815, and were continued with the same obstinacy, the same perseverance during

to him and his wife, Nicéphore continues as follows:

"There is one essential thing missing to our happiness and that, my dear friend, is to have you present with us, which would add an additional pleasure to the happiness which we feel. Circumstances at the moment deprive us of this sweet consolation; we are compensated, in part, if this is possible, by the hope of the not too distant future which, I trust, will fulfill our wishes. The fact that you have so much *omption* (sic) for the future inspires us with the greatest confidence.

"I am very happy to know that the box (¹⁷) has arrived in good order at its destination. It is only to your excessive indulgence, my dear friend, that I owe the very flattering things which you have been good enough to say to me on the subject of my note. I have been able to some extent to give more clarity and precision to make up for my absolute lack of knowledge of mineralogy. The essential point is that we must find a stone of good quality; I desire this particularly for M. de la Chabeaussière, whom I happily have been able to oblige.

"At last, the boat has been started, the work goes on actively. Here is some good news which we have awaited for a long time with an impatience mixed with unrest. You can imagine the agreeable sensation we experienced. In the present state of our relations with MM. de Jouffroy, you could not tell me of anything, my dear friend, which could cause me more joy. Since you must go to Bercy on the 3rd, you will have an opportunity to prove the truth of the matter, and you will certainly not be able to help feeling a hidden emotion in contemplating this *broad vista* where you alone are going to balance the *destinies of Rome and of Carthage*. The die is cast, and there can be no retreat; you are fighting for a very great cause, and you have at your side the interest of more than one which must necessarily assure you the *honours of triumph!* This is less a presentiment than it is the result of my being thoroughly convinced.

"I have read and reread with the greatest interest, with the greatest pleasure, my friend, the descriptive memoir that you have been good enough to send back for me to Isidore; but at the same time I am distressed over the increase of trouble which this work must give you, especially at a time when you are busy with experiments so extraordinary that it seems they must be important. Please accept therefore my most sincere thanks

[25]

and the expression of my appreciation for so delicate and kind an attention on your part. I thoroughly understand all the mechanism of your ingenious apparatus for the ignition of petroleum. You have an excellent idea there; it is a fine reward for our discovery, and I was somewhat curious to know the proper material which you have used, which must combine the quality of simplicity together with that of great safety and regularity in its effects. You advise, my dear friend, that I repeat the experiment with setting the petroleum afire in a closed vessel, to assure myself that the petroleum flame will produce an explosion, the same as with lycopodium powder. I would make this experiment gladly if I had an apparatus *ad hoc,* or simply a copper tube of proper size; but you know perhaps as I, that the expenditure for such an apparatus, reduced even to the most simple form, could better be employed in the construction of a water-gauge, of which we have spoken. I am also persuaded, after your judicious observation of the slight degree of air compression by a large pair of bellows, that this new proof would be almost useless. I remember having read in Lavoisier, on the subject of the combination of volatile oils with air; that when enclosing a certain quantity, it is dangerous to approach it with a flame, because violent explosions result which break the container in pieces to the great danger of the spectators. You know better than I do that the fire in our stove, which burns ordinarily without noise, produces a kind of combustion when it arises spontaneously or is excited by the aid of a pair of bellows. If this explosion of the oil in question behaves differently, then that is why it does not shoot forth with enough speed; and it is easy to remedy this fault. Thus, my dear friend, I believe that we ought not to have the least uneasiness on this account.

"I have considered with care the changes that you expect to make to the Pyreolophore, and which have for their object the simplifying of the mechanism; that was also an object of the greatest importance for us and with respect to this, well merits your consideration. I do not as yet feel at all equal to judge the details of the new apparatus, enough to give you, my dear friend, the just praise which is due you on this point as on all others; but after the machine is assembled, it seems to me that you will have perfectly attained the object you propose. I am too busy at this moment, to attend more closely to so interesting an object,

which deserves more thought, more reflection on your part, and which cannot fail to bring you the greatest honour.

"If the experiment with the water-gauge, immersed in a tank which does not connect with the outer water, has the success that you expect after the trials that you have already made, you will have found an admirable thing and one which seems almost magical. Nothing, in fact, would be preferable to such a process which would offer in the water a point of support as on a solid body. But even if this experiment is not successful, an ample compensation still remains for you; inasmuch as, thank the Lord, you have, my dear friend, two excellent strings to your bow. You would do well to occupy yourself principally with this object because that is the main point. As far as the motive power is concerned, this is at our disposal. Thus I am also curious and eager to know the result of the projected experiment which you are good enough to promise me. We will offer up the most ardent prayers for your success; and in this case there will be more than one *mouth open with surprise and admiration.*

"I am extremely appreciative, my dear friend, of the things both honest and affectionate which you have been good enough to tell me with the unlimited confidence which I also have in you. If this seems to you a testimony of my affection, it is also an homage that I am compelled to render in justice and truth. The fact is that we cannot, as I have often said, put our interests into better hands. According to this you now enjoy complete right to the widest latitude on all that constitutes our engine and its application: that must be so, my dear friend, as much for the good of the affair as for your personal satisfaction

"Farewell, my dear friend, accept from my wife, your nephew and myself the most tender and affectionate embraces." (18)

But let us return to Nicéphore Niépce and to his lithographic and heliographic work. Left alone, and to his own resources after the departure of his brother, he made his principal residence in the country, at Gras (19), and the paternal home at Chalon was no more than a kind of temporary lodging. Not only was he very busy, together with his brother, with mechanical work, but he was also charged with the administration of his personal affairs and of those of Claude. Moreover, man of the world and very well known, although very timid and reserved, he was often disturbed by visitors whom he was forced to re-

ceive owing to social requirements. It can thus easily be seen that he had little time to pursue his dominating tastes for study, especially in scientific research, for his attempts and experiments which incessantly multiplied.

He also often complained to his brother of the annoyance which he experienced in these visits, which forced him to defer experiments with this and that combination, with attempts at this or that object. Thus, relating to lithography, he wrote to Claude on July 8, 1816 as follows:

"I would like to be back again at Saint-Loup in order to take up the continuation of my experiments, which are so often interrupted."

Another time, on the 16th of the same month, he wrote as follows to his brother, on the same subject:

"I wrote to Isidore last Saturday, the 13th, and I told him that, being unable for some time to go to Saint-Loup, I intended to send you on Sunday the little oval stone which he amused himself by engraving. So I sent it by Baptiste. I put it in a small spruce box, tied up and sealed, with your address, and I dispatched it, prepaid, the same day by stage-coach: I presume you have received it. This stone, which is of good quality, can be used to make several trials for gravure by polishing it with pumice-stone; some of it will be needed for analysis, and it will suffice to remove some small particles with a file, to ascertain whether the stone is worth keeping. If it can fill the proposed purpose, you will be so good, my dear friend, to have the kindness to inform me and I will hasten to send you the specimens that M. de la Chabeaussière might want."

It was only four months later, November 19th, that Nicéphore informed Claude again relating to lithography: "You will find herewith a small lithographic gravure of my apparatus, designed and engraved (said apparatus) by your nephew, who is delighted to send it. I have used the same stone as that which we sent to the Société d'Encouragement. It is not necessary to explain this plan; however, I will pass it on to you if you desire."

Leaving lithography for the moment, to which we may perhaps return later, we will now concern ourselves with *Heliography*. We must return to March 21, 1816. On that day Nicéphore Niépce wrote to his brother Claude as follows:

"Ternant's visit here has not allowed me to continue with

the experiments on which I was working. Therefore, after one or two attempts, which I tried to conceal, I am able to anticipate good news of the process in question. I am prevented by this from returning to Saint-Loup where we should be now, if it were not for some matters that still unhappily detain us in town."

On April 1st following, our hero wrote to him again as follows: "The experiments that I have thus far made lead me to believe that my process will succeed as far as the principal effect is concerned, but I must succeed in fixing the colours; this is what occupies me at the moment, and it is most difficult. Without this the matter would be of no value, and I must turn to another method."

On the 12th of the same month Nicéphore wrote to Claude: "I used some of the time while here in making a kind of artificial eye, which is nothing but a small box six inches square; the box will be equipped with a tube that can be lengthened and will carry a lenticular glass. This apparatus is necessary in order to properly complete my process. I will inform you promptly of the result of the experiment which I intend to make on our return to Saint-Loup."

This square box, this apparatus, was simply a kind of camera obscura. But things do not always happen in this world according to our wishes and intentions. Nicéphore, more than anyone, had occasion to recognize this eternal truth, in the course of his laborious existence. We have a small example of this in a letter which he wrote on the 22nd of the same month of April to his brother:

"I planned yesterday to make the experiment of which I spoke, but I broke my lens, of which the focus was best adapted to the dimensions of the apparatus. I have another, but it has not the same focus, thus necessitating several minor changes which I shall make. This will not delay me long, and I will surely have the pleasure of informing you in my next letter of the result which I have obtained. I wish, without expecting too much, that it will justify the interest that you have been good enough to show in this subject.

But it is proper, it is essential, to remark again that Nicéphore Niépce was obliged to invent, to construct himself, or to have constructed after his inspirations and plans, the cameras and the other apparatus which he used continually for his trials, experi-

ments, and the heliographic combinations, which he had made and which he would have to continue to make together with lithography. At the risk of endangering the success of his operations, Nicéphore was accustomed to make on the sides of many of his cameras, holes through which he could observe the effects of the light in the interior of the apparatus; which holes he had to close with a cork, after he had satisfied his curiosity. ([20])

Unquestionably the difficulties which he constantly met in his operations, owing to the insufficiency and imperfection of his apparatus, only enhanced the merit of his work and of his inventions. On the other hand we will see from the following letter to Claude of May 5, 1816 his progress in heliography proceeded rapidly. We must feel, in reading this and the following letters, that Nicéphore is the master of his subject, and that he now progresses with a sure step on firm ground.

"You have noted from my last letter that I have broken the lens of my camera obscura; but I still had another which I hoped to use. My attempt failed: this glass had a much shorter focus than the depth of the box; therefore I could not use it. When in town, last Monday, I found only one lens at Scotti's of a longer focus than the first and I have had to lengthen its tube, by which the proper distance of focus is determined. We returned here Wednesday evening; but, since that day, the weather has always been overcast, which does not allow me to carry on my experiments. I am so angry that I am not very much interested in them. I must leave the house, time and again, to make or receive visits, which is tiresome. I would prefer, I assure you, to live in a desert.

"When my lens was broken, I could not use my camera. I put an 'artificial eye' in Isidore's jewel case, a small box 18 lignes (the 1/12th part of the old French 'inch') square. Fortunately I still had the lenses of the solar microscope which, as you know, came from our Grandfather Barrault. I found that one of these small lenses is exactly of the proper focus; the image of the objects is received very sharply and clearly on a field of 13 lignes in diameter.

"I placed the apparatus in the room where I work, facing the bird-house, and the open casement. I made the experiment according to the process which you know, my dear friend, and I saw on the white paper all that part of the bird-house which is

seen from the window and a faint image of the casement which was less illuminated than the exterior objects. The effects of the light could be distinguished in the representation of the bird-house up to the sash of the window. This is only a very imperfect attempt; but the image of the objects was extremely small. The possibility of painting in this manner is, I believe, almost demonstrated; and if I succeed in perfecting my process, I am eager to include you in it, in return for the kind interest which you have shown me. I do not deceive myself at all that I face great difficulties, especially in fixing the colours, but with labor and great patience one can do much. That which you have foreseen has happened. The background of the picture is black, and the objects white, that is, lighter than the background.

"I believe that this manner of painting has been used, and I have seen engravings of this kind. Besides, it would not perhaps be impossible to change this arrangement of colours, also I have some information on it which I am curious to verify. . . ."

Four days have elapsed since the preceding letter. Nicéphore, in his letter of the 9th of the same month, made a very important declaration, and he could at this very moment replace the word *Heliography* with the word *Photography,* since he announced that it is not necessary that the *sun shine* in order to perform the operation. Here are the terms in which he expresses himself:

"I have constructed another camera obscura of a size between the small and larger; and I have employed for this purpose the lens of our old microscope, which is in good condition and which will do very well. This will enable me to compare my experiments at least two at a time: which will be a great advantage.

"I forgot to tell you in my last letter that it is not necessary to operate when the sun shines, and that the movement of this luminary does not cause any change in the position of the image; at least I have not observed any, which I certainly should have noticed. "

Let us repeat that, since May 1816, Nicéphore Niépce had recognized and declared that it was not necessary that the *sun shine* in order to receive in the camera obscura the images of exterior objects, and that consequently he was entitled from this time on to give to his operations on the effects of light the name *Photography!*

Far be it from us to inject at what may seem an improper time matters of learning and pedantry. Nevertheless, everyone is not familiar with Greek; therefore we believe it necessary and suitable to give, for those who do not know it, the etymology of the words *Heliography* and *Photography*.

Heliography is formed from the Greek words *Helios*: *sun;* *grapho*: *write, depict*.

Photography is composed of the Greek words *Phos, Photos,* which means: *light,* and of the word *grapho, write,* etc., just as in the second part of the word *Heliography*.

Thus, *Photography* means that it is not necessary that the *sun shine* in order to obtain the images by means of the camera obscura; and so one can operate it in any kind of weather: it is enough to have daylight.

Since in the beginning, one operated only when the *sun shone,* thence the name *Heliography* was given to the primitive experiments with the camera obscura.

But let us return to Nicéphore Niépce and to his curious and valuable correspondence. Sunday, May 19, 1816, he wrote as follows to his brother Claude:

"I hasten to reply to your letter of the 14th, which we received on the day before yesterday, and which pleased us very much. I write you on a plain half-sheet because the Mass this morning, and a visit this evening to Madame de Morteuil, leave me but little time; and, in the second place, in order not to increase the weight of my letter, to which I attach two gravures made according to the process which you know. The smaller is taken with the small jewel case and the other with the box of which I have spoken to you, and the size of which is between the jewel case and the large box. The better to judgè the effect, it is necessary to view it somewhat in the shade; the gravure must be placed on an opaque background and held against the daylight. This kind of gravure will alter, I believe, in time, even if protected from contact with light, by the reaction of nitric acid, which is not neutralized. I also fear that it may be damaged by the tossing of the carriage. This is still nothing but a trial; but if the effect could be made a little more like it, (which I hope to obtain), and especially if the order of the colours were reversed, I believe that the illusion would be complete. These two gravures were made in my workroom and

the field is only as large as the width of the window. I have read in Abbé Nollet ([21]) that, in order to be able to represent a large number of distant objects, one must employ lenses of a greater focus, and put another glass in the tube which contains the objective. If you wish to preserve these two *retines,* although they are not worth the trouble, you need only place them in wrapping paper, and keep them inside a book.

"I shall busy myself with three things: 1st, to give more sharpness to the representation of the objects; 2nd, to transpose the colours; 3rd, finally to fix them, which will not be the easiest. But as I have often told you, my dear friend, we have lots of patience and with patience one arrives at the end of all things. If I should be sufficiently fortunate to perfect the process in question, I shall not fail again to send you new specimens in order to reawaken in you the lively interest which I hope you will take in the matter, which might be of great use to the arts and from which we ought to derive a good profit."

The next letter of Nicéphore, dated May 21st, that is three days after the preceding one, contains only this short sentence: "I intend to take up again tomorrow my experiments and attempt at first to obtain a *sharper and more distinct representation of objects.* If I succeed, I shall hasten to send you new proofs in my next letter." The desired result was not attained in these experiments and, on the 28th of the same month, Nicéphore sent his brother Claude the following letter in which he includes the product of the experiments which he had announced to him eight days previous.

"I hasten to send you four new proofs, two large and two small, which I have obtained, sharper and more correct, by means of a very simple process which consists in reducing the diameter of the lens with a perforated cardboard disc. The interior of the box being less illuminated, the picture thereby becomes more vivid; and the outlines as well as the shadows and lights are better marked. You can better judge this by the roof of the bird-house, by the corners of the wall, by the casement of the windows in which one sees the crossbars; the panes themselves seem transparent in certain places; finally the paper retains the exact imprint of the coloured image. And if one does not perceive everything distinctly, it is because the image of the object represented is too small; the object appears as if it were seen

[33]

from a distance. From this it will be noticed that, as I have told you, two glasses are necessary in the objective in order to properly paint the distant objects and to reunite the greatest number on the rétine; but that is another matter. The bird-house appears reversed, the barn, or at least the roof of the barn, is at the left instead of the right. The white mass, which is seen at the right of the bird-house, above the passageway, and which one can see only confusedly but as if it were painted on the paper by the reflection of the image, is the pear tree of "beurré-blanc," which is further away; and the black spot above the pear tree is the light coming through the branches. The shadow on the right shows the roof of the kiln, which seems lower than it is in reality because the boxes are placed about five feet (1.62m) above the floor. Finally, my dear friend, the small white lines, which appear above the roof of the barn, are branches of the trees in the orchard, which can be seen and are represented on the rétine. The effect would be still more striking, as I have told you, or moreover as I need not tell you, if the order of the shadows and lights could be reversed; it is with this that I want to occupy myself before attempting to fix the colours, and this is not easy.

"Until now I have only painted the bird-house in order to compare the different proofs. You will see that one of the larger ones and the two smaller ones are a better colour than the others, although the outlines of the objects are very well delineated; owing to the fact that I reduced the opening in the cardboard which covers the lens. It seems that there are certain proportions from which one must not deviate too much and I have been unable so far to find the best one. When the lens is wide open, the proof which is obtained seems soft and the coloured image has under these conditions that kind of aspect because the outlines of the object are less pronounced and seem to lose themselves in a haze.

"I hope, although it seems too much to expect, that these proofs will reach you in good condition, because you know, my dear friend, they will better enable you to judge the improvements which I hope to obtain."

Five days later, on June 2, 1816, Nicéphore completed the description of his heliographic experiments—which he had al-

ready described in his letter of the preceding May 28th—by the following additional explanations:

"I presume you received yesterday, my dear friend, my letter of May 28th which contained four new proofs which seem to me more correct than the preceding ones. I am extremely appreciative of the praise which you have bestowed upon me and which I do not deserve. But your words are, nevertheless, a source of encouragement to me. If I succeed in fixing the colours and am able to arrange the correct order of the lights and shadows, the process which I am now using will I think be greatly improved; because it is impossible to find a substance which could be more susceptible for retaining even the slightest action of the light. The plaster of the bird-house towards the back-yard is dark brown but over the door and up to the rear there is a white wall which is distinctly marked in black on the gravure.

"Although there is a good deal to be done before I obtain the end, this is already something. I have attempted to etch metal with certain acids, but I have been unable to obtain any satisfactory result so far; the luminous fluid does not seem to modify to any extent the action of the acids. However, my intention is to let matters rest here because this sort of gravure is already superior to the other, everything considered, because of the ease which it presents in multiplying the proofs and keeping them unchanged. If I succeed in obtaining good results one way or the other, my dear friend, I shall let you know."

The reader has, without doubt, noted the modesty and reserve which runs through all of Nicéphore Niépce's letters; also the abnegation which this splendid man readily made regarding himself and his exceptional intelligence, by attributing his heliographic success to the affectionate encouragement of his brother: This was carrying modesty much too far and by acting in this way he detracted from his real value. It is evident that he could not have devoted himself to his work with more ardour and perseverance had he been inspired by his personal urge alone.

How often meanwhile must he have been preoccupied and anxious, observing, examining with anxious eye for hours, for whole days, the effects and variations of the light on his combinations, on the varnish, on the coating which he had mixed and applied after persevering researches on paper, glass and metal plates, and which he exposed in his various cameras. How often

[35]

must his operations have been interrupted—to his despair—by the shadows of the night and forcibly postponed until the morrow, waiting the return of the sun, his principal concern! How often was he not tried, agitated by inner struggles, full of troubles, with their constant turns of fortune for good or bad, testing and trying again, time after time, the anguish of doubt and the unexpected joy of success, incessantly recurring and each captivating his mind and heart, living for a long time with great emotions and disillusionments, a life full of restlessness! Certainly, we repeat, Nicéphore could not have possibly experienced these troubles and hopes had he been carrying out the inspirations of another: This is evident and incontestable.

But this condition is far from the constant changes of restlessness and joy which have been imputed to him by many of his biographers. According to them he "operated in a void, achieving no result and suffering from the ironic self-pity which is the mark of a mind distracted by the impossible, devoted to chimeras, and represented by a fixed idea; a preoccupation analogous to madness in the eyes of the vulgar. His strange ideas at this time alarmed his friends and family; the reproduction of objects by light seemed to them the dream of a monomaniac . . . he was so absorbed, day and night, that they despaired of his health, his fortune and that of his family, which he was throwing into a bottomless pit "

Fortunately there are in some of these lines—repeated by several writers contradicting each other—as many errors as there are words. As a matter of fact, one could judge, by all that precedes it, the confidence which might be inspired by the statements of these authors; if one can believe that Nicéphore "operated in a void", if "no result was obtained." As far as the "self-pity" by which they say he was "distracted"; as far as the "despair to his friends and family"; as far as the subject of his pretended "whims" are concerned, these exist only in the troubled brains of those poorly informed writers. For Nicéphore Niépce was as well respected as he was loved by his relatives and friends, because of the nobility and sweetness of his character; his unchanging reasonableness towards the whole world; his rare and scrupulous probity; his goodness and inexhaustible kindness. Let us add that he had a serene aspect, with the features of a thinker, or a tireless investigator, who showed in his demeanour and in his

tone the manners of a gentleman, who belonged to good society by birth, education and family.

As far as his fortune is concerned, we shall establish and demonstrate later, at the opportune moment, that his experiments concerning heliography did not in any way embarrass him. In short, the following pages will confirm our assertions at every point.

It is true that the biographers of Nicéphore Niépce had not before them, as we have, the interesting correspondence and other unpublished documents which are in our hands. Otherwise they would have spoken differently, and not as having to draw on their imagination.

However, we stress here that this book is not a work of criticism and polemic, but uniquely a history; we do not give the name of the writers, unfortunately too numerous, who have committed the errors to which we have called attention and shall continue to do so. We hope that we deserve approval for our reserve in this respect.

The result of the two preceding letters must confirm without fear of contradiction that Nicéphore Niépce, having overcome great and numerous difficulties, had in May, 1816 created and invented photography;—because it can be given from then until the present this name, because he operated successfully when the sun shone as well as when it did not.—This date of the *creation*, of the *invention* of *Photography* is certain, indisputable and therefore fixed beyond doubt!

However, we do not pretend to wish to persuade the reader to the belief that this marvelous art had arrived at perfection. No! Our own recital would soon meet with cruel disappointment. We merely wish to assert that, from the month of May, 1816, Nicéphore Niépce had discovered the basic principle and foundation of photography, that in one word he had invented this wonderful art; there remained only its perfection and with this he occupied himself incessantly.

We also desire to state that the patient, persistent researches of Nicéphore concerning *Heliography* were made long before Daguerre thought of making experiments of such a nature as had occupied our hero for a long time.

During the fortnight which had elapsed since his letter of June 2nd, Nicéphore continued his combinations and his heliographic experiments. He reports to his brother the results of

[37]

these new attempts on the 16th of the same month in these words:

"I have received, my dear friend, your letter of the 7th in reply to mine of May 28th. The matter and details most interesting to me which it contains have pleased me very much. Your support is sufficient to encourage me in an enterprise, the idea of which belongs to both of us. In these circumstances, success will more than satisfy me. Although I am not afraid of the difficulties which beset me, thank God, I have no illusions about the imperfections of my first attempts, nor the improvements which I desire to make. For several days I have worked, not so much in making new proofs by the same process, which seemed to me useless, but I have applied myself to the task of fixing the image in a satisfactory manner and to place the lights and shadows in their natural order. I have made several attempts along these lines, which I intend to repeat because I see a possibility of success. The idea which you kindly suggest, my dear friend, for attaining the two-fold object is very ingenious and has also occurred to me, because it involves a number of combinations which I can make. But until now my experience has indicated only one substance which the light decolourizes easily and it does not offer as satisfactory a result as a substance which has the property of absorbing light.

"I have read that a solution of muriate of iron in alcohol, which is a beautiful yellow, becomes white in the sun, regaining its natural colour in the shade. I coated a piece of paper with this solution and dried it; the part exposed to the light became white while the part which was not exposed to the light remained yellow; but this solution absorbed too much of the humidity of the air, and I used it no more because by chance I found another substance simpler and better.

"A piece of paper coated with one or more layers of 'rouille' or 'safran de mars', exposed to the vapours of oxygenated hydrochloric acid turns a beautiful daffodil yellow and bleaches better and more rapidly than by the former process. I placed both in the camera and still the action of the light had no noticeable effect on either of them, though I was careful to change the position of the apparatus. Perhaps I did not wait long enough and I must make sure of this, because the substance was only slightly affected.

"I also believed as you did, my dear friend, that if one places in the camera a strong proof on paper, tinted with a fugitive colour or covered with the substance I employ, the image will appear on the paper in its natural colours, since the dark parts of the proof, being more opaque, intercept more or less the passage of the light rays, but without affecting the result. I presume that the action of light is not strong enough and that the paper which I use is too heavy or, being too thickly coated, offers an insurmountable obstacle to the passage of the fluid; because I applied almost six coats of white. Such are the negative results which I have obtained. Fortunately they do not as yet, disprove the value of the idea; I hope to take the matter up again and look forward to some measure of success.

"I have succeeded in decolourizing black manganese oxide, that is to say, a paper coated with this oxide becomes perfectly white when it is subjected to the vapours of oxygenated hydrochloric acid. If, before it is entirely decolourized, it is exposed to the light, it bleaches rapidly and, after it has bleached, if it is slightly blackened with the same oxide, it is again decolourized by the sole action of the luminous fluid. I think, dear friend, that this substance deserves further research and I intend to look into it more seriously.

"I also want to make certain whether the different vapours could fix the coloured image or modify the action of light, by introducing them with the aid of a tube into the apparatus during the operation. I have only used the fumes of oxygenated hydrochloric acid, hydrogen and carbonic acid. The first decolourized the image; the second did not seem to produce any noticeable effect; while the third destroyed in a large measure the capacity of the substance employed of absorbing the light. This substance, though exposed for eight hours, coloured only slightly while subjected to the fumes and only in those parts which were most illuminated. I resumed these interesting experiments and tried several other vapours in succession; especially oxygen, which, because of its affinity with metallic oxides and light, deserves special attention.

"I also have made new attempts to succeed in engraving on metal using mineral acids; but those acids which I used, that is to say muriatic and nitric acid, as well as the oxygenated hydrochloric acid, whether in the form of vapour, or in solution, only

resulted in a blackish stain, more or less deep, according to the strength of the solvent. Oxygenated hydrochloric acid is the only reliable one, but it is only decomposed by the light when combined with water, and in this state does not act on metals with sufficient energy to etch them perceptibly; for it does not produce any effervescence and oxidized them as would liver of sulphur, which is not our object. But I am happy to have recognized that, without producing the troublesome agitation of other acids, it attacks the lithographic stone, which we use for engraving, sharply and cleanly. It attacks it slowly, as we require, in order that the influence of the light may be more sensible and the acid would etch the stone deeper, according to the different shades.

"Stopping everything, I turned to preparing one of these stones instead of paper, on which the coloured image would be reproduced. I let it soak for some time in hot water and then I subjected it to the fumes of oxygenated hydrochloric acid which entered the apparatus, thus carrying out my method. I believe, with the aid of this manipulation, a decisive result will be obtained if, as we cannot doubt, the acid in question is decomposed by the light and, by this, the strength of the solvent is modified.

"You see, my dear friend, for several days I have done nothing but experiment, but it has always been something to contribute to the solution of our proposed problem. As soon as I have found a useful and really proper improvement, to attain this end, I will hasten to inform you."

Notwithstanding the modesty of its language, one must consider this letter,—a veritable course in chemistry,—as one of the most curious and interesting of those in our hands.

On Tuesday, July 2nd following, Nicéphore wrote from Saint-Loup to his brother these few lines: "After repeated experiments, I recognized the impossibility of fixing the image of objects by the engraving process on stone by the combined action of acids and light. This fluid, it seemed to me, had no perceptible influence on the dissolving property of these chemical agents. I have, therefore, entirely given up their use; and I doubt strongly whether it is possible, by this process and with this substance which I employ, to render sensible the different tones which reproduce the paint of the bird-house which is

white in some parts and black in others. I have just made new researches in order to arrive at fixing and transposing the colours of the image represented. The field to be covered is very great but I shall not cease until I have tried all the combinations."

We have often entertained the reader with the *Pyreolophore* and its improvements. It may seem that the silence which we have kept for a long time on this marvelous motor is an indication that it had been forgotten or at least, like many other inventions, abandoned by its inventors. But this is not so; it had not been forgotten for a moment and remained the principal object of the serious preoccupation of the two brothers Niépce. Their letters are full of descriptions of new apparatus, essays, and successive experiments with the Pyreolophore; their attempts to make it better and the improvements contributed to this machine; the results of their experiments with combustible substances to supply motive power to their motors. Claude and Nicéphore employed all their time and their intelligence, not only to this work, but to the necessary measures to place their favorite apparatus advantageously.

Lithography, also, as well as heliography held only a small place in their voluminous correspondence and one finds only rarely some short sentence devoted by Nicéphore to heliography during the time which elapsed between July 1816 and April 1817. We shall reproduce some of these sentences in order to establish the fact that Nicéphore had not abandoned, as might be supposed, his chemical researches and his experiments on the action of light.

In his favorite occupations, his mechanical work and the management of his property and that of his brother, Nicéphore was preoccupied and sadly affected by the public misfortunes and the horrible disasters which desolated France, particularly Bourgogne, calamities which were brought about by constant rains which gravely affected the soil and created fearful misery. The river Saône overflowed twenty-seven times in the space of a few weeks; Saint-Loup-de-Varenne was overwhelmed by these disasters. Nicéphore and Mme. Niépce, in their own name and in that of Claude, gave all their efforts to relief and assisting the unfortunate inhabitants who were reduced to despair. "In our poor Saint-Loup", writes Nicéphore to his brother, "sixty families are reduced to poverty. Many of your tenants find themselves

in this sad position; it is absolutely necessary to give them sustenance and we believe that we must act as you would yourself have done if you had been here." ([22]) Nicéphore distributed the necessary wheat and *turquis* (Turkish grain, or maize). But let us return to heliography and copy the few sentences of which we have just spoken.

In his letter dated Gras, July 29, 1816, Nicéphore writes: "Since we arrived here I have had time to make only some chemical preparations for the new experiments which I intend to make with light. If I receive any successful results I shall hasten, my dear friend, to inform you."

His letter of August 28th contains only these three lines: "Finding myself for a long time like a bird on the branch of a tree, I have been unable to follow my experiments with light." On September 9th he is equally laconic: "My intentions are to take up soon my experiments with light; however, I have had to postpone them for some time and devote myself to the water gauge in question."

We have read and reread the letters written in September, October and November without finding anything concerning heliography and in the letter of December 11th we can only find the following lines:

"I am very glad to finish the small apparatus for the experiment about which I told you, so that Isidore can inform you of the result which deprives me of the pleasure of writing you more by this mail." He follows this with a postscript: "If I can make my experiment today, Isidore will have the time to design and perhaps also make an engraving of the camera."

Three months and a half have elapsed since December 11th (1816) and we have found no trace of heliography. So much was Nicéphore occupied with other things. His letter dated Chalon, March 26, 1817, contains this: "I have not yet been able to give an account of the process which I have mentioned to you for *engraving on stone;* because in the process I must employ a substance which has no relation to the first. I greatly desire that it will answer my requirements and justify the interest which you are good enough to take in it. For this purpose, I obtained from the marble cutter two small stones a good inch or 15 lignes square and at the same time ordered a small apparatus for the experiments which I intend to follow on our next

return to Saint-Loup. If they are successful, I shall hasten to communicate to you in detail."

On his return to Saint-Loup, Nicéphore took up again the pursuit of his experiments on light and on April 8, 1817 he informed his brother of them in the following words: ". . . . I have attained only some probabilities in the matter which occupied me; but even supposing that they will be realized, it will be only a trifle compared with the other. However, the encouragement which you are good enough to give me adds to my zeal, and assuredly I would not abandon the undertaking for some more slaps in the face. You believe perhaps from this, my dear friend, that I have already made some attempts which are less than satisfactory. But the truth is that, since my return from Chalon, I have only had time to mount the small apparatus for my preparatory work. I am at present ready to experiment and, if nothing interferes, I shall, D.V., impart to you the result which I have obtained. This result from all appearances will again not be decisive, but it will at least most likely indicate the certainty of complete success, which will be a good deal."

But, as the reader will have undoubtedly noted, the heliographic operations of Nicéphore Niépce were activated by two systems or perhaps better, by two processes having the same principle, the same basis: *Light!* The first and principal one consisted of obtaining, either on paper or on glass or on metal plates, the spontaneous reproduction of images received in the camera obscura; the second in the application of this process, to engraving these images by means of chemical reagents of which Niépce possessed the secret and which he exposed to the light. It is the realization of these two systems, of these two processes which combined themselves in a sort of a whole to which Nicéphore offered all his intelligence, with which he was admirably endowed, all his science and all his genius. Although his mind was filled and preoccupied with interminable improvements on the *Pyreolophore,* constantly suggested by Claude, who continually demanded his advice, aid and experiments, Nicéphore Niépce nevertheless availed himself of his stay in the country to make experiments with new chemical combinations, all of which he related to his brother, manipulations attempts and results, in his letter of April 20th.

"You must have seen from my last letter that I intend to give

you the detailed circumstances of the researches with which I
am occupied, in which you have the kindness to take an interest,
which I shall be very happy to justify. I have not yet enough
to demonstrate the success with certainty; but I have acquired
some new probabilities which restore my courage and induce me
to take up again my experiments.

"I think I have informed you, my dear friend, that I have
given up the use of muriate of silver, and you know the reasons
which have led me to this determination. I was very much per-
plexed to find another substance by which I could replace this
metallic oxide, when I read in a work on chemistry that the
resin of guaiacum, which is a yellowish grey, becomes a strong
beautiful green when exposed to the light; that it acquires by
this exposure new properties and that it requires for dissolving
in this state a more highly rectified alcohol than when dissolv-
ing it in its natural state. I hastened therefore to prepare a
strong solution of this resin and I noted that, when coated in
thin layers on paper and exposed to contact with the luminous
fluid, it became a beautiful strong green in a very short time;
but no matter how thin the coating is reduced, as it must be for
the proposed object, it offers not the least difference to solubil-
ity in alcohol. Therefore, after several equally fruitless at-
tempts, I have given it up, being convinced of the insufficiency
of this new substance.

"Having seen a note in Klaproth's dictionary (²³) in an
article on phosphor and especially when reading Vogel's memoir
on the changes which the action of light effects in this combust-
ible, I thought that I might make an advantageous application
of this in my researches.

"Phosphorous is naturally yellowish; but when properly fused
in hot water, it becomes almost white and is transparent on glass;
and then is perhaps more susceptible than muriate of silver to
the impression of the light. This fluid changes it very rapidly
from white to yellow and from yellow to a strong red and fin-
ishes by becoming blackish. Lampadius' alcohol (²⁴), which
easily dissolves white phosphorus, does not take red phosphorus
at all and it is necessary to subject the latter to a much stronger
heat than when dissolving the former. Red phosphorus exposed
to the air does not change by deliquescence like white phosphorus
which, after having absorbed the oxygen, changes into phos-

phoric acid. This acid has the consistency of oil and corrodes stone like the mineral acids. I have verified all these assertions without going any further. I am convinced that you think as I, my dear friend, how many useful combinations this chemical agent can offer for the solution of the problem in which we are engaged.

"The only difficulty which embarrasses me at present is to spread the phosphorus on a stone like a varnish. It is necessary that the coating be very thin, otherwise the light will not penetrate and the phosphorus, not being oxidized in all its thickness, one will again fail to attain the goal. This substance is attacked by alcohol and moreover by the oils; but these solvents remove from it a property which it is most important to preserve, as I have learned by experiment. I have arrived at coating the stone by the aid of heat in my apparatus which is a kind of a bellows filled with nitrous gas in which the interior clapper receives the stone in question and which has on its upper clapper a small mechanism to distribute the phosphorus equally; as well as a glass to light up the interior; but this apparatus does not shut tightly enough to prevent the surrounding air from penetrating into it; and the phosphorus becomes inflamed before the operation is over. In order to arrive at a complete demonstration, it is necessary that I undertake first to remedy this great inconvenience and I hope to overcome it in one way or the other. I hasten to inform you, my dear friend, of the result of my last researches along these lines."

Ten days after having written this letter on April 30th, Nicéphore entertained his brother with his future plans and with the difficulties which he would have to surmount in order to attain the end which he pursued with such great perseverance.

"You will think correctly", he says, "that Ternant's (25) visit prevented me from continuing the experiments which I was making; I had to interrupt them, much against my will, but I certainly shall not fail to take them up again at our early return to Saint-Loup. I thank you with all my heart, my dear friend, for all the very encouraging and most flattering words which you have been good enough to send me on this subject; I wish I could merit them but I still have nothing but more or less basic presumptions; from which you can see that I am still very far from any finished results.

[45]

"The greatest difficulty which I must surmount will certainly be my ability to retain the most delicate shades of the coloured image; and this is also for me the least easy of all the lashes of the whip which I must ward off. Notwithstanding this, I am not discouraged and you may rest assured that when I succeed in obtaining a favorable result, I shall hasten to inform you.

"The first and essential thing is to find a way to spread the phosphorus in a smooth and thin coating. Your idea would be excellent, my dear friend, if this substance, fused according to the process which you indicate, would adhere to the stone; but, under the present circumstances, it flows, separating itself in globules like mercury, without my being able to spread it to the least particle as I have assured myself several times in purifying the phosphorus in hot water and putting it on the small cube of stone which I use in my experiments. Since phosphorus has an affinity for fatty substances, it might adhere to the stone if melted in oil at the proper degree of temperature; I will convince myself of this if another more simple process which I have in mind does not succeed."

But these attempts were not successful, notwithstanding Nicéphore's desire; on May 30th he communicated his failure to his brother in the following terms:

"The discovery on which I am working presents some difficulties which I had not foreseen, the solving of which I believe will give me a great deal of trouble. The phosphorus, when placed in a camera obscura, is not affected by the light, while it is very promptly changed by the direct action of the solar rays. You can see there how books will lead you astray! Notwithstanding this impediment, I have not abandoned my researches even though I have lost all hope of success."

At the end of the same letter of May 30th, Nicéphore adds this: "Since my last letter, the weather, which has been almost constantly cloudy, has not permitted much variation in the experiments which I am making, and in which you have been so kind as to take an interest which has been so very encouraging to me; if I ever arrive at success, which is not an easy matter, in spreading the phosphorus properly, I certainly believe, without deceiving myself, that I shall be able to solve the problem."

On the following June 7th, Nicéphore Niépce again informed his brother of his attempts and experiments with phosphorus:

"I have succeeded" he writes "in spreading the phosphorus in a thin layer on a strong sheet of paper, but this is not enough. Notwithstanding this I notice that the phosphorus which has not been coloured by the light becomes acid more quickly than that which has been coloured; and the manner in which it attacks the stones leaves no doubt as to the truth of the underlying principle. This is already a very important point; but it is still far away from the object which must be attained. I am not proceeding very fast because it is necessary to repeat and to vary my experiments and, what is more essential, to carefully observe and compare the results obtained. If I succeed fairly well in engraving a 'fleur de lis' by this process, such as will indicate the lights and shades, I shall not fail to send it to you, convinced that after the fine and flattering interest which you have shown me so often, my dear friend, and which is so encouraging to me, this first proof, imperfect as it may be, will please you."

Three weeks elapsed during which Nicéphore continued his experiments with this same material, manipulating it in different forms; he relates this to his brother on July 2nd in the following terms:

"My most important experiments with phosphorus were unsuccessful; I have not been able until now to record on this substance the image of objects by the aid of the apparatus which, as you know, I employ. I believe that there is a great difference, according to my observations, between substances which retain the light by absorbing it and those which only use it for changing or modifying their colour. However, I have not yet varied my experiments enough to look upon myself as beaten, and I am not at all discouraged."

Nicéphore, having been unable to obtain from phosphorus the results which he had expected, abandoned to some extent this *perfidious combustible,*—to use his own words;—and he again took up his experiments with guaiacum, of which he informed his brother in these terms, on July 11, 1817:

"I am going to occupy myself with analyzing guaiacum. My object is to discover the part of this substance which is susceptible to impression by light. I have already recognized with pleasure that this peculiar property does not exist at all in the gummy matter which the water easily dissolves; and that the resin, freed of this reddish gum, is more sensitive to the action of the lumin-

ous fluid; but this same resin is again united to an element which is not soluble in water or alcohol, namely that which offers the means of obtaining it (the resin) perfectly pure. If, in this state, its combination with oxygen by the aid of light renders it less easily attacked by alcohol, I will have made a great step towards the solution of the problem which I seek.

"You know that phosphorus yielded only slightly satisfactory results; its employment is also dangerous, and a severe burn, which I suffered on my hand, contributed not a little to my complete disgust for this perfidious combustible.

"I therefore must resume my experiments, and I shall not fail to inform you of the results which I obtain, whether they be good or bad. You will conclude from this that I have not yet lost all hope of success."

As we have already remarked, the course which the brothers Niépce followed in order to obtain an extension for their patent from the Government, in regard to the improvements which they had made to the *Pyreolophore,* and their endeavors for a sale or of interesting capitalists met with no success: these proceedings, we repeat, completely failed. Also, Claude, humiliated in his self-respect as an inventor, his interest hurt, left Paris at the end of August 1817, and went to England; he forwarded there his machines, motors and apparatus, hoping to do better there than in France, which was already overrun on all its waterways by promoters of similar enterprises in which everybody who had ambition employed himself according to his means and facilities; it was a regular epidemic!

Claude was encouraged by his brother to emigrate, inspired by the hope that the English would have more appreciation for their work than the French.

"The English" wrote Nicéphore to his brother, "who are usually great admirers of all useful discoveries, will not permit themselves to be outdistanced in the chance of procuring the type of a machine destined to create an epoch in the mechanical science.

"But in case we meet with this piece of luck, it seems to me that we cannot after the propositions which we have made, both to our cousins and to M. de Varennes, abandon the projected association without failing in the undertaking or seeming to be inconsistent. They must have the last word and judge whether

the proposed arrangement would not be of outstanding advantage for us. I do not doubt, my dear friend, that this will also be your opinion." ([26])

Alas! The last word of these gentlemen was an unfavorable reply. And so, Claude left for England from which he never returned, as we shall see later.

Several days after his departure for London, Nicéphore received the following letter dated Paris, September 10, 1817:

"Sir, the Société d'Encouragement pour l'Industrie Nationale, at its general meeting of August 27th last, has resolved that there be addressed to you their thanks for the disinterested zeal with which you have entered upon its ideas of public utility, by devoting yourself to the search, in the department in which you live, for stones fit for lithography. Count Lasteyrie, one of our vice-presidents, will communicate to you the satisfactory results in obtaining proofs on the specimens of the stones which you have sent. My mission today is to serve as the agent of the general assembly of the Society by acknowledging the debt which you have imposed on it by your devotion and the speed with which you seconded its efforts.

"I have the honour to be, etc.

"Jomard: Secretary."

This letter was the only recompense, the only compensation, which Nicéphore received from the Society for having sent suitable lithographic stones, gratuitously, several times during the course of 1816 and 1817; and this, notwithstanding that he had expressed a desire for proofs of the designs which would be engraved on these stones. Disappointed with this treatment, he complained to his brother in one of his letters: " I am not disposed to lose time and money which I can employ more usefully and agreeably in further quests for this."

This decision of Nicéphore is particularly remarkable for he was exceedingly obliging, very disinterested and devoted to the public good.

To our great disappointment, we are now confronted with a great gap in this correspondence. As a matter of fact, we possess only one letter from him between the time which elapsed from July 1817 to May 1826; that is during the long space of nearly ten years.

But fortunately we have, to take their place at least in part,

[49]

during this regrettable interruption, a number of letters which Claude Niépce wrote to his brother from England, covering the dates from October 1818 to December 1825, all dated at Hammersmith.([27]) Unfortunately they have the very serious drawback of keeping almost complete silence as to the means and processes employed by Nicéphore in his heliographic experiments. However, they furnish, in their way, the evidence of some of the results he obtained, proving most convincingly that he constantly devoted himself to his combinations, chemical manipulations and to his study of the effect of light, during this great lapse of time.

We owe this grievous silence on the details of the heliographic operations of Nicéphore to the prudent reserve,—perhaps too much exaggerated,—of Claude Niépce who repeatedly recommended to his brother the need for the greatest discretion and circumspection in the description of his processes and combinations, for fear that their letters would be opened and read by persons other than they; who might possess themselves of their secrets and inventions and who would not scruple to profit by their life's work. Claude practiced the same caution which he gave to his brother and abstained from giving him the details of his apparatus, machines and experiments, concerning the *Pyreolophore* and his other motors, upon which he worked without relaxation.

"Notwithstanding all my interest"—he wrote to Nicéphore on October 29, 1818—"and the pleasure which I enjoy in receiving the details of your work, my dear friend, I fear that you are writing too openly and that your letters might be read, which unfortunately might disclose the principle of your discovery; I ask you to consider this, notwithstanding the privation which my advice will impose upon you."

Later he repeats the same advice in these terms: "I beg of you, my dear friend, notwithstanding the interest which I find in reading the interesting details which you intend to communicate to me, to omit the particular circumstances, because others might perhaps profit by them, which would be very disadvantageous to you; and above all, do not write on the last page of your letter which is visible to those who handle it. This is a strong friendly advice applying to both of us, my dear friend, in which I am motivated by your interest."

However, we shall reproduce literally without annotations and commentary,—in the form of a diary,—the principal and most interesting passages of Claude Niépce's letters. We shall add only to each extract the date of each letter as far as possible.

October 29, 1818. "Receive, my dear friend, my sincerest congratulations for the new success which you hope to attain in your interesting work; I hope also that you will realize still more and that you will arrive at the desired end by the force of your researches and your sagacity. My wishes are most ardent that your hopes and mine in this regard will be realized, and it will come about that there will be, as one says, a good thing: may the Lord also bless the others.

"I have not forgotten to get the information you desired on the camera lucida of Wollaston. I went to London a week ago Monday to procure it and in passing through the Strand, which is one of the great business streets of this great city, I went into the shop of an optician which was well equipped and I saw there this ingenious apparatus. It consists, as you most surely have noticed from its description, of a crystal prism placed vertically, upon which the object to be designed is projected; this image is reflected by two small mirrors inclined in such a manner that they reflect it upon a tablet, above which the instrument is placed. This optician had the goodness to show me the details, which are very ingenious and make this apparatus much more simple and convenient than the camera obscura. The colours of the object, however, are not perhaps so vivid as they show in the camera obscura, because the image is received in daylight which necessarily impairs the effect; which makes me believe that for your apparatus it offers no great advantage over the other process; because there is always an opening in admitting the luminous rays and with it all the other environment also enter, which comes to about the same thing. However, this is only a conjecture on my part; and if you desire, my dear friend, to convince yourself, I could acquire this apparatus. With the small tablet, which is portable, it cost eight guineas and five shillings."

November 19, 1818. "I am pleased, my dear friend, that the information which I had the pleasure to give you about the camera lucida has contributed, with that of my dear nephew, in giving you a more correct idea than the description of the ingenious machine could have conveyed to you; and I anxiously

await the result of your new researches "

December 31, 1818. "I intensely hope that the new substance which you have received from Paris will meet your expectations. You touch very nearly, my dear friend, on a solution of the problem. I cannot precisely guess what this substance might be and I thank you for your discretion in not naming it. If, as you are kind enough to say, the ingenious idea which you are pursuing belongs to both of us, the real right is yours personally, owing to your researches and improvements in which I had no part. I also cede to you with all my heart the glory which the success of a discovery, both remarkable and useful, will procure for you."

August 6, 1819. "I am happy to congratulate you on your work and thank you for the new ingenious and interesting details which you are good enough to send me. I regret exceedingly that I am not able to understand them sufficiently to appreciate their merit. But I believe that the transparency which you propose to use may produce a very good effect. I must admit, my dear friend, that you are dealing with a subject which is much more difficult than mine and which has been proven by your researches and the sagacity of your genius!"

August 24, 1819. "With what satisfaction I have read the interesting details which you have been good enough to send me on your new researches! How much I desire that these encouraging hopes might not vanish and that they will conduct you to the desired end, which is, one may well say, at the same time both beautiful and surprising: I hope that your happy inspiration will conduct you to this. I must admit that this substance which you use and which I do not fully understand, with the exception of one which I presume has sufficiently the property of which you have given me some idea and of which, notwithstanding, I do not wish you to give me any further explanation. Then, if the object is attained, it must be admitted, I say, that it will excite curiosity and general admiration. How much you must congratulate yourself, my dear friend, to have followed so constantly a kind of application which would have discouraged all others but you, by the great difficulties which it offered; but, by a secret inspiration and one that comes from Heaven, so, one must believe, you were encouraged to pursue it."

November 23, 1819. "I note with great pleasure that the dis-

tracting matters (²⁸) which you were good enough to take in hand did not make you lose sight of the interesting object which requires uninterrupted application; and that your last research gave you the hope of a justly deserved success. I earnestly wish for you the greatest reward for your continuous and ingenious work."

December 11, 1819. "It seems, my dear friend, according to the information you sent me of your interesting work, that you have had the good fortune to obtain results which promise to enable you to arrive at a complete solution of the problem which you are trying to solve, so difficult in its nature"

January 22, 1820. " . . . I believe that your ingenious process will merit the preference over all others, if the ground after the operation will remain for a long time in the same condition; it is that which, I believe, presents the greatest difficulty to be surmounted. From what you have been good enough to tell me, it seems that you have found the means to give to this substance, which receives the *effect,* this precious faculty. I hope so with all my heart; for, as it is said, the matter would be in the bag and the success would crown your ingenious and very difficult labours."

February 8, 1820. "I have read with the greatest interest of the new discovery which you have made. When the experiments which you intend to repeat confirm the happy result which you achieved in the first one, I regard it, as you do, as a solution of the problem with which you are occupied, and you may say you have surmounted the greatest difficulty which opposed the success of your ingenious process"

February 25, 1820. "I noticed with great pleasure that you have made new experiments which promise very interesting results for your object. The transposition will be a process otherwise as expeditious as the first, which I believe will be under other circumstances of great advantage Some day when you are assured that you have laid the foundation for the phenomenon which occupies you, you will then have realized the dream of my dear sister."

March 17, 1820. " Let us first speak of the experiments on which you are working, which seem to lead rapidly to the end you desire, so difficult to discover and apparently as great as it is extraordinary. Receive then, my dear friend, the expression of the great satisfaction which I have experienced when reading and re-reading the interesting details which you communicated to me.

How much I wish that your splendid hopes may be realized, and that the process which you intend to try with the dark varnish, sensitive to the luminous fluid, by means of *l'h . . . oui* (sic), which I remember very well and which, however, allows the impression to remain unalterable. Without doubt the problem will then be solved in the most decisive way "

April 4, 1820. "I hasten to thank you for the details, so satisfactory to me, contained in your letter. I have read and re-read them with the most lively interest. I congratulate you from the bottom of my heart for the new road which your sagacity and constant researches have opened to you and I hope, with you, that it will lead you to the solution of the problem so ingenious and difficult which occupies you. It is truly very extraordinary that the luminous fluid can work in harmony with heat; and the problem would be (as you very justly observe) solved entirely if the tones could be entirely carbonized while conserving their respective intensity, which produces the effect "

April 21, 1820. "Please accept my hearty congratulations on the fortunate discovery which you have made. Accept my affectionate thanks for the interesting and ingenious processes in which you are kind enough to include me. I believe, as you do, that this lucky hit will clear away the almost insurmountable difficulties which have obstructed your road, in arriving at the end which you intend with good reason to attain. I hope that the results that you have obtained have actually initiated you into the marvellous secret of nature's work, and that you will be able with the ingenious apparatus which you intend to construct, to facilitate greatly this operation in being able to combine at will the materials which, following your last and interesting results enter into the production of so admirable a result which was so difficult to attain."

April 24, 1821. " It seems essential to find a means of conserving without subsequent alteration the image of the object after it once has been engraved; for it is here, as far as I can judge, that the whole difficulty lies, and without doubt this will seem *insurmountable* to everyone but you. However, I dare hope that your ingenious and indefatigable researches will attain their goal and that a happy inspiration will crown with satisfaction that, which so astonishing a discovery must prove to you as well as to me."

July 19, 1822. " General Poncet must have been equally

enthusiastic over the beauty of your discovery, as the new success has caused me the greatest satisfaction. I have read and re-read with admiration the interesting details which you have been good enough to send me; I imagine to see you as well as my dear sister and my dear nephew attentively following with their eyes the wonderful work of light, and I imagine that I can see myself a view of which I have happy recollections. How much I desire, my dear friend, that an experiment, so beautiful and so interesting to you and for science, might have complete and definite result."

The reading of these extracts from the correspondence of Claude Niépce must produce a lively regret for the lost letters of Nicéphore, in which are. described the heliographic operations of which Claude gives us merely the results in a few lines, and in a style more or less bombastic. It would truly be very interesting to follow step by step the attempts, the experiments and the progress of Nicéphore on the action of light. Nevertheless, we must congratulate ourselves that the letters of Claude, quite incomplete as they are, had not been destroyed or lost as those of his brother, for the gap in time which we have noted above would be still more regrettable.

It still remains for us to give copies of two or three extracts from Claude Niépce. But since the letters are dated 1824 and 1825, it is necessary before reproducing these extracts to present to the reader one of the most important and most interesting results of the heliographic operation of Nicéphore, obtained in 1822.

Claude Niépce, in speaking of the enthusiasm of General Poncet in his letter of July 19th and of the beauty of the heliographic work of his brother, alludes to a portrait of Pius VII which Nicéphore had recently obtained on glass by the action of light by means of his ingenious process.

General Poncet du Maupas was a relative by marriage of the brothers Niépce. As a relative and, moreover, a friend of the family, he frequently visited Nicéphore and often witnessed his heliographic work. On a summer's day in 1822 the general arrived in Gras, at the time when Nicéphore had obtained by his process the portrait of Pius VII of which we have spoken and which was so admirably successful; the success was complete!

General Poncet, already a great admirer of the talents of his

relative, became so enthusiastic over this new scientific product of his friend that he eagerly asked Nicéphore for the gift of this marvelous portrait, which Nicéphore granted readily. The general was so enchanted and so happy to possess this image that he presented it to the admiration of the whole world. After a while, he made a trip to Paris; he instructed M. Alphonse Giroux, rue du Coq-Saint-Honoré,—well-known to the whole world—to frame this precious portrait for him. This portrait was on glass, as we have said, enclosed between two other glasses and then placed in a frame of gilded copper, so that the picture could be seen from both sides. This portrait of Pius VII aroused the admiration of many art amateurs who visited the shop of Alphonse Giroux. Everybody vied with each other, used all their intelligence and their knowledge of science to seek, to divine, to find, without success, alas! by what means this beautiful design had been obtained.

Unfortunately, General Poncet carried this fragile image of the Pope with him on his travels, so great was his pleasure in showing it to his friends. One fine day, or rather one unfortunate day, a clumsy person dropped it: it was broken in a thousand pieces; nothing is left of this lamented image. The grieved general gave the frame to Nicéphore, expressing to him his disappointment at what he justly considered a misfortune. Isidore Niépce still has this frame. We have seen and had it many times in our hands in his house.

The details concerning this portrait of Pius VII have been told many times by the son of Nicéphore Niépce and confirmed by several members of General Poncet de Maupas' family, whom we have the honour of knowing very well.

Nicéphore spent the years 1823 and 1824 in improving his processes, experimenting with combinations of his chemical reagent. He arrived finally—not without trouble and after having suffered alternately joy and pains following the success or failure which he met—he arrived, we say, to *fix definitely* on his metal plates, on glass, on paper, prepared according to his valuable process, the image of the camera obscura.

But it was with difficulty that he dared,—for so great was his modesty—to announce to his brother in a positive manner the success which he had obtained; he took pains,—so much did he fear the disappointments from which he had suffered so often,—

to permit some doubt to remain in his letters, to keep a reserve, which rendered him less susceptible to sad disappointments which might arise at the moment when he least expected them. But let us return to the letters which Claude Niépce wrote from Hammersmith to his brother Nicéphore. That of February 24, 1824 contains the following: "I see you no longer need to wait for the return of good weather in order to obtain its bright reflection for your proofs; that you wait only the return of the good season in order to prove the thoughts which the winter will give you time to mature; and that you are determined, my dear friend, to occupy yourself principally with views of landscapes in preference to copying paintings. *A good original, it is said, is worth more than a copy,* although these copies have been, as far as this art is concerned, true originals. I congratulate you with all my heart, on the choice of mediums so precious and so admirable, which surely, when you make them known, cannot help but give you great honour and obtain for you the glorious reward which is due to researches as difficult as they are ingenious."

We have on several occasions mentioned in the course of our recital the great friendship, the sincere attachment and the respect which the two brothers Niépce had for each other. We must indicate once more—as a beneficial example—this exquisite sentiment of devotion, the strong and unlimited fraternal love, as well as the expressions of inexhaustible tenderness to which they incessantly testified; attributing the success of their work to their reciprocal and kind encouragement, mutually expressed. Verily, nothing could be more charming or touching than the correspondence of these two brothers which we sincerely regret not being able to reproduce in its entirety; for, without any contradiction, one would find there the useful precepts of a wholesome morality, the principles of respect for family and the most absolute unselfishness.

In the meantime, and as we have done for Nicéphore ([29]), we will copy here in its entirety a letter from Claude; it will give in addition a new idea of the favorite work of the two brothers and will to some extent be a corollary of that which has preceded.

"Hammersmith, September 3, 1824.
"My dear friend, I have had the pleasure of receiving yester-

[57]

day afternoon your very dear and interesting letter of August 26th; and in order to answer with the tender haste which you have shown of promptly receiving the news of my work (for I have unfortunately nothing more decisive to announce to you), I do not want to prolong your just anxiety by deferring longer to let you know the lively satisfaction which your last letter has caused me, my dear friend.

"Receive therefore, I beg of you, my tender and fullest congratulations on the fortunate results which you have obtained; they are such as you could not possibly have expected and they confirm your hopes of having achieved the means for engraving on stone, on copper and on glass! What more can be lacking, my dear friend, to bestow upon you the greatest honour and to compensate you fully for all the trouble and efforts which this brilliant discovery requires? For, I must say that you have made giant strides since your last attempts with the views, because you have been able to obtain certain details which prove the possibility of its total success. The difficulty which remains to be overcome is less obvious, owing to the correct observations of the weakness of the effect of the *Mezzo-tinto*. But it will be possible, I presume, to increase the intensity of the image by causing it to be reflected from a glass from which it then will be projected into the camera obscura. This is an idea which has come to me and which you undoubtedly have had before me, my dear friend; it might be possible to try it and thus obtain a good effect.

"The engraving of the view is still more magical than the other, which is nothing else but a bauble, as you have called it; but it is a most useful discovery and one of the most brilliant of the century; I am convinced and I want to tell you with all my heart that it will become infinitely productive. As far as the other discovery (the *Pyreolophore*) is concerned, it is also within your province, my dear friend, since you have worked on it as much as I. This (*Heliography*), however, belongs to you exclusively, and in spite of your generous and kind intentions, I certainly hope that it will also be your exclusive inheritance. I am no less infinitely moved by this proof of your close attachment for me, so precious and so true, my dear friend, and I hope that the Divine Providence will deign to favor my work also in order to deserve your consideration as you have merited mine!

[58]

I hope, as you do, that we will arrive together at the end of our laborious researches, that is, at the success which we await.

"However, I have not advanced very far since my last letter; because the essential point for me to overcome is the difficulty which opposes the reaction from the force of ineptitude as the good Langrois ([30]) said. I have had the good luck to find a new material which gives me the greatest hopes of having found out the difficulty, something like seizing a mouse in the prairie, *by the hide, the neck or the head;* it will be just like the mouse, taken beyond escape. I have just made for this purpose a large iron hoop almost twenty-four feet in diameter, which, I hope will produce a point of support for which I have searched for a long time; and before I incur this new expense, I want to be fully assured that it will be useful. Our workman, who is usually not very busy, is at present occupied with smoothing it off; then I shall proceed to apply it to the production of a continuous movement, but which must not be very complicated.

"My greatest regret is to have been at it so long up to now and, moreover, to be deprived of the satisfaction to have been able to announce to you, my dear friend, the success of my work before I was obliged to request from you new subsidies; because my poor purse has made, as my sister says, *luttimo sforzo di paillasso* (sic). I have only enough to pay for this week, and I shall be forced to await the arrival of the money in order to pay for the time which will have elapsed from now until then. But let us have courage. It is a matter of our honour and to our interest to terminate gloriously our works, yours and mine, my dear friend, and I hope the Lord will bless them. I have also had to give a demonstration of the rotary movement as much as possible without raising the apparatus; for the other movement, it is assured.

"We must also trust in the future and I hope that Messrs. Coste will also see it that way. I very much regret, however, my dear friend, having to believe that this new obstacle ([31]) must be painful to you, but I cannot advance my work without this troublesome necessity; I hope that this will be less disagreeable on account of the flattering hopes which seem to be in store, thank God, for our work.

"Receive, I beg of you, my dear friend, as well as my dear sister, the assurance of my most tender and sincere attachment,

[59]

which I promise as long as my life lasts. I embrace my dear nephew with all my heart; my respects and usual compliments to our dear relatives and friends; the best of luck to all our men and my usual caresses to the happy band."

The *happy band* were four beautiful hunting dogs, two old ones: *Pyrame* and *Tenor;* and two young ones—after the return of Isidore Niépce to his father's house—and which were called *Figaro* and *Trompette;* this happy band always found a tender remembrance in all of Claude's letters. Nicéphore also dealt with this subject every time he wrote to his brother.

One more short extract and we have finished with the correspondence of Claude Niépce. For the most part, his other letters contained, as far as heliography is concerned, more or less elaborate sentences, which are nothing but repetitions of those which we have copied; and which would only be tiresome and superfluous.

Letter of December 8, 1825. "Please receive my sincere and heartfelt thanks, my dear friend, for the interesting details contained in your dear letter relative to your interesting work and your fortunate success. You are quite right in not depriving yourself of the ingenious apparatus, of which you desire to give me an exact and clear explanation. I believe, as you do, that this apparatus could not have come more timely for the completion of your success for all the kinds of engraving in which you are going to employ it, and I believe that the effect will be infinitely more advantageous than the other method of reflecting the image. I sincerely desire that M. Carbillet will be able to return to you, my dear friend, such proofs as will enable one to see in an intelligible manner your ability, by your ingenious process of retouching, to eventually correct those parts which are not sufficiently pronounced; this will be the last seal on your curious and sublime discovery."

In giving this last extract of Claude Niépce's letter dated December 8, 1825, we have anticipated the march of events; because the works of Nicéphore during this year of 1825 have left behind material traces which still remain today and which can be seen in the Museum at Chalon-sur-Saône; particularly two pewter plates, one of which represents a *landscape* and the other one *Christ carrying the Cross.* This latter is particularly remarkable owing to the sharpness of the design. On the back

of this plate Isidore Niépce wrote the following remark: "Helio-graphic design, invented by J.-N. Niépce. 1825." This picture of Christ presented by Nicéphore to M. de Champmartin, father-in-law of Isidore Niépce, came back to the latter who offered it to the Museum in Chalon, with other objects belonging to his father, which were used by him in his heliographic operations.

Claude Niépce, in his letter of December 8, felicitating his brother on having acquired a new apparatus, took for reality that which was still only a project on the part of Nicéphore. Really it was not until the beginning of the year 1826 that the latter bought the instrument mentioned there; here are the circumstances:

One day at the beginning of January 1826, Nicéphore learned that his cousin, Colonel Niépce, of Sennecey-le-Grand, was about to leave for Paris; he requested the Colonel to buy for him from Messrs. Vincent and Charles Chevalier, manufacturing-opticians, different objects, particularly a camera obscura equipped with a meniscus prism. ([32]) Besides the memorandum giving these commissions, Nicéphore sent to his cousin several heliographic proofs.

The Colonel really left on January 8th in order to take command of the Ile de Ré, replacing General Ordonneau, called to other functions. On the 12th of the month the Colonel visited Messrs. Chevalier at Paris in order to select the articles which Nicéphore had asked him to buy. While examining the apparatus shown to him, Colonel Niépce informed these gentlemen that for a long time his cousin, Nicéphore Niépce, had success-fully occupied himself with *fixing*, by means of his own pro-cesses, images received in the camera obscura, which process he had seen and of which he had several proofs. Messrs. Vincent and Charles Chevalier, expressing great surprise over what seemed to them a most extraordinary novelty, the colonel showed them one of the heliographic proofs of Nicéphore, representing a young woman spinning. These gentlemen were entranced by the mar-velous image before their eyes and expressed their great satis-faction to the Colonel, assuring him that they placed themselves at the disposal of Nicéphore Niépce for any material that he might need in his interesting experiments.

In 1822, and during the following years, there existed at Paris, the most curious and magnificent spectacle imaginable, of

which the contemporaries of this period who have seen this marvel have retained great memories. As a matter of fact, the Diorama had something magical, something startling about it, which excited both astonishment and delight in the spectator.

Daguerre, clever painter and full of imagination, had employed all his talent, his genius, to make this admirable spectacle perfect, and exploited it together with Bouton.

Arthur Chevalier, in the Notice which he consecrated to the memory of his father, Charles Chevalier, having first stated the early relations of the latter with Daguerre at the end of 1824, continues thus: "Daguerre made use of the camera obscura for sketching and he often came to visit Vincent Chevalier for the purpose of choosing his lenses. My father frequently visited him at his studio in the rue de Crussol and, as reported in his *Souvenirs historiques,* Daguerre often exclaimed how wonderful it would be if one could fix the fugitive images of the camera obscura. He was very anxious at this time about the camera obscura with the meniscus prism, and constantly came to the shop at the quai de l'Horloge, asking many explanations on the subject of the camera obscura and its different construction.

"One day he announced excitedly to my father and grandfather that he had found the famous secret; he exclaimed: I have fixed the image produced by the camera obscura! But he did not show a picture, or a result. However, no one could make him doubt this discovery; and one awaited with anxiety the fortunate moment when Daguerre would speak! In the interval of trials, hopes and expectations a year had elapsed; and we were then in the first days of the year 1826 " ([33])

"Admitting,—states Charles Chevalier, in his *Souvenirs historiques,*—that Daguerre had really found that which he announced and, as far as I am concerned, I have no reason to doubt it, it is certain that he proclaimed his victory prematurely or rather, that after having obtained the image, he could not fix it and that the moment when he contemplated his captive, it vanished, returning to the source from which it emanated.

"Whatever one may think of his first attempts, photography was still only a hope even for Daguerre, when a relative of Nicéphore Niépce informed us that this scientist and modest investigator had the desire to try out our new camera obscura with

prism, in order to use them in his researches which dealt with the fixation of luminous images " ([34])

Chevalier relates then his interview with Colonel Niépce—which we have reported above. Although it is essentially the same, his story differs from ours in some facts, in some details, for which we are obliged to Colonel Niépce, who was kind enough to relate them to us several times.

A few days after the interview of Colonel Niépce with the Chevaliers, the latter received a visit from a young man, unknown to them, who bought from them a cheap camera.

"I regret", he said, "that my means do not permit me an apparatus equipped with a prism because with this instrument I would without doubt succeed in fixing the image traced for a moment on the ground glass" ([35]). Later, he showed proofs of positive images on paper. Still later, he brought to Chevalier a small bottle containing a brown liquid. But neither Chevalier nor Daguerre was able to obtain any of this liquid from the unknown person; Chevalier expected the young man to return in order to obtain explanations from him; but he never came back.

It was after this, and after the fruitless incident of the unknown's brown liquid, that Chevalier talked to Daguerre about Nicéphore Niépce and his heliographic work; he gave him the address of the latter and advised him to get in communication with Niépce.

"Like most men sure of their superiority and accustomed to success," again says Charles Chevalier in his *Souvenirs historiques,* —(the Diorama was then at its climax; no one questioned this marvel anywhere and the name of Daguerre resounded in every civilized country), "Daguerre was not fond of advice, he refused mine but preserved Niépce's address." ([36])

But Daguerre changed his mind and, some days after his conversation with Charles Chevalier, he wrote to Nicéphore Niépce: this was towards the end of January 1826.

Much to our regret, we are not able to give here the exact date of this first letter of Daguerre; there are also some other letters which will enter into this: for which we shall presently give the reason.

In a letter dated Gras, May 26, 1826, addressed to Isidore Niépce who was at that time on a pleasure trip with his young wife in the Alps, Nicéphore,—after having told him of his

cares and troubles regarding the interminable work concerning the *Pyreolophore* undertaken by his brother Claude,—expresses himself as follows:

"We still have no answer from London. My heliographic work is coming along at full speed. I have made new pewter plates; this metal is much more adaptable to my object, principally for the views from nature; owing to the greater reflection of the light, the image seems much more sharp. I congratulate myself on this happy inspiration."

The heliographic work of Nicéphore Niépce in 1826, just as in 1825, has left material records. This is represented especially by a portrait engraved on a pewter plate of Cardinal Georges d'Amboise, Minister of Louis XII. Isidore Niépce testifies, as we have already said, to most of the heliographic experiments of his father in a letter which he wrote to us on March 10, 1867, in which he describes the manner in which Nicéphore operated at this time.

"I witnessed the operations relative to the portrait of Cardinal d'Amboise. My father spread on a well polished piece of pewter, bitumen of Judea dissolved in Dippel's oil. ([37]) On this varnish he placed the gravure which was to be reproduced and had been made transparent, exposing the whole to the light entering his apparatus. After a time, more or less long according to the intensity of the light, he immersed the plate in a solution which little by little made the image appear which until then remained invisible; after that he washed the plate and let it dry. After these different operations, for the purpose of etching it, he placed it in water containing more or less acid.

"My father sent this plate to Lemaître, requesting him to contribute his talent in engraving the design still deeper. Lemaître acceded very courteously to the request of my father. He pulled several proofs of this portrait of Cardinal d'Amboise; he retained one: he sent the others with the plate to my father. I have given to my elder son, who asked me for it, the last proof which I had in my possession. Concerning the plate, this I have given to the Museum at Chalon, with other different heliographic equipment which my father used."

We have searched vainly for this plate at the Museum at Chalon; it is true that the glass case, closed and locked, which contains the heliographic relics of Nicéphore Niépce is placed in

a very dark corner; this does not permit one to see the objects clearly which it contains; it is true that our permanent near-sightedness undoubtedly contributed to our inability to discover this precious plate. However that may be, it exists; for we have seen and held it in our hands many times at Givry, at the house of Isidore Niépce.

Nicéphore,—always considering that the copies of the views from nature, which he obtained by means of his process and the aid of the camera obscura, as the first and most important of his valuable invention,—was not yet aware of the variety of advantages which this great and beautiful creation was capable of procuring for him.

Until now, he only thought of its application to the art of engraving; but since he had only imperfect notions of this art, he was forced to have recourse to the assistance of an engraver. It was fortunate,—as we have seen from the letter of Isidore Niépce,—that he was able to communicate with Lemaître, one of the most famous and clever engravers of Paris, who was also and still is among the most honourable men of his craft.

These relations date back to the middle of 1825, according to the following letter which Nicéphore Niépce wrote to Lemaître on January 17, 1827. ([38])

"Monsieur, it is about eighteen months that Chevalier ([39]) brought you two small copper plates, varnished and ready for etching. You had the courtesy to make the experiment in his presence; and I hasten to take advantage of the opportunity which presents itself to beg you to accept in this matter my belated and sincere thanks. This experiment, however, notwithstanding the precautions which you were kind enough to take, was unsuccessful; it must be attributed to the varnish which was applied in too thin a layer or was of bad quality. I do not want to bore you, Monsieur, with the nature of my researches of which the experiment in question was a very imperfect result. M. de Champmartin must have told you, and you will also have heard more of it from Count de Mandelot, who was kind enough to interest himself in a most particular manner, in the success of my discovery "

On February 2nd following, Nicéphore wrote this to him: "In accordance with the offer which could not be more gracious,

which you kindly made in your letter of January 22nd, I hasten to send you *five pewter plates*

"The largest of these five plates is the copy of an engraving representing the Virgin, the Infant Jesus and Saint-Joseph. The other four, smaller, are two copies each of a portrait and of a landscape. These plates, as you will see, Monsieur, are not on varnish but etched very feebly with *acetic acid* very much diluted with *wood vinegar*, especially those which represent the landscape. I believe I have not been as successful in the copy of the portrait; please examine them and be good enough to tell me frankly what you think of them. I am entirely deprived of the resources required for this; having been unable to procure a small piece of a plate etched in acid which might at least serve me for a comparison: which would have been a great help to me in the absence of advice and especially of my lack of practical knowledge; for I deal with this as a matter of chance. I have interrupted my work during the last two months of the Fall and I cannot take it up again until the good season returns. I am busy principally at present, Monsieur, with engraving a view from nature, using the newly perfected camera: the application of this to my process will probably seem to you of great interest

"P.S. Are you acquainted, Monsieur, with one of the inventors of the *Diorama*, Daguerre? Here is why I am asking you this question. This gentleman, having been informed, I do not know to what extent (⁴⁰), of the object of my researches, wrote to me last year, during January, to let me know that for a long time he had occupied himself with the same object and he asked me if I had been more fortunate than he in my results. However, if he is to be believed, he had already obtained very astonishing results; notwithstanding this, he requested me to tell him first whether I thought the matter was possible at all. I do not want to deceive you, Monsieur, that a seeming incoherence in his ideas has caused me not to tell him too much. I have, therefore, been very discreet and reserved in my explanations and, nevertheless, I have written to him in a very honest manner, sufficiently obliging in order to cause him to write me again. I have not heard from him until today, that is not until after an interval of more than a year; he addresses me particularly in order to know where I am at in this matter, and to ask me to

send him a proof because he has great doubt that it would be possible to be entirely satisfied with the shadows by this process of gravure; that he had made researches with another application, tending more towards perfection than to multiplicity. I am going to leave him, I wrote, to *perfection* and by a short response cut short relations of which *multiplicity*, as you will readily see, might quickly become disagreeable and boresome. Will you be good enough to send me your personal information on Daguerre and your opinion of him."

Replying on the 7th of the same month, Lemaître acknowledged receipt of the five plates mentioned in Nicéphore Niépce's preceding letter. According to Lemaître, some were etched so feebly that he could only obtain proofs which were defective; the impression from the others resulted in proofs like those from a plate after a long run. Lemaître in addition proved to be a judicious critic—although full of polite reserve,—of the weak and imperfect parts of the plates. He regretted that Niépce did not continue to use copper instead of pewter; finding the latter metal unfit for this kind of engraving, unable to stand more than a small number of impressions. Returning to Niépce's method of engraving, he doubted that he could ever arrive by these processes, at reproducing faithfully the lines of an engraving, nor that he would ever succeed in arriving at the different tones and the fineness of the lines which characterized the reproduction of a design in a good plate, etc.

"You see," continues Lemaître, "that I do not spare you, I freely offer the advice you request; moreover, your discovery has enough other fine sides to cover this shortcoming, because the defective parts could be retouched with a tool, which is necessary to do with all engravings etched in nitric acid. One of your portraits, if it were etched on copper as it is on pewter, and if it were retouched, could give a passable engraving, but it would require additional work.

"I look forward to seeing your examples of images from nature, because this discovery seems most extraordinary to me and at first incomprehensible. However, I am certain that you will succeed by deliberating upon your attempts at engraving, and thus find the possibility of fixing the rays of the camera obscura. I wish with all my heart that this attempt may be crowned with the fullest success, because it is a discovery which

should be of great usefulness in the arts, and will perhaps make as much of a sensation as lithography has made since its appearance

"You ask me if I know Daguerre? It is several years since, without knowing him particularly, I attended some soirées, where I met him. Last spring, having been employed by a publisher to engrave one of his paintings in the Luxembourg Gallery, I showed him the sketch I made from it: this is how I made his acquaintance; I have not seen him since although I went to see one of his tableaux at the Diorama, and I must submit to him at the end of the month a proof of my engraving, which is almost finished.

"Concerning the opinion which I have of him, Daguerre, as a painter, has a fine talent for imitation and an exquisite taste for preparing his tableaux. I believe he has a rare intelligence for the things which deal with machines and lighting effects; the amateur visitor of his establishment is easily convinced; I know he has occupied himself for a long time with perfecting the camera obscura, without nevertheless knowing the object of his work, such as you and Count Mandelot has discussed."

On February 16th, Niépce thanks Lemaître for his criticism, both frank and severe; he is also grateful for his good advice, by which he intends to profit; he knew that his observations on various subjects were well-founded and consequently just.

"I myself have always noticed," he added, "in my experiments with engraving on stone, copper and pewter, this *graininess* and the *roundness* of *edges* which you point out. The grain is certainly produced by the brittleness or permeability of the varnish when applied in too thin a layer; but, as far as the rounding off and unsharpness of the lines in the shadows is concerned, I cannot, Monsieur, explain the cause, but I attribute it to the divergence of the *luminous* rays, and to the more or less great resistance shown in their *transmission;* an obstacle which, as far as I believe, will cease if I succeed in substituting a *Megascope* (⁴¹) for the methods which I am now using in the reproduction of engraving. You will undoubtedly object that even under the most favorable circumstances you cannot conceive how I can possibly succeed without the help of art. In addition, Monsieur, I would ask you to consider that, in that case, the result of the principal operation will be such that the part which the human

hand plans will be reduced to pouring the acid on the plate which will be attacked and incised in the preparation of the *gradation of tones;* for were it otherwise, I would have the strongest reason to despair in fixing the image of objects as viewed in the camera obscura; this image may be regarded as the highest ideal of a wash drawing, being composed entirely of extremely delicate tones. However, my process is susceptible of retaining them and expressing them with the greatest fidelity If it becomes necessary to abandon this in order to gain the advantage of multiplying the proofs by means of engraving, we would have at least this method which would procure an exact and unalterable copy of nature by this particular process."

On March 5th following, Lemaître informed Niépce that he had returned his five etched plates received by him and five proofs of the plates, that the printing had been done with a great deal of care under his own eyes, and that they were better than he had at first expected.

On the 17th of the same month, Niépce acknowledged receipt of these plates and proofs; he thanks Lemaître for his great courtesy and, since there was no art dealer at Chalon, he asked that he buy for him six or eight engravings representing landscapes, figures and interiors, on thin and smooth paper. Lemaître sent these engravings on March 28th; they consisted of "four etchings and engravings (*eau-forte et burin*) and four black and white aquatints (*aquatinta et manière noire*)."

On April 3rd following, Nicéphore Niépce, after having expressed his gratitude to Lemaître for this new service, continues his letter as follows: "I have forgotten to tell you in my last letter that Daguerre wrote and sent me a small design very elegantly framed, drawn in sepia, and finished with the aid of his process. This design, which represents an interior, gives a very good effect, but it is difficult to determine whether it is solely the result of the use of the process, because the work of a brush was used. Perhaps, Monsieur, you are already acquainted with this kind of a drawing which the author calls *Dessin-fumée,* and which is for sale by Alphonse Giroux.

"Whatever may be Daguerre's intentions, as a courtesy, whatever it may be worth, I shall send him a pewter plate slightly etched, according to my method, chosing as a subject one of the

engravings which you sent me, which can in no way compromise the secret of my discovery."

In his letter of July 24, 1827 Nicéphore Niépce informs Lemaître that he had sent an etched copper plate which the latter had loaned him; he also informs him of having despatched to him a hamper of twenty bottles of wine of which a dozen were Pommard, of the vintage of 1822, and eight of sparkling white wine; he asked him to accept this as a testimony of his gratitude. Nicéphore then expresses himself as follows:

"Since the last letter which you have received from me, I have not given much time to engraving; the use which I have made of your plates has served me particularly in being able to examine and to profit by my observations by returning to the most difficult and least important of the applications of my processes.

"As I wrote you at the time, Monsieur, I have sent to Daguerre one of my examples of engraving and I have chosen the *Holy Family*. His criticism was impartial, I believe, but severe. It reminds me of your having honoured me by discussing this subject and your advice has contributed considerably to arrest my zeal. I have now devoted myself to another application which does not require the use of acids. I have at first copied very fortunately one of the engravings which you have been good enough to procure for me, and I am now working to copy a view from nature by the aid of the camera. I am entirely satisfied with my *heliographic* process, but I cannot say as much for the instrument which I employ, which, just as those of the same kind, is very imperfect. In short, Monsieur, the only part of the image which is well lighted and reasonably sharp is that located exactly at the focus of the lens; all the rest is more or less dim and confused; and at present I am solely occupied with finding ways to remedy these serious imperfections. But it is already something remarkable to have been able to arrive, notwithstanding so many obstacles, to receive the image of objects viewed in the camera obscura. If my present researches are not entirely fruitless, I shall soon be close to my goal and I shall hasten, do not doubt it, Monsieur, to inform you of the new results which I shall have obtained."

In order not to interfere too much with the chronological order, we must return to Daguerre, before continuing and closing

the correspondence exchanged between Nicéphore Niépce and Lemaître.

As we have seen, Daguerre did not persist very long in his refusal made to Charles Chevalier to place himself in touch with Nicéphore Niépce; as a matter of fact, in the last days of January 1826, he addressed to the latter, as Isidore Niépce says, a "letter written in a very high toned and bizarre fashion".

Isidore Niépce continues: "My father showed at first a certain repugnance to answering Daguerre whose letter, he stated, seemed to have for its object to pull his leg (tirer les vers du nez). However, he decided to write to him and he did so with the circumspection of a man who is afraid to compromise his secret" (⁴²).

After Daguerre had written his first letter, as a sort of a trial balloon, he remained silent for more than a year, as we see in the postscript to a letter which Niépce addressed to Lemaître on February 2, 1827. If we rely on this postscript, we will see at once the subject of the second letter of Daguerre to Niépce, and the repugnance of the latter to form a contact which would prove unsympathetic to him and which, on the contrary, would cause him a certain misgiving. Notwithstanding this and as he had informed Lemaître, Niépce wrote to Daguerre on February 2, 1827 a letter, short and full of careful reservation.

"I received yesterday your reply to my letter of January 25, 1826. I have not done very much work in the last four months; the bad season absolutely prohibited this. I have perfected my methods for engraving on metal perceptibly, but the results which I have obtained have not yet in any way furnished me proofs sufficiently correct and I am not able to satisfy the wish, which you express. This is regrettable, more for myself than for you, Monsieur, because the mode of application which you use is entirely different and *promises you a degree of superiority which is not comparable with that of gravure;* all of which in no way hinders me from wishing you all the success which you may wish."

This prudent reply could not satisfy Daguerre completely; because he desired to have in his possession one of Niépce's designs in order to be able to analyze it and to discover, if he could, the process employed by Niépce in his heliographic operations. It was this, without doubt, and in order to prompt the gift of this

[71]

design that Daguerre sent to Nicéphore Niépce in the following March a *Sepia* elegantly framed, which is mentioned in the previously quoted letter of Niépce to Lemaître on April 3rd. If this was Daguerre's intention, he only succeeded in part; because Niépce persisted in his prudent reserve and sent him, as he himself declared, only "a pewter plate lightly etched" representing the Holy Family; and from which he had taken the trouble to remove first the varnish which covered it. Niépce wrote him later in these terms on June 4, 1827:

"Monsieur, you will receive almost as soon as my letter a box containing a pewter plate engraved according to my *heliographic* processes, and a proof of the same plate, very defective and very much too weak. You can judge by this how much I require your indulgence and if I finally have decided to send you this, it is only in order to respond to the *desire* which you have been good enough to express. Notwithstanding this, I believe that this manner of application is not to be disdained because I can, although a stranger to the art of design and to that of engraving, obtain a similar result. I beg of you, Monsieur, to tell me what you think of it. This result is not one of my most recent, it dates from last Spring. Since then, I have been turned aside from my researches by other matters. I shall take them up again today because the countryside is in the full splendour of its attire and *I shall devote myself exclusively to the copying of views from nature.* It is beyond doubt that this subject will prove itself more interesting, but I do not deceive myself over the difficulties which it presents to the work of an engraver. This enterprise is much beyond my strength, also all my ambitions are limited by my ability to demonstrate more or less satisfactory results, by the possibility of a complete success and the possibility of enlisting a clever hand versed in the Aquatint process who would then cooperate in this work. You will probably ask, Monsieur, why I engrave on pewter instead of on copper. I have also used this latter metal but in my first attempts I had to prefer pewter of which I had at first procured some plates intended for my *experiments in the camera.* The clear whiteness of this metal tends to render more exactly the image of the object viewed in the camera.

"I think, Monsieur, that you will follow up your first attempts; you seem to be on the right way in following this road! *We are*

engaged in the same subject, we must find a mutual, reciprocal interest in the efforts for obtaining the object. I learn, therefore, with greatest satisfaction that the new experiments which you have made with the aid of your improved camera have met with success, confirming your expectation. In this case, Monsieur, *if you will not think me indiscreet, I also shall be interested to know the result* and I shall be flattered to be able to offer you those of my researches along the same lines in which I am engaged."

As we have also seen from the letter cited which Niépce addressed on July 24, 1827 to Lemaître, Daguerre criticized the plate which he had received from Nicéphore very severely. This criticism, which was very analogous to that of Lemaître on the same subject, contributed greatly to disgust Niépce in the application of his precious heliographic invention to gravure.

It is necessary to remark that Niépce in the letters written to either Lemaître or Daguerre did not confine himself only to the application of heliography to engraving; but he was absolutely silent about his processes and the manner of operation on the *fixing* of the images in the camera: in this respect his reserve is complete.

The ten years which Claude Niépce spent in England, while combining, inventing, and experimenting with apparatus, motors applicable to new machines, had used up the vitality of this indefatigable searcher and inflicted upon him a very serious illness.

Although in ignorance of the seriousness of the illness from which his brother had suffered for a long time, Nicéphore did not hesitate an instant to travel to England as soon as he was apprised of Claude's ailment, and when he required his affectionate care. He set out with Mme. Niépce in the second half of August 1827. But he was detained several days in Paris by the difficulty of obtaining places in the public conveyances, owing to the fact that Charles X travelled at the same time to Calais; and also by the difficulties which he met with in obtaining a passport for England.

While he was in Paris he met with a very serious and unfortunately irreparable accident which he communicates to his son on August 27, 1827 in the following terms: "Another mishap, my dear Isidore. I wrote yesterday to M. Champmartin and I write you in haste today to inform you that I have lost my

pocketbook. It was not stolen but it fell into the cesspool of our hotel with great speed and I had to bid it goodbye. It contained besides the last letter of your uncle and the one which I was to hand him from you, my correspondence with Messrs. Daguerre and Lemaître and some papers of little importance ... "

The regrettable loss of the letters of Lemaître and Daguerre explains why we have not been able, as we have mentioned above ([43]), to give the exact dates of some of the letters which we have copied. The loss of this pocketbook of Niépce deprives us also of the reproductions of the actual text of their letters, which would throw a great light on the early relations between Niépce and Daguerre.

Nicéphore Niépce made use of his enforced stay at Paris by visiting among other persons Lemaître and Daguerre. But let him relate himself his impressions in a letter which he wrote to his son Isidore, which he began on the 2nd and did not finish until September 4th, 1827.

" M. Lemaître, who received me in a very friendly manner and whom I have visited twice, showed me the etched copper plate of which he had promised me a proof. This plate, perfectly and very correctly engraved, is now almost finished; for he had printed two trial proofs and it requires now only very slight corrections. It seems that he has taken a great deal of trouble with this engraving, which is of large size, and it is hardly necessary to add that it sustains his reputation as an artist. Later he had the kindness to show us his portfolio. I saw some very beautiful things in it but, not being a connoisseur, I was not able to give an intelligent opinion in this regard. What I wanted to see with my own eyes and convince myself in a most positive manner was principally the indispensable necessity of the engraver's tool, independently from the action of the acid, in order to obtain a strong proof. Thus, according to M. Lemaître's advice, I cannot flatter myself that I can obtain a satisfactory result without this; but this proves nothing against the value of my process, which always seemed to him most extraordinary. He urged upon me very strongly to continue to pursue my attempts with engraving, especially insofar as the application is concerned with the views and he also asked me, in case I am successful, to send him my latest results.

"I have had frequent and very long interviews with M. Da-

guerre. He came to see us yesterday. His visit lasted for three hours; we shall have to return it before we depart, and I do not know how long we shall remain with him, because this will be the last time, and the conversation on the subject which interests us is really endless.

"I must repeat to you, my dear Isidore, what I said to M. Champmartin. I have seen nothing here that impressed me more, which gave me more pleasure, than the Diorama. We were conducted through it by M. Daguerre, and we had the opportunity to contemplate the magnificent tableaux which are exhibited there, quite at our ease. The interior view of St. Peter's at Rome, by M. Bouton, is certainly an attempt at an admirable work and it produces the most complete illusion. But nothing is superior to the two views painted by M. Daguerre; one of Edinburgh taken by moonlight during a fire; the other of a Swiss village, looking down a wide street, facing a mountain of tremendous height, covered with eternal snow. These representations are so real, even in their smallest detail, that one believes that he actually sees rural and primeval nature, with all the fascination which the charm of colours and the magic of light and shade endow it. The illusion is even so great that one attempts to leave his box, in order to wander out into the open and climb to the summit of the mountain. I assure you there is not the least exaggeration on my part, the objects in addition are, or seem to be, of a natural grandeur. They are painted on canvas or taffeta coated with varnish which has the defect of being sticky; it requires certain precautions when it is necessary to roll up this kind of decoration for transportation; because it is very difficult to unroll them without cracking.

"But let me return to M. Daguerre. I must tell you, my dear Isidore, that he insists in believing that I am further advanced than he in the researches on which we are both working. One thing is now fully demonstrated, and that is that his process and mine are entirely different. His is a marvelous thing and its effects so rapid that it can be compared with that of the electric current. M. Daguerre has arrived at the point of registering on his *chemical substance* some of the coloured rays of the prism; he has already reunited four and he is working on combining the other three in order to have the seven primary colours. But the difficulties which he encounters grow in proportion to

the modifications which this same substance must undergo in order to retain several colours at the same time; his greatest obstacle and that which mystifies him completely is that these diverse combinations result in entirely opposite effects. Thus, when a very strong shadow is projected on the mentioned substance through a blue glass it produces a lighter tone than the same shadow when viewed in the direct light. On the other hand, this fixation of the primary colours results in tints so fugitive and weak that one does not perceive them at all in daylight. They are only visible in darkness, and this is the reason: the substance in question is like the *Bologna stone* and like *Pyrophore;* it absorbs the light eagerly, but cannot retain it long, because the prolonged action of this fluid ends by decomposing it; M. Daguerre also does not pretend to be able to make the coloured images of objects permanent by this process, even if he could succeed in surmounting all the obstacles which he encounters; he has not been able to use this medium as anything but an intermediate step. After what he told me, he has little hope of succeeding and his researches can hardly have any other object than that of pure curiosity. My process seemed to him much preferable and more satisfactory, because of the results which I have obtained. He felt that it would be very interesting for him to procure views with the aid of a similar simple process which would also be easy and expeditious. He desired me to make some experiments with coloured glasses in order to ascertain whether the impression produced on my substance would be the same as on his. I have ordered five glasses from Chevalier (Vincent), such as he has already made for M. Daguerre. He insisted principally on the greater speed in the registering of images, a very essential condition really and which must be the first object of my researches. As far as the method of application to engraving on metal is concerned, he is far from deprecating it since it will be indispensable to retouch and deepen it with an engravers tool, he believes that this application would only succeed very imperfectly for the views. What seemed to him more preferable for this kind of engraving was glass, etched by employing hydrofluoric acid. He is convinced that printing ink, applied with care to the surface etched by the acid, would produce on white paper the effect of a good proof and would have, moreover, an original aspect which would be more pleas-

ing. M. Daguerre's chemical combination is a very fine powder which does not adhere to the material upon which it is projected, therefore it is necessary to place the plate in a horizontal position. This powder, on the slightest contact with light, becomes so luminous that the camera is partly illuminated by it. This process is very analogous as far as I can recall to *sulphate of baryte* or to the *Bologna Stone,* which enjoy equally the property of retaining certain of the prismatic rays

"Our places for Calais are reserved and we will definitely leave on next Saturday at eight o'clock in the morning. We have not been able to obtain them sooner; the journey of the King to Calais has attracted many people on this side Farewell, receive, as well as *Genie* and your dear son, our embraces and assurances of our most tender affection. Good luck to all our people and best regards to our human friends, our quadrupeds and to our feathered bipeds."

The reader has doubtless noticed that we have emphasized this letter, in which is found the point which Daguerre had reached at the beginning of September 1827 concerning the fixation of images received in the camera obscura. We shall return to this letter when we reach the third part of this book.

Arriving in England, Nicéphore Niépce found his brother much more seriously ill than he had supposed at the time of his leaving France. As a fact, Claude suffered from dropsy, which left little hope for recovery.

We have before us a letter dated Kew (⁴⁴), near London, November 5, 1827, which Nicéphore Niépce wrote to his son, and which is full of painful and intimate details of the physical, moral and mental condition of Claude Niépce, and which decency does not permit us to submit to the morbid curiosity of the public. We will therefore copy only that which is indispensable to the understanding of our story; we read there with interest the unfortunate and deplorable result of the mechanical work of Claude Niépce; as well as the steps which Nicéphore took in England, in the endeavour to make the progress of his heliographic operations known.

" I want to spare your feelings as well as ours, my dear Isidore, by refraining from the sad details. Our troubles are softened by seeing my poor brother indifferent to his condition and more occupied with agreeable illusions which keep him

from realizing the trouble. Would that he may preserve them until the end! This illness does not only date from this year; he tells us that he has felt ill for five or six years, and we did not know it! Neither did we know that the *great news* (*Grand Nouvelle*) *and the success with perpetual motion* were nothing but dreams, the vain delusions of a delirious imagination. As far as we can see, the trouble cannot be remedied, because I do not see how it will be possible to utilize a mechanism so complicated as that of this rotary machine. Even if it should ever function, it could only be by virtue of a new principle based solely on the spontaneity of movement, and in that case everything that he has constructed with the exception of the chassis would be completely useless. As far as the *Pyreolophore* and the hydraulic machine are concerned, I do not know what we can do about them; we do not intend to risk any further outlay on these two ventures.

"I informed you in my last letter that I wrote on October 16th to the director of the Royal Parks and Gardens. I waited for six days for his reply, and when it did not arrive I wrote him again on the 22nd, to find out if he had anything new to tell me. He writes that he had passed my letter on to the Marquis Connyngham, who had replied that he is very busy and has not been able to attend to my request; but that he would certainly take it up within two or three days. We must, therefore, have more patience.

"It occurred to me that, possibly, I might not be permitted to deliver myself a lecture on my experiments; if I must use an intermediary, I shall be unable to answer verbally any questions that might be propounded or to explain the different improvements to which my new born discovery is susceptible. I have, therefore, written a note which, in a few words, should answer everything and which, I believe, moreover, will properly lend a greater degree of interest to the object of my request. I am holding myself ready and we are resting for seven or eight days in expectation of being called. Last Tuesday M. Aiton, the director, informed me that he was coming to see my samples. These had already attracted the attention and excited the surprise of two persons who had examined them: they made no less an impression on M. Aiton. He tells us that the road which we are pursuing is not regular; that our proofs before being presented to

his Majesty would first have to be submitted to the Royal Academy of Painting; but if I wanted to put the matter into his hands, he would refer them to the Marquis Conningham as he offered to do. I replied that I would accept with the greatest pleasure. He then asked me if he could keep them for two or three days only: I replied that he might do so as long as he desired; we shook hands affectionately, and he left. We then made a package of framed and engraved plates which I addressed, with a note in the form of a letter to M. Aiton; all of which was dispatched to Windsor last Wednesday. We have not heard from it as yet, but can only interpret the silence favorably. You see that it was a fortunate idea for me to write the note in question. I have prepared another which I hope will be of no less interest for us if my request is approved; in this case we shall not await your reply before informing you of the good news.

"But, before they arrive, we cannot leave you in ignorance, my dear friend, that our funds are so very much exhausted that we can no longer defer to inform you of it, and to recommend to you to make some sort of an arrangement so that we may receive funds from M. Granjon on his arrival here; our hosts are very nice people but the food is bad, the sleeping quarters more so and we are paying a horribly high price. It costs us, your mother and me, for lodging and food more than a *hundred francs a week*. Everything else is simply a privation for us, which does not matter as long as we have at least one person to whom we can confide our troubles; but we are living in isolation and in the most absolute destitution "

During his stay at Kew, Nicéphore Niépce made the acquaintance, among other eminent persons, of Francis Bauer, one of the most honoured and distinguished members of the Royal Society of London, and with him he soon formed a lively and close friendship. Nicéphore having mentioned to his friend the desire to submit his valuable invention to the consideration of the Royal Society, not with the intention of presenting it to England any more than to any other foreign country, but particularly to have the judgment of this famous society on the result of his heliographic work; and also in order to establish his right to the priority of his invention in case this should be contested.

Francis Bauer urged him to write a Memoir *ad hoc,* and to

present it with his designs and engraved plates to the Royal Society. This is the Memoir which qualified the "Note" and the *preparation* of which he announced to his son in his preceding letter of November 5th. Here is the Memoir, dated Kew, December 8, 1827; it is entitled:

HELIOGRAPHY. (⁴⁵) DESIGNS AND ENGRAVINGS.

"Notice on some results obtained spontaneously by the action of light.

"The examples which I have the honour to present and the first results of my long researches on the *method of fixing the image of objects, by the action of light, and their reproduction by printing, with the aid of known processes of engraving.*

"I have made these researches until recent circumstances have forced me to come to England, and prevented me from continuing them and from presenting more satisfactory results.

"I request that these first attempts be judged, not so much by the rules of artistic requirement, as by the method presumed to achieve the production of the phenomenon, because a complete success depends on the efficacy of these methods. I also, at the same time, ask indulgence for my work, which you will perhaps grant me readily when it is considered only as marking the first step ventured along an entirely new road.

"My framed designs on pewter will probably be found very weak in tone. This defect arises principally from the fact that the lights and shades are not sufficiently traced owing to the reflection of the metal. This would be easy to remedy by giving more brilliancy and lustre to those parts which represent the lights, and by receiving the impressions of this fluid on silver plates, well polished and burnished, because then the contrast between black and white would be much more noticeable, and the latter colour, rendered more intense by some chemical agent, would lose the brilliant reflection which offends the eye and produces a kind of clash.

"The proofs of my engravings leave nothing to be desired but the purity of the outlines and the depth of the etching. I also wish to call your attention to the fact by stating the possibility of improvement in this important discovery of my processes. The obstacles which I must overcome apply less effectively to the nature of these processes than to the insufficiency of my re-

[80]

sources in an art, with the practice of which I am unfamiliar. It would be well to observe that this process can be applied on copper as well as pewter; I have tried several times to make experiments on stone and I am urged to believe that glass would probably be preferable.

"It suffices, after the operation, to slightly blacken the etched part and to place it on a white paper in order to get a strong proof. *M. Daguerre, painter of the Diorama at Paris, counselled me not to include this mode of application which has not, it is true, the advantage of being able to multiply the product, but he regards it as eminently proper for rendering all the details of nature.*

"Among the principal steps for improvement are those offered by optics, which must be put into the first rank. Again I have been deprived of these resources in one or two of the attempts in making views by the aid of the camera obscura, although I have made several efforts to supplement this by special combinations. I am particularly concerned, however, about this sort of perfected apparatus inasmuch as it may be possible that a faithful image of nature could be procured, and that I might succeed in fixing it properly.

"I regret that I am not able to explain more fully the other improvements lying closer to the principle of my discovery, which would therefore be more apt to arouse interest; I abstain from speaking about them, being also convinced that this explanation is not strictly indispensable to arouse some opinion on the subject under consideration.

"I have undertaken an important problem for the arts of designing and engraving; if I have not yet got all the data necessary to its full and entire solution, I have at least indicated those which, in the present condition of my researches, might contribute to it more efficaciously, although they are only of a secondary nature; it must be admitted that the difficulty lies essentially in a demonstration of the underlying principle, and once this difficulty is overcome, it seems to me to be a fortunate augury for the subsequent results which I hope to obtain when I can dispose of means of execution which at present I lack.

"I have not spoken of the advantages which my discovery promises eventually by the various applications which can be made of it; I confine myself to calling attention to a piquant

effect which by its attraction as a novelty might perhaps be recommended for the attention of the curious.

"I feel that I must declare formally that I am the author of this discovery; that I have not confided its secret to anyone and that this is the first time that I make it public."

"Nicéphore Niépce"

This document, *unpublished and unknown until this day,* states anew the difficulties which Nicéphore Niépce had to overcome in his heliographic operations owing to the insufficiency of his resources and the imperfections of his apparatus. Notwithstanding, when he refused to make known and explain his secret, his Memoir was returned to him together with his designs and engraved plates, and the matter was no longer considered by the Royal Society of London.

This was also the fate of the Note, as well as the frames and plates, which he had confided to Aiton, who was to present all of it to the King at Windsor; and consequently he had no more success in England with his heliographic work than his brother had with his machines and motors.

Nicéphore left England and returned to France during January 1828. Some days after his return to Gras on February 10th, his brother Claude died at Kew Green and was buried the next day by the rector of the parish of St. Anne.

Let us return to the interesting correspondence exchanged between Nicéphore Niépce and Lemaître. The conditions of all kinds which Nicéphore faced after the death of his brother, considerably postponed his heliographic work; and several months passed before he was able to take it up again. On August 20, 1828 he wrote to Lemaître as follows:

" Since I have been permitted to resume my researches, I have again suffered by the bad weather and by the delay in obtaining some *silvered plates* prepared as I desire. Notwithstanding this, and although without much experience, I note with satisfaction, Monsieur, that I definitely approach the goal which I have set for myself. I have given up entirely the copying of engravings, and confine myself to the views taken in the camera obscura perfected by Wollaston; the *Periscopic* ([46]) lenses have procured results for me much superior to those which I had obtained up to the present with ordinary lenses and even with the meniscus prism of V. Chevalier. My sole object, there-

fore, must be to copy nature with the greatest fidelity, and I am concerning myself exclusively with this, for it will not be until I have accomplished this (if I am not too bold in this supposition), that I will be able to occupy myself seriously with the different modes of application which may perhaps be made of my discovery. Until that time, Monsieur, I shall postpone sending you any more of my trial views prepared on copper I can assure you that I have more reason than ever to count it a complete success, if from now until the end of the favorable season I shall also be as well satisfied with the result of the researches as I have been since I have taken them up again I do not know whether M. Daguerre is in Paris; it will soon be a month since I have written to him and he has not yet replied."

Nicéphore ends his letter by thanking Lemaître for having been good enough to compliment him on his magnificent engraving of the *Rape of Proserpine.*

More than a year had elapsed between the foregoing letter and the one which follows, dated October 4, 1829, and of which we give only an extract without notation or comment, because the facts speak sufficiently for themselves, so that it is not necessary to explain them; there will also be extracts from three other letters which terminate the correspondence between Nicéphore Niépce and Lemaître.

"When I was in Paris," writes Nicéphore on October 4th to Lemaître,—"and also on my return trip, M. Daguerre expressed a desire to know the results of my new *heliographic* researches, I have therefore sent him an example on a silvered plate of a view from nature taken in the camera, and asked him at the same time to notify you of it, presuming that this example, defective as it is, might interest you, even if only in the way of a novelty. I believe that I must call your attention, Monsieur, to this view taken in the camera when I worked in the country and which is entirely unfavorable since the objects in it are illuminated from behind, or at least in a very oblique direction during part of the operation; this must necessarily produce a shocking incongruity in the result. But you will observe as soon as some of the details are favorably rendered, that this might be the result of another circumstance entirely different; a further proof which I shall make directly will put me within reach of assuring myself of this "

Lemaître replied to Niépce on the 12th of the same month as follows: "I have visited M. Daguerre, having received a card inviting me to see the example of engraving by your heliographic process. Since I have known of your different attempts in reproducing various engravings, your views from nature taken in the camera obscura did not surprise me; but it gave me the greatest pleasure, especially in thinking that it was the reproduction of nature without any manual work other than the preparation of the plate and, I suppose also, an acidification of the metal to fix the image on it.

"As you yourself call these attempts defective, I shall be sparing in my remarks; I expect that you will show me some more perfect results; however, I cannot fail to state an observation in which I am in accord with M. Daguerre. We have noticed that the two sides of the house, which in nature must be parallel and opposite, appear in your image to be equally illuminated; this is contradictory. Since the objects are illuminated from behind or obliquely, the two parallel and opposite sides could not be illuminated at the same time. We have attributed this circumstance to the length of the operation, during which time the sun necessarily changed its direction.

" The distant objects which are in the center and which form the best part of the picture, completely render the detail of nature's design but the full value of the tones is absent. In general, there are in this engraving shadows which must be strongly emphasized. I do not want to say any more and I have criticised more than I should have done "

Nicéphore Niépce replied to Lemaître on the 25th of October as follows: " You believe that my plate was etched, but it is not: It is only blackened, without the use of any acid whatever, after a process which, owing to my own fault, did not succeed very well, the black having covered the less pronounced lines of the print: which has forced me to clear them as best I could with the aid of a very soft rag. My object was to obtain as near as possible all the gradation of tints from white to black on this silvered plate. Notwithstanding this, I think that, with more precaution and a little more dexterity, a good result could be obtained from this process.

"But you are not mistaken, Monsieur, in attributing this, one of the most serious defects which you have noticed, to the too

prolonged action of the light. Unfortunately I am not able to avoid it with an apparatus in which the foreground is so little illuminated that it takes considerable time for it to be impressed, even slightly; and from this arises this incongruity and confusion produced by the change of direction of the solar rays, which are sometimes oblique and sometimes opposed. In order to obtain a decided success it is indispensable that the effect be accomplished as promptly as possible, this presupposes a great luminosity and sharpness in the image of the object; it would be necessary to have a camera as perfect as that of M. Daguerre; lacking which I shall be condemned in advance for my greater or lesser inability to approach the goal without any hope of attaining it.

"I hasten therefore to respond to his courteous offer of assistance and to propose to him a cooperation with me in the perfecting of my heliographic processes, and to consolidate our mutual advantages, which might result in a complete success. I have advised him how much I would desire, Monsieur, to address to you the same proposition, hoping to find a guaranty for our greater success by combining your distinguished talents with ours. I should like to believe that after the lively interest which you have been good enough to take in the object of my researches, and because, from now until the time when the results will become useful, we would deal only with such experiments as would respectively tend to the desired end to be attained by our combined efforts, to the necessary degree of perfection "

On the 2nd of November following Lemaître accepted the proposition of Nicéphore Niépce in these terms:

"I am somewhat tardy in my reply; I first wanted to see M. Daguerre and my affairs prevented me from doing this earlier.

"M. Daguerre has lately perfected his camera and has become quite proficient in its use. No one could better than he cooperate in the improvement of your processes; and I congratulate you in associating yourself with him. He does not approve of the application of your process to engraving, and desires that you occupy yourself entirely with perfecting it. I deceive myself no less as to the difficulties which will have to be overcome in trying to multiply by engraving, because we will be obliged to add handwork to the primary work, either by the action of acids or by the retouching which probably would have to be made.

However, since we must not give up anything before having at least made some attempts, and since you have been able to reproduce plates by your process, I believe in the possibility to reproduce by engraving views taken in the camera, I reiterate the offer which I have made to cooperate in the successful accomplishment of these trials, by the knowledge which I have acquired in the different kinds of engraving, and I request you to use them fully.

"I accept gratefully the proposition which you have made of associating myself in the profits which will result in case of success."

Arthur Chevalier, in his *Etude* on his father, which we have cited several times, states as follows: "At the end of this volume will be found the letters written by Niépce to my father and my grandfather in 1826, 1827, 1828 and 1829. These letters have a great historical interest, as well as those in the possession of M. Lemaître, the famous engraver; because these are the only letters which can positively enlighten all those who will later write the history of Photography." (⁴⁷)

In writing these lines, Arthur Chevalier ignored, without doubt, that there existed back in Bourgogne a modest historian who had in his possession for a long time SEVENTY LETTERS of Nicéphore Niépce and THIRTY-ONE LETTERS from his brother Claude, *entirely unpublished,* in which, as will be seen, are related the attempts, experiments and heliographic operations of Nicéphore Niépce and other material necessary in the composition of the History of the Invention of Photography.

As far as the letters of Lemaître and of Niépce are concerned, which we have reproduced either in extract or *in extenso,* everybody must appreciate their great historical value.

Concerning the NINE LETTERS of Nicéphore Niépce written between October 8, 1826 and March 25, 1829, and published by Arthur Chevalier in his *Etude* on his father, they concern especially orders sent to Messrs. Vincent and Charles Chevalier for instruments of their profession; notably lenticular glasses for the *Megascope,* lenses *Periscopic, Achromatic* (⁴⁸), *Biconvex* (⁴⁰), and other lenses of various dimensions, silver plated plates, patent glass and glass ground on one side, etc., etc., etc.

Arthur Chevalier informs us in his book (p. 20) that he has deposited these letters in the archives of the Academy (?) ; also

that the *specimen of the application of the heliographic processes on silvered plates* which Nicéphore sent to Chevalier's father as a model on January 12, 1829 in order that he might make plates similar to this on which the above-mentioned heliographic specimens had been obtained.

As we have seen also from the two last letters of Lemaître and of Nicéphore Niépce, the latter had offered to associate himself with Daguerre for cooperating in the perfecting of his heliographic processes and for the purpose of drawing from it the advantages which they were capable of producing.

The month of November and a part of December were employed by the future associates in conferences and in discussions of the terms of their association. Having agreed, Daguerre went to Chalon, and on the 14th of December 1829 the contracting parties approved and signed the preliminary act which we copy literally.

BASIS OF PROVISIONAL AGREEMENT

"Between the undersigned Monsieur Joseph-Nicéphore Niépce, landowner, living at Chalon-sur-Saône, department of Saône-et-Loire, party of the first part, and

"Monsieur Louis-Jacques-Mandé Daguerre, artist, painter, member of the Legion of Honour, director of the Diorama, living at Paris, party of the second part;

"Who, in order to succeed in the formation of the Society which they propose to form between them, before everything else, have set forth the following:

"Monsieur Niépce, desirous of fixing by a new method, without having recourse to a designer, the views offered by nature, has made researches on this subject; the numerous samples proving this discovery have been the result of his researches. This discovery consists in the spontaneous reproduction of images obtained in the camera obscura.

"Monsieur Daguerre whom he has acquainted with his discovery, and who showing his full interest, especially since it is susceptible of considerable perfection, offers to Monsieur Niépce to join him in order to arrive at this perfection and associate himself in recovering all possible advantages from this new kind of industry.

"This statement having been made, the respective gentlemen

[87]

have agreed between themselves in the following manner on the provisional and fundamental status of their association:

"Article 1. There will be between MM. Niépce and Daguerre a Society under the commercial name Niépce-Daguerre and for the purpose of cooperating in perfecting the said discovery invented by M. Niépce and perfected by M. Daguerre.

"Article 2. The duration of this Society shall be for ten years from the fourteenth of December instant; it cannot be dissolved before this term, without the mutual consent of the interested parties. In case of the decease of one of the two associates, he will be replaced in the said society, during the balance of the ten years which have not expired, by him who naturally replaces him. In case of the decease of one of the two associates, the said discovery can never be made public without the signature of both names designated in the first article.

"Article 3. As soon as the present agreement is signed, M. Niépce must confide to M. Daguerre, under the seal of secrecy which must be conserved under penalty of all expense, damages and interest, the principle upon which his discovery rests and he must furnish him with the most exact and substantial documents of the nature, the use, and the different modes of application of the processes which apply to it; finally he must devote himself with all his ability and speed to researches and experiments directed towards the purpose of perfecting and utilizing this discovery.

"Article 4. M. Daguerre undertakes under the above-mentioned condition to guard with greatest secrecy both the fundamental principle of the discovery as well as the nature, use and explanations of the processes which will be communicated to him, and to cooperate to the fullest extent in the improvements which are judged necessary by the useful contribution of his lights and talents.

"Article 5. M. Niépce puts at the disposal and releases to the society, his share as partner in the invention, representing the value of half of the product of which it may be susceptible; and M. Daguerre contributes a new combination of the camera obscura, his talents and his industry, equivalent to the other half of the above-mentioned product.

"Article 6. Immediately after the signature to the present agreement, M. Daguerre must confide to M. Niépce, under the

seal of secrecy, which must be conserved under penalty of expense, damages and interest, the principle on which are based the perfections which he contributes to the camera obscura and he must furnish the most precise documents on the nature of the said improvement.

"Article 7. MM. Niépce and Daguerre will furnish in equal parts the cash required for the establishment of this society.

"Article 8. Whenever the partners find it practical to apply said discovery to the process of engraving, that is, the use of the advantages which will result for an engraver from the application of the said process which would give him the preliminary sketch, MM. Niépce and Daguerre agree not to choose any other person than M. Lemaître for making the said application.

"Article 9. After the final contract, the associates will nominate between them the director and treasurer of the Society whose office will be at Paris. The director will administer the operations ordered by the partners; and the treasurer will receive and pay the bills and demands required by the directors in the interest of the Society.

"Article 10. The term of office of the director and treasurer will extend for the period of the present agreement; however they may be reelected. Their services will be gratuitous, or there may be allowed to them a part of the profits, as it may be deemed proper by the partners, according to the final contract.

"Article 11. Each month the treasurer will render his accounts to the director, giving the condition of the Society; at each semester the partners will draw the profits in accordance with the article stated later.

"Article 12. The accounts of the treasurer and the statement of affairs will be audited, signed and initialed each semester by the two partners.

"Article 13. The improvements and perfections contributed to the said discovery as well as the improvements contributed to the camera obscura are and remain acquired for the profit of the two partners who, after they have arrived at the object which they propose, will make a final contract between them on the basis of the present one.

"Article 14. The profits of the partners and the net products of the Society will be distributed equally between M. Niépce in his capacity of inventor, and M. Daguerre for his improvements.

"Article 15. Any disputes which may arise between the two partners in consequence of the present agreement will be finally adjudged, without appeal or recourse to the courts, by arbitrators, nominated by each of the parties in order to settle any quarrel amicably and conforming with article 51 of the Commercial Code.

"Article 16. In case of the dissolution of this Society, the liquidation will be made by the treasurer, also amicably, or by both of the partners, or finally by a third person whom they will amicably nominate or who will be nominated by a competent tribunal in the best interests of the partners.

"All this is regulated provisionally between the parties who, for the execution of the present, will elect a domicile in their respective homes designated above.

"Signed in duplicate at Chalon-sur-Saône, on the fourteenth of December, one thousand eight hundred twenty-nine.

"I approve, although not written by my hand,

"J.-N. Niépce.

"I approve, although not written by my hand,

"Daguerre.

"Recorded at Chalon-sur-Saône on the thirteenth of March 1830, fol. 32, Vol. C.9 and following. Received five francs fifty centimes, 1/10th included.

"Ducordeaux." (⁵⁰)

According to article *three* of this act of Association, Nicéphore Niépce obligated himself to *confide to Daguerre the principle on which his discovery was founded and to furnish him with the most exact and substantial documents on the nature, use and the different methods of application of the connected processes.* For this purpose Niépce composed and wrote the following document which we also copy literally.

NOTE ON HELIOGRAPHY

"The discovery which I have made and designate by the name *Heliography,* consists in the *spontaneous* reproduction, by the action of light, with their gradations of tones from black to white, of the images formed in the camera obscura.

Fundamental Principle of this Discovery.

"Light, in its state of composition and decomposition, reacts

chemically on substances. It is absorbed by them, combines with them and imparts to them new properties. It augments the natural density of some substances, it even solidifies them and renders them more or less insoluble, according to the duration or intensity of its action. This is, in a few words, the principle of the invention.

First Substance.—Preparation.

"The first substance or material which I use, the one which makes my process most successful and which contributes more directly to the production of the effect, is *Asphaltum* or *Bitumen of Judea,* prepared in the following manner:

"I fill half a glass with this pulverized bitumen. I pour, drop by drop, essential oil of lavender on it until the bitumen will absorb no more and it has been entirely penetrated by it. Then I add enough of this essential oil so that it stands about three lines above this mixture, which must then be covered and left in a moderate temperature until the added essence is saturated by the colouring matter of the bitumen. If this varnish is not of the required degree of consistency, it is allowed to evaporate in a dish in the open air, protecting it against moisture which would change it and finally decompose it. This mishap is particularly to be feared during the cold, and humid season when making experiments in the camera.

"A small amount of this varnish, applied cold to a highly polished silvered plate with a very soft leather ball (tampon), gives the plate a beautiful ruby colour and spreads itself over it in a thin and uniform coating. The plate is then placed on a hot iron plate covered with several layers of paper, from which the moisture has been previously removed; when the varnish is no longer tacky, the plate is withdrawn for cooling and is finished by drying it at a moderate temperature, protected from contact with moist air. I must not forget to call attention to the fact that this precaution is indispensable. In this case, a thin disk, in the center of which is fixed a short stick held in the mouth, is sufficient to arrest and condense the moisture of the breath.

"A plate prepared in this manner can be exposed immediately to the action of the luminous fluid; but even after having been exposed long enough to ensure that the effect had been obtained, nothing indicates that it really exists because the impression re-

mains invisible. It is, therefore, a question of bringing it out, and this can only be accomplished by the aid of a solvent.

Solvent.—Manner of Preparation.

"Since the solvent must be adjusted according to the result to be obtained, it is difficult to determine exactly the proportions of the composition. But, all other things being equal, it had better be weaker rather than too strong. The mixture I preferably employ is composed, by volume, not by weight, of one part of essential oil of lavender to six parts, same measure, of *white oil of petroleum*. The mixture, which at first shows quite milky, becomes perfectly clear at the end of two or three days. This mixture can be used several times in succession. It loses its solvent property only when it approaches the saturation point, which is recognized because it becomes opaque and of a very turbid colour; but it can be distilled and rendered as good as before.

"The plate or varnished tablet, having been removed from the camera, one puts in a tinned sheet iron dish, an inch deep, longer and wider than the plate, and a sufficient quantity of the solvent to permit the complete immersion of the plate. The plate is plunged in this liquid and is viewed at a certain angle in indirect light; the impression will appear, revealing itself, little by little, although still veiled by the oil, which floats on the surface, more or less saturated with varnish. The plate is then removed and placed in a vertical position, in order that it may be well drained of the solvent. When the plate is completely drained, I proceed to the last operation, by no means the least important.

Washing.—Manner of Procedure.

"It is sufficient for this to have only a very simple apparatus, composed of a board four feet long and wider than the plate. On the long side of the board two strips are nailed, which form a ledge two inches high. The ledge is fastened by hinges to a support at the top, which permits it to be inclined at will, in order to pour the water on to the plate as rapidly as required. At the lower end of the board is a vessel for catching the water which flows off.

"The plate is placed on the inclined board and prevented from sliding by two small hooks which, however, must not be higher

than the plate. It is necessary at this season to use lukewarm water. It is not flowed directly on the plates but from above, in order that, spreading on it, it will carry away the last particle of the oil adhering to the varnish.

"The image will now be completely developed and will show everywhere perfect definition, if the operation has been well done, and especially if one has a perfected camera at one's disposal.

Application of the Heliographic Processes.

"Since the varnish can be applied equally to stone, metal, and glass, without change of manipulation, I shall confine myself to the method of application to silvered plates and glass, however, noting that in engraving on copper there may be added without inconvenience to the varnish mixture a small quantity of wax, dissolved in lavender oil.

"Up to now silvered plates seem to me best for the production of images, owing to their white colour and resplendency. There is no doubt that the result obtained will be satisfactory, after washing, provided the image is quite dry. It would be desirable, however, that, by blackening the plate, all the gradations of tone from black to white could be obtained. I, therefore, devoted myself to this object by using at first a solution of *potassium sulphide* (sulfure de potasse liquide) ; when used in concentrated form it attacks the varnish, and if diluted with water, it only turns the metal red. This twofold defect compelled me to give up this medium. The substance which I am now using with greater hope for success is *iodine,* which has the property of evaporating at the temperature of the air. In order to blacken the plate by this process, it is only necessary to place the plate against the inner side of a box open at the top, and to put a few grains of *iodine* into a small groove in the opposite side on the bottom of the box. It is then covered with a glass, in order to judge the effect which, if it operates less rapidly, is, on the other hand, more certain. The varnish can then be removed with alcohol and not a trace remains of the original impression. Since this process is still quite new for me, I shall confine myself to this simple indication, until experience has enriched me with more information on the exact details.

"Two attempts in making views on glass, made in the camera

[93]

obscura, have presented results which, although still faulty, it seems to me should be recorded, because this method of application can be more easily perfected and therefore may later become of very particular interest.

"In one of these experiments, the light, having acted with less intensity, uncovered the varnish in such a manner that the gradations of tones showed more clearly so that the impression seen by *transmission* reproduced, up to a certain point, the well known effects of the Diorama.

"In the other experiment, however, where the action of the luminous fluid was more intense, the parts most illuminated, not having been affected by the solvent, remained transparent and the difference of tones resulted solely from the proportionate thickness of the greater or lesser opacity of the varnish. If the impression is viewed by reflection in a mirror from the varnished side, and held at a certain angle, it produces a striking effect, while, if viewed by *transmission,* it presents only a confused and colourless image and, what is more astonishing, it seems to have taken on the local colours of certain objects. Meditating on this remarkable fact, I was led to believe that I might draw certain conclusions from it, which would permit me to connect them with Newton's theory on the phenomenon of coloured rings. It would be sufficient for this to suppose that such a prismatic ray, the green ray for instance, acting on the substance of the varnish and combining with it, gave it the necessary degree of solubility, so that the layer which had formed by this method, after the double operation of the solvent and the rinsing, *would reflect the green colour.* Finally I have made this observation merely in order to determine the truth of this hypothesis and the matter seems to me of sufficient interest to provoke new researches and deserves a more profound examination.

Observations.

"Although undoubtedly there is no difficulty in the method of execution which I have explained, the result may not at first be completely successful. I believe, therefore, that it is advisable to start in a small way by copying engravings in *diffused light,* according to the following very simple preparation:

"The engraving is varnished on the *reverse* side only, in order to make it thoroughly transparent. When completely dry, the

engraving is placed, *right* side down, on the varnished plate under a glass; diminishing the pressure by inclining the plate at an angle of forty-five degrees. In this manner, several experiments can be made in the course of a day, using two engravings, thus prepared, and four small silvered plates. This can be done, even in overcast weather, providing that the room is protected against cold and especially against moisture which, I repeat, deteriorates the varnish to such a point that it will come off the plate in layers when immersed in the solvent. This prevented me from using the camera obscura during the inclement season. Repeating the experiments of which I have spoken will soon enable one to carry out the manipulation of the process in its entirety.

"Concerning the manner of applying the varnish, I must recall that it can be used only in a consistency thick enough to form a compact and as thin a coating as possible, so it may better resist the action of the solvent, and at the same time become more sensitive to the action of light.

"Concerning the use of *iodine* for blackening the images on silvered plates, as well as regarding the *acid* for etching the copper, it is essential that the varnish, after rinsing, be used just as described in the report given above in the second experiment on glass; because it becomes thus less permeable, both in *acid* and under the *iodine* vapours, particularly in those parts where it has preserved its full transparency, for only under these conditions can one hope, even with the best optical apparatus, to arrive at a completely successful end.

"Executed in duplicate at Chalon-s.-S., November 24, 1829.

"J.-N. Niépce.

Additions.

"When the varnished plate is removed for drying, it must be protected not only against moisture, but care must be taken to shield it from exposure to light.

"In speaking of my experiments made in diffused light, I have not mentioned those experiments on glass. I add this in order not to omit an improvement which is peculiar to it. It consists simply in placing under the plate of glass a piece of black paper, and interposing a border of cardboard on which the engraving has been tightly stretched and glued between the plate on its coated

side and the engraving. This arrangement results in the image appearing much more vividly than on a white background, which will contribute to the promptitude of the action; in the second place, it will prevent the varnish from being damaged by close contact with the engraving as in the other process, a mishap which is not easy to avoid in warm weather, even when the varnish is quite dry.

"But this disadvantage is quite compensated by the advantage which the 'epreuves' on the silvered plates offer, in resisting the action during the rinsing while it is rare that this operation does not more or less damage the images on glass, a substance to which the varnish adheres less easily, owing to its nature and its highly polished surface. It would be necessary, therefore, in order to remedy this disadvantage, to increase the adhesive quality of the varnish, and I believe that I have achieved this, at least insofar as I may be permitted to judge after new and numerous experiments. This new varnish consists of a *solution of Bitumen of Judea in Dippel's animal oil,* which is allowed to evaporate at the ordinary atmospheric temperature to the required degree of consistency. It is more greasy, tougher and more strongly coloured than the other, and it can be submitted to impressions of the luminous fluid as soon as it is applied, and it seems to solidify more rapidly because of the great volatility of the animal oil which causes it to dry more quickly.

"Executed in duplicate, December 5, 1829,

"J.-N. Niépce.

"Duplicate of this note received from Monsieur Niépce.

"Daguerre." [51]

This *Notice on heliographie* is not a simple and dry formula of the ingredients employed by Nicéphore; it is a truthful exposition full of judicious observations on the different methods of experiments; and, just as he stated in 1816, Niépce affirms anew that one could operate efficaciously during *cloudy weather.*

After the partnership *Niépce-Daguerre* was formed, in the form of the agreement of December 14th, Daguerre remained several days at the house of Nicéphore Niépce at Gras; where he took part in various heliographic operations of his associate. When he was fully initiated into the secrets and the manner of operation of the latter, he returned to Paris. Then each of the

associates devoted himself ardently to the perfecting of the admirable invention of Niépce, without however any appreciable progress.

At the moment, however, when Nicéphore was about to attain the most complete success and achieve finally the fruit of his long and persistent work, he succumbed in a few hours to the consequences of a congestion of the brain. This modest scientist, this fine man, died unknown to the learned world on July *fifth* 1833, in his country home at Gras, sixty-eight years and four months old, deeply regretted by his family and numerous friends. His mortal remains repose in the cemetery at Saint-Loup de Varenne. On his tomb, on a smooth grey stone, exposed to the sun, the following epitaph is engraved:

HERE REPOSES
M. JOSEPH-NICEPHORE NIÉPCE
MODEL OF ALL THE VIRTUES
FATHER OF THE POOR
A MAN OF PROFOUND GENIUS
ON WHOM THE SCIENCES BESTOWED
FINE AND IMPORTANT
DISCOVERIES. EXCESSIVELY MODEST
HIS LIFE PASSED PEACEABLY
IN THE BOSOM OF HIS FAMILY
FROM WHOM HE PASSED
JULY 5, 1833 AT THE AGE OF 69 YEARS

At the head of the grave, the tomb is surmounted by a cross, also of smooth grey stone; it is, like the adjoining graves, overrun by weeds and nettles which we had to remove before being able to read and copy the epitaph which has almost become illegible.

Just as his brother Claude, Nicéphore Niépce—so profound was his faith in the excellence of his work and so deeply engraved on his mind—preserved until the last his confidence, his conviction of the realization of the glory and the inevitable advantages which he believed must follow his admirable invention. In short, we cannot doubt that endowed marvelously as he was with such patience, such persistence so necessary for scientific research, he could not have helped,—no matter what his detractors unjustly say—but give the required perfection to his

complete work. But death prevented this, and another, he to whom were confided his secrets, he who had taken part in his work, it was he who has·reaped, or rather has usurped, the honours, the glory and the advantages, which follow and rightly belonged to our illustrious compatriot. *Tulit alter honores!*

How wrong it is, therefore, inconsiderate and without any proof whatever, that several writers have repeated, copying one from the other, that Nicéphore Niépce died "with the *disconsolate* belief of having lost twenty years of his laborious career, having *dissipated* his inheritance and compromised the future of his family in the pursuit of a *chimera!*"

No, gentlemen, Nicéphore Niépce did not die with the *disconsolate* belief with which you gratuitously endow him; he had faith in his work and did not consider it a *chimera*: all his correspondence offers superabundant proof of this. In addition, his death, which came suddenly, could not possibly have permitted him sufficient time to have this pretended *disconsolate* thought.

As far as his *patrimony* is concerned, *dissipated,* according to you, in the researches for this alleged *chimera,* the time has arrived for us to prove the contrary of that which you have written, without other proof than that which activated your troubled imagination.

Although each one of the brothers Niépce possessed their personal fortune, their monies and their interests were dealt with in a kind of common chest. "We have never separated your interest from ours,"—wrote Nicéphore to Claude on June 16, 1816,—"thus we draw on our purse as we draw on yours; justly so and we should be sorry if this were otherwise."

As a matter of fact, it was Nicéphore who, in his quality of administrator of the two fortunes of which the income amounted together to more than fifteen thousand francs per year, sent to Claude all the monies which he required for the construction of his machines, motors, apparatus, boats and improvements, etc. concerning the *Pyreolophore,* the hydraulic pump, etc. The income of the two brothers did not suffice and they had to have recourse to heavy and successive loans.

Most of Nicéphore's letters to Claude are full of the recital of these embarrassments and worries which made Nicéphore incessantly dejected, either because he had to contract new loans

or renew the old ones. We could give here a number of extracts from these letters concerning these loans, but this would abuse the patience of the reader too much.

However, it is necessary to reproduce some of the passages in this correspondence, in order to prove to the poorly informed detractors of Nicéphore that the heliographic work of the latter did not "compromise his inheritance and the future of the family."

The first trace found of the loans obtained by the brothers Niépce is shown on July 28, 1817; it dealt with finding a sum of twelve or fifteen thousand francs, indispensable for the payment of expenses incurred in Paris by Claude and to cover those which were necessitated by his approaching departure for England.

" Accordingly," wrote Nicéphore on July 28, 1817, to his brother, "if this is your advice, it will be necessary to borrow twelve or fifteen thousand francs, which M. Vassal will convert into a draft on London, payable at the bank which you will determine " It was not until Nicéphore had knocked at several doors before he found this sum.

We shall not follow Nicéphore in his wandering, trying to procure the money; we shall only give two or three more extracts from his correspondence in order to give an idea of the fatal road upon which the two brothers had set out. On October 22, 1819 Claude wrote as follows: "I am exceedingly sorry over all the troubles which you have encountered in so important a negotiation. This sum of *twenty-five thousand francs* will enable us to discharge in part the most pressing loans, and I agree with great pleasure to the intelligent views which you already express on the most convenient way of escaping from the condition in which we have found ourselves for some years. While waiting, receive, my dear friend, my sincere and heartfelt thanks for all your sacrifices and the disappointments which this affair has caused you; how much I wish that I were able to see you finally out of this embarrassment "

In his previous letter of September 10, 1819 Claude Niépce expresses the desire that this loan would amount to thirty thousand francs; he enumerated his principal expenses, namely: five hundred pounds sterling for the patent, one hundred eight pounds sterling for a year's lodging and food; then he added "one hundred and some pounds sterling" for laundry, shoes, up-

[99]

keep and other objects; this did not include the expenses connected with the construction of his machines, of his apparatus, etc., an annual expense of about eighteen thousand francs.

On April 6, 1821, Claude wrote thus to Nicéphore: "I agree with you, my dear friend, that if we could procure a loan at Dijon, it would be more advantageous than at Lyons You are right in refusing the propositions which were made to you with such onorous conditions Admittedly our position is very embarrassing and I regret not being able to participate with you in the vexations and troubles which these proceedings cause you "

In 1824, the situation became still more aggravated. Thus MM. Coste wanted to be paid. "Perhaps it is possible," wrote Claude, on October 22 of that year, "to find other lenders than those with whom we are negotiating; perhaps those at Lyons might,—considering the punctuality with which you pay the interest,—undertake to give us this credit (that of MM. Coste). If it pleases the Lord, your works and mine will soon put us in the position where we can liquidate our debts to our creditors, and I believe that we must do everything in our means to arrive at this; we must keep from selling a part of our possessions; we must keep it quiet if possible so as not to give the envious and jealous occasion to laugh at our expense "

This seems to be sufficient to convince the incredulous and to prove that if the fortune of the brothers Niépce was *dissipated,* it was done so mostly by Claude, especially during his stay of more than ten years in England. It would require a volume to enumerate the numerous sums which were used by him for his work, alas! fruitless and useless, as he related to Nicéphore in his letter of November 5, 1827, reported above.

Not only was the entire personal fortune of Claude swallowed up, but also the greatest portion of that of Nicéphore, for which he never thought of reproaching his brother.

Compared with the excessive and useless expenses of Claude Niépce, those of Nicéphore spent on his heliographic work may be considered—as they really were,—of very little importance. Those which were considerable were the different purchases made from MM. Chevalier, engineer-opticians, which we have mentioned; because most of the other apparatus and utensils which Nicéphore used were, lacking workmen and proper implements,

roughly made either by himself or by artisans, more or less incompetent.

The sum of the current household expenses was much less than that of his revenues. Nicéphore was very orderly; he kept daily account of his income and expenses, whether for his brother or for himself or his family. This is borne out by having before us two detached leaves of his personal expense book, written in his own hand from May 8, 1808 to January 27, 1809. ([52]) This detail may seem superfluous to some readers but it will without a doubt interest the great majority who read this; because one likes to know everything which attaches to the intimate and private life of persons who, like Nicéphore Niépce, leave behind them a name that passes into posterity.

We have been compelled to give these explanations, perhaps on account of being too fastidious, in order to clear the memory of Nicéphore Niépce from the imputation of having by his useful and marvelous heliographic work, *dissipated*—as his poorly informed biographers state,—*his inheritance and compromised the future of his family by the pursuit of a chimera*: which is not true, as demonstrated.

These same writers are also badly informed when they write that "Nicéphore was far from being what is called a scientist. He belonged to that class of indefatigable investigators who, without overmuch technical knowledge, and slight training, go far from known roads, over mountains and rivers, seeking the impossible, calling on the unexpected, invoking the God of Chance; Niépce, when everything has been said, was a demi-scientist."

Without being a scientist of the first class, Nicéphore Niépce possessed a broad knowledge of chemistry, physics and mechanics: he loved science, owing to its great charm, which he proved by cultivating it; besides, he was very well versed in history and literature; he was even a poet in his hours; and if he had lived and practiced in Paris among the great "Lights" instead of living unknown, timid and isolated, back in his province, devoting himself simply to his scientific experiments, he would have shone without doubt, in the first rank and with as much lustre as most of those who are considered scientists. Following his modest tastes, it was only opportunity he lacked.

THIRD PART

· III ·

Let us now carefully examine the part which belongs to Daguerre in the invention of Photography, which at its appearance before the world became popular under the strange name of *Daguerreotype*.

We do not delude ourselves that the subject matter of the third part of this book offers many difficulties; the more so because we have to combat, destroy or at least to modify a generally adopted opinion, hallowed by more than a quarter of a century of existence. But however difficult our task may be, we are going to follow it to its end, courageously, conscientiously observing the strict proprieties.

During the course of about fifteen years, from 1824 to 1839, Daguerre has declared, affirmed and claimed for himself under many circumstances, either verbally or in his letters, in the writings signed by him, that he has found the means of fixing in a permanent and durable manner, the images received in the camera. It is our task to demonstrate and establish that these declarations, these affirmations, this boastful claim of Daguerre in this respect, were not founded on truth and fact, in order that the reader, if he wishes to continue to give us his attention, can see the matter in its true light.

But before proceeding with our narrative, it is first essential to give some explanation concerning the source from which we have adapted the matter contained in this third part.

We will find this principally in the second part of this volume, especially in the numerous letters of which we have given more or less exhaustive extracts. We will avail ourselves also,—with due carefulness,—of the brochure entitled: *Historique de la découverte improprement nommée Daguerreotype, précédée d'une notice sur le véritable inventeur feu M. Joseph-Nicéphore Niépce,*

de Chalon-sur-Saône, par son fils Isidore Niépce, which we have already had occasion to quote.

At first, this brochure inspired us only with caution; we feared that the author might have allowed himself to be influenced too easily by passion, and especially by the very natural desire to render to his father the glory of which another had robbed him.

However, the perfect conformity of the larger part of the contents of this brochure with the facts which we knew to be authentic, necessarily modified our first impression. Nevertheless, this was not sufficient and we felt that we must look further for our information. We, therefore, expressed our fears and scruples frankly to M. Isidore Niépce. M. Niépce assured us several times on his honour that he could not retract one word of his brochure, that he had told the truth; that when what he had written was published, he sent it to Daguerre so that he might deny any of his words, that, notwithstanding this challenge, Daguerre has kept the most absolute silence: for the quite simple reason that the brochure contained nothing but the expression of the truth. Isidore Niépce confirmed his verbal statement in a letter written to us.

However, we shall make no other use of this brochure of Isidore Niépce than that of corroborating rather than recital; and we are adding nothing of which there can be the slightest doubt of the facts here recorded.

As we have seen, Daguerre, owing to his *Diorama,* made frequent use of the camera obscura with great cleverness; it is true that he had at his disposition the best lenses and the best constructed apparatus.

We have also seen, as Arthur Chevalier relates in his *Etude* on his father, that Daguerre "often expressed the idea that it would be very marvelous to fix the fugitive image of the camera obscura and that he boasted that some day he would find the famous secret."

Arthur Chevalier also reports the same language in his *Souvenirs historiques:* that Daguerre, "after having obtained the image, could not fix it and in the moment when he contemplated his captive, it vanished, returning to the source from which it emanated."([53]) That is to say, to the Sun.

It was in 1825 that Daguerre used this language to Chevalier. In January 1826 Daguerre was informed by this same man that

he had a rival down in Bourgogne; that this rival, more fortunate than he, had arrived at fixing the images in the camera. Daguerre, following the advice of Charles Chevalier, advice which he had at first rejected, wrote to Nicéphore Niépce a letter "in a very high-toned and bizarre style" which Isidore Niépce mentions, and in which he declared that: "for a long time he also had sought the impossible". Which simply means: I have not yet found anything!

Nevertheless, an acquaintance resulted between Niépce and Daguerre, at first slight and with much reserve on the part of Niépce. We have seen that Daguerre inquired repeatedly as to the nature of Niépce's experiments, of his heliographic attempts; while Nicéphore had the prudence not to send him anything but more or less defective designs, destined to be applied to engravings; that Daguerre did not inform Niépce of a single result of his own researches at that time, notwithstanding the desire which Niépce expressed several times in this regard.

We have also seen that on his trip to England at the end of August 1827, Nicéphore, during his passage through Paris, visited Daguerre several times. Nicéphore relates to his son in his letter of September 2/4 (⁵⁴) the result of this visit; that the "fixation of the elemental colours reduced itself to fugitive tones, so feeble that one could not see them at all in daytime, they are only visible in darkness." It is evident that if Daguerre could have obtained better results, he would have hastened to show them to Nicéphore; and since, as Isidore Niépce judiciously states, "the time could not have been more favorable for M. Daguerre to have profited by showing to M. Niépce some results which he had obtained by his process, of which he spoke in his letter of February 1827, which were entirely different from those of my father and which even had a degree of superiority.

"Surely M. Daguerre must have had some proofs because, according to him, *he already made in 1824 researches on light, of which the sole object was fixing the image in the camera.* (⁵⁵)

"Very well! is this credible? M. Niépce saw nothing! not the smallest design, even imperfect! not the shadow of an attempt which could convince him of M. Daguerre's work was communicated to my father in all his letters! He saw nothing and one can easily guess why." (⁵⁶)

The reason is very simple. He had nothing to show other

than these "fugitive nuances" of which Nicéphore speaks in his letter of September 2/4.

However, after numerous conferences, Niépce and Daguerre formed their association of December 14, 1829. After the signature of the *Agreement*, Nicéphore, according to the terms of article *three* of this document, loyally furnished Daguerre with his *Note on Heliography*, containing the description of the principle of his invention, his processes, his manner of operation for fixing the images received in the camera obscura. He did more, he experimented several times with his processes in the presence of Daguerre during the stay of the latter at Gras. The director of the *Diorama* then returned to Paris, carrying with him the *Note on Heliography* for which he had given a receipt to Nicéphore Niépce.

On his part, according to the terms of article *six* of the agreement of December 14, Daguerre had to *confide to Niépce the principles on which rested the improvements which he had contributed to the camera, and he had to furnish the most precise documents on the nature of this said improvement.*

As far as this *improvement* is concerned, there are in existence two contrary declarations, emanating from two men equally honourable. One, *affirmative,* from Lemaître, who in his letter of February 7, 1827, states: "I know that he (Daguerre) has devoted himself for a long time to perfecting the camera"; and in his letter of November 2, 1829: "M. Daguerre, having greatly perfected the camera obscura and having become quite adept in its use " In writing these lines, was Lemaître the echo of a hearsay? or did he recite what he had seen (*de visu*)?

The other declaration, which is *negative,* comes from Isidore Niépce, according to the testimony which he received from Charles Chevalier, about conversations with Daguerre since 1824. The latter had simply bought a camera obscura with a meniscus prism from MM. Vincent and Charles Chevalier; and the camera obscura perfected by Wollaston, whose invention goes back to 1812, according to a Memoir read at the meeting of the Royal Society of London on June 11th of that year.

"An extract from this Memoir," states Isidore Niépce, "is related in a small work published by Charles Chevalier, engineer-optician, entitled *Notice sur l'usage des chambres obscures et des chambres claires.*

"The lenticular biconvex lens," states Charles Chevalier, "employed until now in the cameras, produced the spherical aberration and an aberration of refrangibility, phenomena which destroy, first, the clearness of the outlines of the image and renders them confused; second it adds still more to this confusion, forming around the images irradiations similar to a rainbow. These are great defects which Dr. Wollaston tried to remedy and which he has in some degree overcome by employing a periscopic lens.

"The lens of M. Daguerre's camera," adds Isidore Niépce, "is nothing but the periscopic lens of Dr. Wollaston, achromatized. Certainly it is not M. Daguerre who has discovered achromatism! This means of avoiding the aberration of refrangibility was known before him; and if it was not in general use, it is because the price was considerably increased by it. As far as the circular opening placed at the end of the tube is concerned, which is called a diaphragm, Wollaston gave the diameter for it, calculated according to the focal length of the lens. This opening has for its object the determination of the quantity and direction of the rays which are transmitted. Charles Chevalier also expresses himself on this subject:

"The size of the aperture through which the luminous rays enter the camera obscura has a very great influence upon the sharpness and clarity of the images. When the opening is very small, little of the light enters, which emanates from all points of exterior objects; the image is less brilliant, but the outlines are then received sharply and offer a perfect silhouette of the object represented. When, on the contrary, the opening is of a certain size, every point of the exterior object sends too great a quantity of luminous rays; the images are then very strong, more fully illuminated; but the outlines lack the precision and show faintly. Finally, if the opening is still more increased, the images of the exterior objects fail to appear on the screen of the camera obscura." (57)

"M. Daguerre has simply followed with the most scrupulous exactitude the process of Dr. Wollaston and the instructions which were furnished him by MM. Vincent and Charles Chevalier relating to achromatism. I do not mention the parallel mirror which transmits the exterior images by reflection into the lens; I do not suppose that in this lies *his improvement;* because similar mirrors have long been employed; that of Wollaston is

[106]

placed just as that of M. Daguerre's camera and finally, the lens, the diaphragm, the mirror of M. Daguerre, are all reproduced in plate I, figure 8 of M. Charles Chevalier's work, anent the article *Chambre obscure periscopique de Wollaston.*" ([58])

Thus, according to the above, at the time of the association of December 14, 1829, Daguerre, notwithstanding his claims, had not *perfected* the camera obscura, had not *perfected* the heliographic invention of Nicéphore Niépce; and in signing the *Preliminary Agreement* of December 14th, which relates *his* two pretended improvements, Daguerre had signed a double falsehood! It must be agreed that this peculiar action in not employing another expression must inspire very little confidence for the subsequent claims of Daguerre.

However this may be, he showed nothing, he did not communicate anything to Nicéphore Niépce concerning these two alleged improvements; it was therefore very easy for Nicéphore *to preserve the secret* which was prescribed by article *six* of the preliminary agreement of December 14th.

"I confirm on my word of honour," again says Isidore Niépce, "that since the first letter which he wrote to my father at the end of January 1826, until the articles of agreement were signed between them on December 14, 1829, M. Daguerre was never able to show to M. Niépce the slightest example of his pretended photographic work! How could he have done so, since he was searching for the impossible?

"After the signing of the agreement of association," again says Isidore Niépce, "Daguerre visited Niépce's house, in the country at Gras near Chalon-sur-Saône; the *inventor* of the *Diorama* showed us a small pasteboard box containing a yellowish powder, which could not have been anything else than calcinated sulphur of Baryte; he let a ray of light fall on this powder that preserved for some time a phosphorescent property which was gradually destroyed and ended by disappearing entirely. This was simply what is called Bologna Phosphorus, on which the physicists have made numerous but fruitless experiments for a long time." ([59])

However, Daguerre published *urbi et orbi* that he had found the secret of fixing the images received in the camera!

And so Daguerre, accepting an association with Nicéphore Niépce for the exploitation of the heliographic invention of the

latter, gave the most evident proof that he had invented nothing nor discovered anything, concerning the fixation of the images of the camera obscura. Otherwise he would have been extremely careful to join,—as he did in an agreement,—of which he subsequently made, it is true, short work;—he would have hastened, on the contrary, to publish his invention, his processes, in order that he might not be anticipated and outstripped by Niépce, who for a long time had produced admirable results from his heliographic experiments. For Daguerre certainly was not the kind of a man to divide unselfishly his glory, "the benefits" of his discovery if he had made one; he proved this abundantly later when he found the means of rapidly obtaining proofs (épreuves) of the images received in the camera obscura, as we shall see later.

This establishes one point. After the passage of the agreement of association dated December 14, 1829, Daguerre, notwithstanding his claims, related in article one of the six mentioned acts, did not *improve* either the *invention* of Nicéphore Niépce or the *camera obscura.*

Let us see now what happened after the preliminary agreement of December 14th was signed; solely with regard to the improvements contributed by Daguerre to the heliographic invention of Nicéphore Niépce; for of the improvement of the camera obscura there is no longer any question.

The heliographic invention of Niépce had one grave defect: several hours were necessary for obtaining satisfactory images received in the camera. It was necessary for the two associates to find a means of correcting this disadvantage; to this end they searched for a more active physical agent, one that was more rapid to act than those employed until then by Nicéphore, in order to obtain images more rapidly. In this, each one searched and experimented separately.

Niépce, at Daguerre's suggestion, vainly experimented with *iodine,* as he related in his letters of June 24th, November 8, 1831, January 29th and March 3, 1892, annotated and published by Daguerre in his brochure entitled: *Historique et Description des Procédés du Daguerréotype et du Diorama,* 1839. However, Nicéphore was not discouraged, on the contrary he renewed his researches, he attempted to combine new agents and he was about to attain the object so greatly desired when untimely death struck him on July 5, 1833.

Was Daguerre, on his part, more fortunate than his partner? Did his experiments have more success than those of Niépce? Did he find this chemically active agent so impatiently awaited? We must answer *NO!* with all certainty and without fear of error, for he had not communicated anything in this regard to Nicéphore, as was his duty according to the terms of the preliminary agreement of December 14, 1829. We cannot suppose that he thought of despoiling his partner during his life as he had done after his death. And although the untruthful statements concerning his alleged improvements, of which we have spoken, had inevitably modified the confidence which we had in him before this, one cannot, however, give way for a moment to the thought—so repugnant—that he had hidden his discoveries from Nicéphore Niépce. This would have been an act of dishonesty, not to say more, which Daguerre, as far as we are concerned, was incapable of committing; to cheat, by a proceeding so reprehensible, a man who without reserve had put all his confidence in him, and to whom he had given so loyally all his secrets.

We must accord the honour to Daguerre, believing, which is also the truth, that until the time of Nicéphore Niépce's death, he had not found anything, and that from the time of his association he had made no progress whatever concerning the discovery of a proper chemical agent which would rapidly obtain images in the camera obscura.

Serious-minded men cannot consider that Daguerre's pretended success which, according to himself, had *even a degree of superiority* over that of Nicéphore Niépce, as anything but the dream of a person who likes to repeat his imaginations which the awakening will dispel; Daguerre proclaimed them as the truth, in order to satisfy his excessive vanity with which he was filled! For he could not familiarize himself with the thought that he, occupying so high a position in the opinion of the world, might appear inferior to a modest chemist and physicist of the provinces.

"Suddenly," says Charles Chevalier in his *Souvenirs historiques,* "Daguerre becomes invisible! Locked in his laboratory, hidden away in the recesses of the Diorama, where he lived, he went to work with new enthusiasm, studied chemistry and for nearly two years lived almost continuously in the midst of his books,

flasks, retorts and crucibles. I had a glimpse of this mysterious laboratory, but neither I nor anybody else was permitted to enter it. Madame, the widow Daguerre, MM. Bouton, Sibon, Carpentier, can testify to the correctness of my recollection."

"Daguerre," continues Charles Chevalier, "from that time on was the sole possessor of the great secret; but before his death, Niépce asserted his rights and those of his heirs by a clause in the agreement which obligated Daguerre to publish the process within a given time." ([60])

Charles Chevalier, expressing himself in this manner, undoubtedly alluded to the agreement of December 14th; by this agreement, Niépce had, it is true, insured his rights and those of his heirs; but there is neither in this document nor in those that followed, no clause which obligated Daguerre to make known the principles and heliographic processes of Nicéphore Niépce within a given time after the death of his associate. It is simply directed by article *two* that "the said discovery can only be published under the two names designated in the first article." We shall soon see in what manner Daguerre conformed to this peremptory clause.

It is evident that it was not until he had in his possession the *Notice on Heliography,* in which the processes and manipulations of Niépce were described, and not until after the latter's death, that Daguerre devoted himself so ardently and secretly to the chemical experiments of which Chevalier speaks, in order to discover the real agent susceptible to procure rapidly the images of the camera obscura. This voluntary seclusion of the Diorama's director would not have caused any surprise to Charles Chevalier and to his friends had they known of the existence of the *Notice on Heliography* of Niépce in Daguerre's hands. For there can be no doubt that the latter did not occupy himself seriously with the chemical manipulations until he possessed this precious *Notice,* which put in his way that which could not help but lead him to success.

Nearly two years had passed since the regrettable death of Nicéphore Niépce. Without his premature, and so much the more deplorable, death, it is evident that *Heliography* would never have received the strange name of *Daguerreotype;* for, without this sad event, Daguerre would never have thought, or at least have dared, to propose to Nicéphore Niépce the substi-

tution of his own name for that of Niépce: which, however, he was not afraid to demand from Isidore Niépce, as we shall see. In the beginning of May 1835, Isidore Niépce, in his capacity as the legitimate and natural heir of his father, whose place he took in the *Niépce-Daguerre* partnership, in pursuance of article *two* of the *Preliminary Agreement* of December 14, 1829, came to Paris, in order to discuss with Daguerre the best means of deriving a profit from the invention of Nicéphore Niépce.

Daguerre, whose name appears second in the terms of the first article of the *Preliminary Agreement,* demanded that from now on he should occupy the first place in the firm's name; not only because of the so-called great perfection which he had contributed to Niépce's invention, but also because, according to him, he had discovered a process which "replaced the basis of the discovery as expressed in the preliminary agreement of December 14, 1829"; so that from now on the commercial title should be *Daguerre et Isidore Niépce,* and not *Niépce-Daguerre.* A lively debate took place between the two associates regarding this exorbitant demand of Daguerre. But let Isidore Niépce relate what happened on this occasion.

"After a discussion caused by my refusal to acquiesce in M. Daguerre's demand, and after he had objected to the clauses of the preliminary agreement, which specified that the firm's name be *Niépce-Daguerre,* and that in case of the decease of one of the two associates the discovery could only be made public, subscribed by both the above names, I finally consented that the name of Daguerre should figure as the first in the trade name! We must recall what my position was under these circumstances. I exercised all my efforts to oppose this arrogant pretention; but in vain did I recall to his attention the lack of loyalty and the offense which he offered to the memory of my father! He was inflexible!

"The continuous work of M. Niépce and of my uncle Claude had absorbed to a great extent the fortune which I had inherited! It was natural and in the interest of my children to ardently desire the solution of a discovery upon which my father had himself placed the hope for a better future. I had several times informed M. Daguerre of my embarrassment and of my hopes; he knew my position: thus, from this moment, he conceived the odious project of turning this to his advantage, im-

posing on me this new obligation.

"He also was in possession of my secret, because he held in his hand the motive power which alone could lead me to great sacrifices! He insisted more obstinately and I signed! But signing with a trembling hand I protested against this outrageous act against the rights of my father." ([61])

Here is the *verbatim copy* of the document in question quoted in the recital of Isidore Niépce, the original of which is in my hands.

"Additional contract based on the preliminary agreement entered into between Messieurs Joseph-Nicéphore Niépce, and Louis-Jacques-Mandé Daguerre on December fourteenth, one thousand eight hundred twenty-nine at Chalon-sur-Saône.

ADDITIONAL CONTRACT

"Between the undersigned Louis-Jacques-Mandé Daguerre, artist-painter, member of the Legion of Honour, administrator of the Diorama, living at Paris; and Jacques-Marie-Joseph-Isidore Niépce, proprietor, living at Chalon-sur-Saône, son of the late M. Nicéphore Niépce, and in his capacity as sole heir in conformation with article 2 of the preliminary agreement dated December 14, 1829, he agrees to the following, namely:

"1st. That the discovery with which this deals having been improved by being greatly perfected through the collaboration of M. Daguerre, the said associates recognize that it has arrived at the point which they intended to attain, and that further improvements have become almost impossible.

"2nd. That M. Daguerre, having, after numerous experiments, realized the possibility of obtaining a much more advantageous result tending to rapidity by means of processes which he had discovered and with which (hoping for an assured success) he had replaced the basis of the discovery disclosed in the preliminary agreement dated December 14, 1829, the first article of the said provisional agreement is hereby cancelled and the following is substituted:

"Article 1. There shall be between MM. Daguerre and Isidore Niépce an association under the firm name *Daguerre et Isidore Niépce* for the exploitation of the discovery invented by M. Daguerre and the late Nicéphore Niépce.

"All other articles of the preliminary agreement remain intact.

[112]

"Executed and passed by the two undersigned, May ninth, one thousand eight hundred thirty-five at Paris.

"I approve the foregoing, although not written by my hand.

"I. Niépce. Daguerre."

From the energetic protestations—related above,—by Isidore Niépce, it is incontestable that the drawing up of this additional contract was the work of Daguerre. The praises which he heaps on his pretended improvements, on his pretended discoveries, leave no doubt whatever in this regard; nor in the minds of those most prejudiced in favour of Daguerre. The praises are, after all, only additions to what he wrote, as we have seen in February 1827, that "his process was entirely different from that of Nicéphore Niépce and even had a degree of superiority over it."

"I shall be criticized undoubtedly despite all" says Isidore Niépce, "for having consented to the changes introduced in this contract; it will be said that I have subscribed to my father's failure, that I have recognized the validity of M. Daguerre's claims by vesting them with my signature!

"It is true! I did not have to wait until today to convince myself of the weight of these arguments which seem to condemn me.

"But I repeat, the disloyalty of my associate, and the force of circumstances which he turned to his profit, are alone responsible for forcing a signature which I gave only after having despaired of my case." (⁶²)

The transposition of the names made in the name of the firm by the additional contract, blameworthy as it is and induced by an excessive vanity, in no way altered the duties and obligations of Daguerre. For the pretended *great changes and discoveries* which, according to him, changed the basis of Niépce's invention, were in reality in the terms of article *thirteen* of the *preliminary agreement,* "acquired to the profit of the two partners;" since, with the exception of the transposition of the names, all other conditions of the said *preliminary agreement of December* 14, 1829 remained intact.

However, it is evident that these pretended improvements and discoveries were only—just as up to now,—vainglorious imaginings of Daguerre; that if the latter had really perfected or discovered any new processes he would have,—as we have observed before,—hastened to exploit them; he would not have waited

to act and he would not have remained inactive during almost four years, as he did; he was too eager for glory to expose himself to the risk of being outstripped by another who might be more diligent than he.

If his improvements and discoveries had been real, he would have hastened, as much from self-respect as from duty and interest, to communicate them to his new associate, particularly after the signature of the additional contract of May 9th. But, as Isidore Niépce states, "he told me nothing of his work, he informed me only of his hopes, notwithstanding that I had signed the new act! And article 13 of the provisional agreement states: *that the improvements and perfections contributed to the said discovery* (that of Niépce) *are and remain acquired* to the profit of the two partners." (⁶³)

The *additional contract* of May 9, 1835, must therefore be considered solely as suggested by the excessive arrogance of Daguerre; thus was the first step made by him towards the end which he had set himself to attain and which he effectively did attain.

Undoubtedly the presumptuous phrase of the first paragraph of the said *additional contract* will have been noticed: "that the discovery (that of Niépce) with which this deals, having been improved by being greatly perfected through the collaboration of M. Daguerre, the said associates recognized that it has arrived at the point which they intended to attain, and that further improvement had become almost impossible."

Employing this arrogant language, Daguerre never thought of the eminent artists who would come after him, who have already advanced so far in the progress of the photographic science, and whose insistent works extend day by day the limits of the perfection of this commercial art.

But let us go on, and arrive, without delay, at the *final contract* which stripped Nicéphore Niépce of his great glory for the profit of Daguerre.

We are now in 1837. "Two years had hardly elapsed," says Isidore Niépce, "when, on the invitation of M. Daguerre, I visited him; he had arrived at the realization of his hope, conceived by him, in the interest of which he had caused the first article of the preliminary agreement to be cancelled in 1835.

"On my arrival in Paris M. Daguerre showed me some proofs

(épreuves) which he had obtained by employing *iodine* and *mercury*.

"They excited in me the same admiration which all persons who have seen them since have shared!

"The moment had arrived for M. Daguerre to place the seal on his insatiable ambition and from now on he knew no bounds!

"It will be noted that the early name of the firm was *Niépce-Daguerre* and that in the second contract of May 9, 1835 the names are already transposed!

"Nothing was left but to eliminate entirely anything that might recall the memory of the first inventor, Niépce, who, having delivered up his secret, had also permitted Daguerre to participate in one single day in the fruits of twenty years of continuous research. From now on, M. Daguerre, by means of labour which cost him nothing, could advance without fear, along a new road which M. Niépce had opened to him! It was a beautiful road; M. Daguerre followed it; he arrived at the desired end but pursuing it he forgot Niépce, who was guiding his steps. He disclaimed him!

"Encouraged by his first success, he now demanded that I affix my signature to the Final Contract which he had prepared in advance.

"The demand for my signature, made at this time in an imperative tone, made me revolt; I formally refused and told M. Daguerre that I had done enough by permitting the name of my father to be replaced by his own, and that I would not permit that he carry his ridiculous pretentions further! That, in acting in this manner, he trampled all sentiments of honour under his feet! That the memory of my father was too precious to me to permit another attack on it, and that I would employ all legal means in order to make him render to him the justice he deserved!—You are right, he told me then, and I would have a very bad opinion of you if you acted differently towards the man whose memory is as dear to me as it is to you!

"He tried vainly to dissimulate, by the expression of this thought (which was probably dictated at this moment by the remorse of his conscience), the dissatisfaction which he felt! Irritated finally by my constant refusal, he informed me that if I did not consent to his demand he would keep his process to himself; that we would publish only that of M. Niépce, and after

which he would make his own public; and that by this means he would keep me from attaining the slightest advantage of my father's discovery. Vainly I tried to make him see that such an action was contrary to the rights stipulated in my favor by the act of association; he answered that his process had nothing at all in common with that of my father, and that he was quite at liberty to protect his own!

"He knew very well the effect which this must produce upon the strings which he made vibrate. Stupefied by this declaration, which destroyed at once all my hopes, I signed again! M. Daguerre never communicated to me, not even after this act was signed, anything about the secret of the process for which I had paid with such a cruel sacrifice!" ([64])

Here follows a verbatim copy of the *Final Contract* mentioned by Isidore Niépce, the original of which, just as the foregoing contract, is in our possession.

"I, the undersigned, declare by this present writing that M. Louis-Jacques-Mandé Daguerre, painter, member of the Legion of Honour, has communicated to me a process of which he is the inventor; this process has for its object the fixation of the images produced in the camera obscura, not with colours but with perfect gradations of tone from white to black. This new method has the advantage of reproducing objects from sixty to eighty times more rapidly than that which my father, M. Joseph-Nicéphore Niépce, invented, perfected by M. Daguerre, and for the exploitation of which a provisional agreement of association was entered into on December fourteenth one thousand eight hundred twenty-nine, and in which document it is stipulated that the said process is to be made public in the manner following:

"Process invented by M. Joseph-Nicéphore Niépce and improved by M. L.-J.-M. Daguerre.

"In consequence of this communication, M. Daguerre agrees to surrender to the Society, formed under the terms of the preliminary agreement above cited, the new process of which he is the inventor and which he has perfected, under the condition that this new process carry the name *only of Daguerre,* but it can only be made public jointly with the first process, in order that the name of M. J.-Nicéphore Niépce figure always, as it should, in this discovery.

"By this present agreement it is and remains established that

all the articles and bases of the preliminary agreement of December 14, 1829 remain intact and in force.

"In consequence of these new arrangements, made between MM. Daguerre and Isidore Niépce, and which form the' final contract which is spoken of in article nine of the preliminary agreement, the said associates, having decided to make public their various processes, have chosen the mode of publication by subscription.

"The announcement of this publication will appear in the daily journals. The list will be opened on March fifteenth, one thousand eight hundred thirty-eight and closed on April fifteenth following.

"The price of the subscription will be one thousand francs.

"The subscription list will be deposited with a Notary; the money will be paid into his hands by the subscribers, whose number is limited to four hundred.

"The articles of subscription will be published under the most advantageous conditions, and the processes cannot be made public until the subscriptions shall attain at least one hundred in number; but, if the contrary is the case, the partners will consider another method of publication.

"If, before the opening of the subscription, a way is found for selling the process, the said sale must not be consented to at a price less than two hundred thousand francs.

"This made in duplicate and agreed to, at Paris, on June thirteenth, one thousand eight hundred thirty-seven, at the house of M. Daguerre at the Diorama, we have signed.

"The writing of the above and of the other parts is approved.
 "Isidore Niépce. Daguerre."

Now, one can no longer permit himself any doubt of contesting Daguerre's success; he had arrived in obtaining rapidly, in some instances, images received in the camera obscura; he showed them to Isidore Niépce whose admiration was greatly aroused by them.

But Daguerre carefully abstained from designating to his associate the chemical agents with which he had obtained these proofs (épreuves) ; for, if he had informed him of them, if he had indicated the manner of employing them, Isidore Niépce would have realized immediately that Daguerre's processes were identically the same as those of Nicéphore Niépce, and that he oper-

ated exactly and in the same manner as the latter. The sole difference—-an immense difference it is true—which existed between the two methods consisted simply of the employment by Daguerre of chemical agents more active and more rapid in their action than those which had been employed until then and the fact that the two associates—ever since the enactment of the preliminary agreement of December 14, 1829—had recognized as necessary, indispensable, required by the invention of Nicéphore Niépce for its final perfection. These chemical agents were by agreement sought jointly, without success for four years, by the two associates; which researches death alone had interrupted for Nicéphore, but which were crowned with full success by Daguerre, after four years of combinations and experiments. We repeat, Daguerre changed nothing in the principle of Niépce's invention and he proceeded and operated exactly as the latter had done. Daguerre simply substituted *Bitumen of Judea* by *iodine* and the *Lavender oil,* mixed with a tenth *white petroleum oil by mercury.* ([65])

The materials employed by Daguerre constituted an immense and admirable improvement of Nicéphore Niépce's *invention,*—and not the *invention* of a new thing. This permitted him to exploit the invention of Niépce from that time on with advantage, rapidly obtaining proofs (épreuves) of the images received in the camera obscura. We have compared the two methods: they are similar as far as the principle is concerned.

Daguerre has launched the discovery of this chemical agent and consequently this improvement which was entirely fortuitous in its origin and due to chance.

"He happened one day," says Figuier, ([66]) "to leave inadvertently a silver spoon on an *iodized* silvered plate and he noted that the spoon left its impression on the plate under the action of the surrounding daylight. This lesson was not lost on him; he substituted *iodine* for the resinous substances and found that it gave to the silvered plates an exquisite sensitiveness to light. This was the first step towards the *complete solution* of a problem which had already cost twenty years of assiduous research."

It is evident that if Daguerre had communicated to Isidore Niépce the chemical agents which he succeeded in discovering, and his method of employing and operating them, Isidore Niépce would have recognized how effective they must be for the im-

provements which Daguerre had undertaken to contribute to the invention of Nicéphore Niépce under the terms of the *Preliminary Agreement* of December 14, 1829. Incontestably, also, Isidore Niépce would have refused peremptorily to sign this final contract of June 13, 1837, virtually admitting the failure of his father. In this case Daguerre's ambitious designs would inevitably have miscarried, notwithstanding all the adroitness which he had employed in conceiving and preparing this final contract.

Here are the terms in which Isidore Niépce expresses himself on the improvements which Daguerre contributed to the heliographic invention of Nicéphore Niépce:

"Had not my father," he said, "discovered a sensitive substance on which light acted proportionately to the greater or lesser intensity of its rays? This substance was *Bitumen of Judea,* pulverized and dissolved in Lavender oil; this solution was then applied to a silvered plate, and exposed in the camera. ([67])

"M. Daguerre, himself, also uses a silvered plate; his sensitive substance is iodine. Which of the two first used a coating of silver? Had not M. Niépce made use of iodine? did he not point this out in his *Notice on Heliography?* And, although he did not use it in the same manner as M. Daguerre, how could this latter have thought of making use of it, had it not been revealed to him by my father? I know that M. Daguerre might answer to this that nothing is impossible to him who knew all the properties of iodine, perhaps even before M. Courtois ([68]) had thought to extract this marine substance from the ashes of varec (kelp)

"Let M. Daguerre enjoy in peace the good opinion which he has of himself! It is quite evident that he could not obtain by this process satisfactory results on any other matter.

"My father used a *solvent* in order to make the image visible which existed invisible on the silver; this solvent was a mixture of one part in volume of Lavender oil with ten parts of white petroleum. For this solution M. Daguerre substituted mercury; and the *washing* was employed by my father and equally terminated M. Daguerre's operation.

"It will, therefore, be seen that the principle of M. Daguerre's process is the same as that of the discovery of M. Niépce; that the operation is the same, there being no change other than a change of the substance from bitumen of Judea to iodine, which was more sensitive, it is true, than the former, and mercury

which replaced the solvent." ([69])

We can only conclude from all this that Daguerre had simply *perfected* the heliographic invention of Nicéphore Niépce and had *invented* nothing new. This double point being established, let us examine to whom this *improvement* belongs.

Daguerre, according to article *four* of the *Preliminary Agreement* of December 14, 1829 "agreed to cooperate to the fullest extent to the improvements which are judged necessary by the useful contribution of his lights and talents." According to article *five* of this said agreement "M. Daguerre contributes (to the Society) a combination of the camera obscura, his *talents* and his *industry*."

Article *thirteen* expresses itself thus: "The *improvements* and *perfections* contributed to the said discovery (that is, the heliographic invention of Nicéphore Niépce), as well as the improvements contributed to the camera obscura *are and remain acquired for the profit of the two partners,* who, after they have arrived at the object which they propose, will make a final contract between them, *on the basis of the present.*"

And if we retrace our steps we will find in article *two* of the same *Preliminary Agreement* this stipulation: "In case of the decease of one of the two associates, the said discovery (always that of Niépce) cannot be made public without the signature of both names designated in the first article." This means those of *Niépce-Daguerre.*

And thus, having recognized and established that Daguerre agreed to *cooperate* in the improvement and perfection judged necessary, that he contributed to the Society his *lights,* his *talents* and his *industry,* the chemical agents which he had found, were an improvement, a perfection, contributed by him; he agreed to this as a contribution to the heliographic invention of Nicéphore Niépce and in no way a *new invention;* all of which, according to the terms of article *thirteen* of the *Preliminary Agreement,* were the *property absolute and entire of the Society;* and consequently Daguerre had no right, he was not permitted to make use of it for his profit; and he was, moreover, prohibited by article *two* to publish under his *sole name,* as he improperly did.

In order to seize, as he did, what did not belong to him, Daguerre was reduced to seek and employ subterfuge. First, on May 9, 1835, he made his new associate subscribe to a transposi-

tion of the names; prompted by his first success, he caused Isidore Niépce to *declare* and sign, in an agreement prepared in advance, the following: "M. Daguerre informed me of a process of which he is the inventor." This is not a truthful statement, and, as we have seen, Isidore Niépce declares that "M. Daguerre never informed me, even after the agreement was signed, (the final one of June 13, 1837), of the secret of the process for which I paid by a cruel sacrifice!"

We have seen in Isidore Niépce's recital that Daguerre only obtained the latter's signature by employing the threat of publishing separately and first the *process* of Nicéphore Niépce's invention, and then that which he called his *process,* which was nothing else, as we have seen, and as we shall see shortly, than that of Niépce with the exception of the improvement which he, Daguerre, had added to this invention. And so, Isidore Niépce complains rightly: "I asked him what could possibly be the value of a title obtained by force and violence?" (70)

He also states as follows: "I refrain from relating several circumstances which only would aggravate M. Daguerre's conduct in the eyes of persons who will read this memoir; but, *I declare upon my honour* that all that is contained in it is true, exact, and I defy M. Daguerre to contradict me." (71)

Nevertheless and notwithstanding this deplorable conduct of Daguerre towards him, Isidore Niépce never would have thought of publishing his pamphlet entitled: *Historique de la Découverte improprement nommée Daguerréotype,* (History of the discovery improperly called Daguerreotype) —to which we have made several references—if Daguerre had not, in order to laud his process, committed the impropriety of deprecating and criticizing the processes and the manner of operation of Nicéphore Niépce, which the latter had described so clearly in his *Notice on Heliography;* which deprecation and criticism we shall examine directly.

If we read the final agreement of June 13, 1837 by itself, before knowing the clauses of the *Preliminary Agreement* of December 14, 1829, we find quite naturally and equitably that Daguerre imposed the condition that "the new process of which he is the inventor and which he has perfected . . . will carry the name *only of Daguerre;*" one is even urged to congratulate him on his kind thought "that he consented to give over to the So-

ciety, formed in virtue of the preliminary agreement above cited, the new process . . . which only could be made public jointly with the first process, in order that the name of M. Joseph-Nicéphore Niépce figure always, as it should, in this discovery."

The reader, we do not doubt,—after having read our explanation will have promptly judged this pretended generosity of Daguerre, presenting to the Society of which he was one of the members, something which did not belong to him, Daguerre, but which, on the contrary, was the absolute property of the said Society by virtue of article *thirteen* of the *Preliminary Agreement* of December 14, 1829.

But the loyal reader—and we would like to believe that all our readers are endowed with this precious virtue,—who has read the contract of June 13th has perhaps not sufficiently realized with what perfidy the fallacious clause was drafted by which Daguerre's process could not be published unless it was in conjunction with that of Niépce.

This clause, which seems at first an honour rendered to Nicéphore Niépce, was in reality nothing but the annihilation of his name and of his glory, as events justified. In effect, after the publication of the invention of photography, the processes and manipulations were presented in such a strange manner that the name of Daguerre alone was proclaimed, acclaimed with enthusiasm! But let us not anticipate events.

After the signature of the final agreement of June 13, 1837, the two partners appealed together to amateurs in the fine arts and to capitalists, in order to place the four hundred shares mentioned in the said agreement. But their appeal and attempts failed and the subscription which was opened on March 15, 1838, was unsuccessful. ([72])

It was then that they thought of selling their processes to the French government. For this purpose, they made visits to persons who were in a position to help them to accomplish their plans. Daguerre addressed himself particularly to Arago, to whom he had confided under the seal of secrecy his processes and those of Nicéphore Niépce. Arago displayed enthusiasm after seeing the proofs made under his own eyes; and, on January 7, 1839, he communicated for the first time to the Académie des Sciences the invention of Nicéphore Niépce and the improvements of Daguerre. But this communication was made in

such a manner that the invention of Niépce, as well as his name, were somehow annihilated; while the processes and the name of Daguerre were vividly acclaimed.

However, the secret of this communication was not very well kept—and we shall see directly why—for on the day before, on January 6th, the *Gazette de France* informed its subscribers of it. The following letter of Francis Bauer, member of the Royal Society of London—to whom we have already had occasion to refer—appears to fit in here quite naturally. Although it has been known for some time, we reproduce it here so much more readily because it will serve as a sort of corollary to a part of our recital. This letter was addressed by Francis Bauer to the Editor of the *Literary Gazette of London*.

"Sir, I notice with great satisfaction in one of the last numbers of your worthy publication, (*Literary Gazette*), the great attention which you pay to what you call the new discovery in the fine arts; and I hope that the few facts relative to this interesting subject, of which I inform you in this letter, will attract your attention still more!

"In September 1827, a Frenchman, M. Joseph-Nicéphore Niépce, of Chalon-sur-Saône, arrived at Kew on a visit to his brother, who had been in England for a long time and who was dangerously ill. I soon became acquainted with M. Niépce, who informed me then that *he had made the important and interesting discovery of fixing in a permanent manner the image of any object by the spontaneous action of the light.* He showed me several very interesting specimens of images fixed on polished pewter plates, as well as prints made on paper from the plates prepared by his chemical process. M. Niépce called these specimens *the first results of my long researches.* M. Niépce desired to have this interesting and important discovery communicated to the Royal Society of London, in order that the priority of his discovery might be established. I therefore assisted him in drafting a note or memoir on this subject which was later to be presented to the Society: it was done; he wrote it at Kew and dated it December 8, 1827.

"I have the pleasure of sending you enclosed a translation of this interesting memoir.

"Soon after, M. Niépce was introduced to some of the most influential members of the Royal Society, to whom he presented

his memoir and several specimens of his discovery; but although he had several interviews with these members, who were able to deliberate for several weeks on his memoir, since M. Niépce did not wish to explain his secret, the memoir and his specimens were returned to him and the subject was never presented to the Society.

"M. Niépce was obliged, by pressing family affairs, to return to France in the beginning of February ([73]) 1828; and about a fortnight after his departure, his brother died at Kew. This event naturally caused a great interruption in the scientific researches of M. Niépce; we continued, however, a friendly correspondence for some time; but a letter from him which I received dated January 9, 1829, was the last. In this letter, as well as in all other, he speaks of the success of his researches, and he expresses the fond hope that in the following Summer he would be enabled to complete his discovery, and he promised to inform me faithfully and promptly of the final result of his long researches. But since that day (January 9, 1829) I have not heard from M. Niépce or from his heliography, until January 12, 1839, when my attention was attracted by the *Literary Gazette*, which reported an article from the *Gazette de France*, dated Paris, January 6, 1839 and signed H. Gaucherant, in which I find to my great surprise that M. Daguerre, well known for his Diorama, claims not only having been the first to discover this interesting and important art, but wants to imprint on it also his proper name! I remember very well that M. Daguerre was connected with M. Niépce; but I have never heard nor understood that he had an active part in the researches of M. Niépce, other than to encourage him to persevere in his work. I also know that M. Daguerre was zealously occupied with researches and experiments in which he obtained success; but this *object was different by a long way,* from that of M. Niépce: it is what M. Daguerre now calls *his decomposition of the light,* a method by which he produced the astonishing and admirable effects in his representations in the Diorama, and of which the public papers are replete with their marvelous recitals. (See the *Morning-Post*). But his *discovery of the decomposition of the light* is a matter *greatly differing from the discovery of fixing in a permanent manner objects by the action of light.*

"This latter discovery was largely reported in the same man-

ner in the French journal (See *Gazette de France* January 6, 1839), in which there appears for the first time the word *daguerreotype* as follows:—'It is with great pleasure that we announce the important discovery made by M. Daguerre; the celebrated painter of the Diorama, etc.:'—and again: 'M. Daguerre has discovered a method of fixing the images which are represented in the focus of the camera, etc.'—and a second time: 'MM. Arago, Biot and von Humboldt have convinced themselves of the reality of this discovery, which merits their admiration, and M. Arago in a few days will communicate it to the Académie des Sciences;'—at the end of the article the author gives us the following important information:—'M. Daguerre *generously advised that the first idea of this process* was given to him about fifteen years before by M. Niépce, of Chalon-sur-Saône, but in a condition of such imperfection that he had to work a long time and perseveringly in order to attain the result.'

"Now," continues Mr. Bauer, "I do not think that M. Niépce could have given him an imperfect idea fifteen years before, because specimens which were brought by M. Niépce and exhibited in England in 1827 (and some of which are still in my hands) were just as perfect as the results of M. Daguerre, described in the French papers of 1839, although this is the first time that M. Niépce's name was mentioned! In a later journal there is an article dated Paris, January 9, 1839, in which, after several lengthy praises, this is established:

" 'M. Arago made on the 7th of this month a verbal communication to the Académie des Sciences on the beautiful discovery of M. Daguerre;' and in the following article: 'Considering the great usefulness of this discovery for the public, and the extreme simplicity of the process, which is such that anyone can make use of it, M. Arago thinks that it will be impossible, either by a patent or otherwise, to assure to the inventor the advantages which he ought to draw from his discovery, and he believes that the best way would be that the Government acquire it and present it to the public.'—But the name of M. Niépce,"—still continues Mr. Bauer,—"was not mentioned in this report, which, I insist, is incomprehensible. I have the honour of knowing very well Baron de Humboldt and M. Arago, and to express the opinion that there are not any men more learned or honourable! I believe that any impartial reader who combines the formal recla-

ration of M. Niépce and the generous statement of M. Daguerre will be convinced, as I am, that M. Niépce is the inventor of this interesting art. Although, however, during the long period of ten years, and the interruption and entire cessation of our correspondence in 1829, M. Daguerre could have made great progress; although, moreover, if he has lawfully purchased M. Niépce's secret, I believe that he should draw the greatest possible profit from the sale of this secret, the merit of the invention belongs no less to my estimable friend Nicéphore Niépce.

"I have not seen any of Mr. Talbot's photogenic designs, but after what I have seen in the journals, I presume that he pretends to have made very interesting experiments during the four or five years which have elapsed; but it seems to me that his process is based on the same principles as M. Niépce's discovery and, if Mr. Talbot succeeds in fixing in a permanent manner the image of nature on paper, this would certainly be most important because he will have created the most useful process!

"Before leaving England, M. Niépce presented me with several interesting specimens of his newly discovered art, one of these is his first successful experiment in fixing an image of nature; another a plate, prepared with what he calls the chemical process, for acting on a copper plate similar to engraving by acid and for taking impressions of the same plate.

"If you, sir, or some one engaged in the arts or sciences, attach any interest to this subject and desire to see the specimens which I have in my possession, I shall be glad to have you come to my house, and will be happy to show them to you and to give you any further explanations which you may desire.

"This communication, sir, is entirely at your service and you may make any use of it that you judge proper. If you will acknowledge receipt of this communication in your next number, I shall know that you have received it and you will greatly oblige, sir, your humble servant,

"Francis Bauer, F.R.S.

"Eglantine Cottage, Kew Green, Feb. 27, 1839." ([74])

This very interesting letter of Francis Bauer,—written by a perfectly honourable gentleman, completely disinterested and inspired solely by his sense of justice and friendship,—requires no comment: one will recognize the importance of it.

In short, we have the right to remark that if the French jour-

nals of January 6 and 9, 1839 have, six months in advance, named the heliographic invention of Nicéphore Niépce perfected by Daguerre—Daguerreotype—it is evident that they could only have acted so through the inspiration of the latter, because they have reproduced somehow word for word the principal clause of the final agreement of June 13, known only to Daguerre and Isidore Niépce; and certainly it was not the latter who had developed this fatal clause, annihilating the glory of his father! It was premature and in anticipation on Daguerre's part to put in practice, to execute the agreement consented to, however, not without protest, by Isidore Niépce.

Undoubted the articles in the journals and Arago's report, of which Francis Bauer speaks as discussing only Daguerre and not Niépce, were only trial balloons, sent up and directed to the Government, in order to suggest to it the idea of buying the heliographic process of *Niépce-Daguerre*: which it subsequently did.

Let us note with Bauer that the heliographic images, presented by Arago to the Académie des Sciences in 1839 were not, as far as the finish is concerned, superior to those which Nicéphore had communicated in 1827 to the Royal Society of London.

Bauer's letter contains also a phrase which we cannot allow to pass in silence; this phrase reads as follows: "If he (Daguerre) has lawfully purchased M. Niépce's secret, I believe that he shall draw the greatest possible profit from the sale of this secret . . ."

We cannot believe,—and our belief is assured by all honest men,—that Isidore sold the glory of his father, that he committed an action so guilty, which would be so shameful for the buyer as well as the seller! No, such a repugnant iniquity was not committed!

Through the intervention of Arago and that of other influential personages, Daguerre and Isidore Niépce were put in touch with Tannegui Duchâtel, Minister of the Interior; and a preliminary agreement was made and signed by the contracting parties on June 14, 1839 by which the two associates ceded the heliographic process to the State, in consideration of:

1st, For Daguerre an annual pension during life of *six thousand francs* of which *four thousand* are for the heliographic processes and *two thousand* for the processes of painting and lighting used in the tableaux of the Diorama;

2nd, for Isidore Niépce, an annual pension for life of *four thousand francs* for the invention of his father;

Half of these pensions were to revert to the widows of MM. Isidore Niépce and Daguerre.

On the following day, the Minister of the Interior drafted a law *ad hoc;* he presented it to the Chamber of Deputies at the meeting of June 15th. This project was, according to usage, accompanied by an exposition of the motives; in this exposition the improvements by Daguerre were lauded and extolled, just as the works of the real inventor, Nicéphore Niépce, were relegated to the lowest place.

This was also done in Arago's report, made in the name of the Commission charged with examining the aforesaid proposed law. In his report, Arago was inspired by the verbatim text of the final agreement of June 13, 1837, and by the captious explanation which was given to him by Daguerre based on the declarations of Isidore Niépce related in the said contract. And Arago did not know that these declarations were not truthful statements, nor the brutal conduct of Daguerre towards Isidore Niépce; he wrote his report from what he had read and heard.

In the Chamber of Deputies, Gay-Lussac did still worse; he did not mention Nicéphore Niépce's name once in his report; it is only a question of Daguerre and *his marvelous processes!*

The law was voted on in the Chamber of Deputies on July 3, 1839 and in the Chamber of Peers on the 30th of the same month.

After the promulgation of this law, Arago communicated the heliographic processes and manipulations to the Académie des Sciences on August 19th following. His communication was received with enthusiasm by the select audience which attended this memorable session, and by the crowd who impatiently awaited, on the outside, the publication made by Arago.

And now fame sounded its trumpet and proclaimed the glory of Daguerre unto the most remote corners of the earth, while the name Niépce, that of the real inventor of photography, was not even mentioned!

"In the midst of this great triumph," says Charles Chevalier, in his *Souvenirs historiques,* "we must remember there were many persons who regretted that they did not see on the certificate of baptism two names instead of only the one; for even if

the double paternity had been mentioned, photography on metal, at least has taken the name Daguerreotype." (⁷⁵)

The absence of Niépce's name alongside that of Daguerre is still more grievous, deplorable and prejudicial to the memory of Nicéphore Niépce, because Daguerre is considered by the greatest number of people as the sole and real inventor of photography; and this simply for the reason, all-compelling for the vulgar, that this marvelous invention carries the name of *Daguerreotype!*

However, it cannot be denied that his ambition was a very bad counsellor for Daguerre. Bound as he was by the agreements which he himself had created, and to carry out loyally the agreehonour to submit himself to the consequences of the situation which he himself had created, and to carry out loyally the agreements which he had contracted with his loyal associate. He could not continually evade attaining the object which he had set himself as he had and not debase himself by employing the unworthy methods of a man without self-respect. Certainly the admirable improvement which he had contributed, belated it is true, to the marvelous invention of Nicéphore Niépce, had acquired for him a sufficiently brilliant glory, certainly sufficient to satisfy his ambition, great as it was! His name proclaimed alongside that of Niépce would have been just as famous, just as glorious, and would, as a whole, have had as much celebrity as if it had been proclaimed alone! At least it would not have been tarnished, as it is, by the title of a *usurper!*

Our first intention was to reproduce *in extenso* an exposure of the motives of the Minister of the Interior, of Arago's reports to the Chamber of Deputies, and of Gay-Lussac's to the Chamber of Peers; but we soon realized that the reproduction of these documents, interesting as they may be, would have the serious disadvantage of being tiresome to the reader, without having any great usefulness or interest for him.

But since Daguerre has given them in his brochure (⁷⁶), we shall analyze them as well as the other documents accompanying them. This analysis will, moreover, have the advantage of corroborating many of the important points of our recital.

This brochure contains first the act of sale to the State, of June 14, 1839, of the heliographic processes of Niépce and Daguerre. 2nd, the text of the law which grants to the latter the annuities for life as the price of their sale; 3rd, the exposé of the

motives of the said law as it was read by the Minister of the
Interior to the Chamber of Deputies, in which are exposed, are
aggrandized, as we have said, the processes of Daguerre at the
expense of those of Nicéphore Niépce;

4th, Arago's report and the many and long notes which he had
added and published later in the *Comptes-rendus de l'Académie
des Sciences.* These notes are explanatory of Daguerre's processes
compared with those of Nicéphore Niépce, and to the disad-
vantage of the latter; thus was done by praises pronounced either
on persons or subjects, flattering the one to the disadvantage of
the others.

5th, the report which Gay-Lussac made to the Chamber of
Peers, in behalf of the special Committee charged with the exam-
ination of the proposed law mentioned, which is written in terms
which we have indicated above.

This brochure contains besides the reproduction of the Notice
on *Heliography* of Nicéphore Niépce, accompanied by many notes
of Daguerre in which Niépce's processes and his manner of
operating are criticized and deprecated in a most improper manner.
These notes are followed by an article entitled: *Modifications
contributed to M. Niépce's processes by Daguerre.* The *improve-
ments* are simply the complement, the corollary of the critical
notes mentioned above and are dictated in the same deprecating
spirit.

This was followed by a *Historical Note on the Process of Da-
guerreotype,* in which Daguerre relates some of his dealings with
Nicéphore Niépce and his son, Isidore Niépce. He recalls par-
ticularly the final contract of June 13, 1837 "by which document,"
he said, "M. Isidore Niépce recognized that M. Daguerre demon-
strated to him his new process. It is also specified in this docu-
ment that the process will carry the *sole name* of M. Daguerre,
since he was in fact the sole inventor." ([77])

We have pointed out the *subterfuges* used by Daguerre in order
to obtain from Isidore Niépce this untruthful statement, and con-
sequently the confidence which the contract of June 13th de-
serves; we, therefore, need not recall that again.

We have seen previously ([78]) that Nicéphore Niépce, accord-
ing to Daguerre's suggestion, had unsuccessfully made new ex-
periments with *iodine;* these fruitless results were recorded by
Niépce in his letters of June 24th, November 8, 1831, January

29th and March 3, 1832, which Daguerre published in his brochure with which we are dealing; in doing this, Daguerre did not consider for a moment respect or disrespect for the conventions in giving publicity to confidential letters.

These letters, or rather the extracts from these four letters, as well as an extract from another letter from Isidore Niépce, dated November 1, 1837, and which treats of the same subject as the letters of his father, are attested "a true copy" by Arago and Daguerre; they are also preceded and accompanied by critical and deprecatory notes of Daguerre in which we read as follows:

"In the advertisement which precedes the description of M. Niépce's process, may be read that an act of preliminary association was signed between him and M. Daguerre in December 1829. In this agreement, M. Daguerre *undertook* to improve M. Niépce's process, and had given him all the information on the improvement which he had added to the camera obscura. M. Daguerre judged it necessary to give here an extract of the correspondence with M. Niépce in order to prove that the latter had nothing to do with the discovery of the Daguerreotype." ([79])

But what you have qualified as the *discovery* of *Daguerreotype*, M. Daguerre, is nothing else,—as we have superabundantly demonstrated, and which you have yourself declared,—is nothing else, we say, than the improvements which you have *pledged,* according to your own words, in the preliminary agreement of December 14, 1829, to contribute to the invention of Nicéphore Niépce; and you would have no right to dispose of them, as you have done, to your own profit, because they are, according to the terms of article thirteen of the agreement,—we repeat,—the property, entire and absolute, of the Society which you have voluntarily formed with Nicéphore Niépce; and that, therefore, you were not permitted, according to article *two* of the said act, to publish these *improvements* under your *sole name* as you have unjustly done.

In writing these lines, which we have reproduced, you have, M. Daguerre, yourself pronounced your just condemnation.

The brochure with which we deal contains also the *Practical description of the Daguerreotype, by Daguerre, painter, etc.*

"The process," says Daguerre, "is divided into five operations:

"The first consists in polishing and cleaning the plate in order to put it into proper condition to receive the sensitive coating;

"The second consists in applying this coating;

"The third in exposing in the camera obscura the prepared plate to the action of the light so it may receive the image from nature;

"The fourth consists in making visible this image, which is invisible when taken out of the camera obscura;

"And finally, the fifth consists in removing the sensitive coating, which will continue to be modified by the light which necessarily tends to destroy the image altogether." ([80])

As will be seen, the manner of Daguerre's operations is the same as those indicated by Nicéphore Niépce in his *Notice on Heliography;* there is nothing changed,—as we have said several times,—but the bitumen of Judea and lavender oil and petroleum which Daguerre replaced, as we have seen, by iodine and mercury. But the course of operations of the two processes is exactly the same.

This *Practical description of the Daguerreotype* is accompanied by six engraved plates; and it is followed by a supplementary article entitled: *Explanation of the Daguerreotype plates.* ([81])

Finally, the brochure is ended by the "Description of the processes for painting and lighting effects invented by Daguerre and applied by him to the tableaux in his Diorama."

All the contents of this brochure seem to be the complement of the *note* which follows and is found on the *back* of the title page. This *note,* which we copy verbatim begins thus:

"It is necessary to recall here the importance of the valuable discovery of M. Daguerre: any one can already appreciate the immense services which it must render to the sciences and arts, as well as to new enjoyments which it promises to amateurs; but it is necessary to warn the public that the success of the operations depends greatly on the precision of the instruments, and on the care with which the different apparatus are manufactured and the proper quality of the materials employed.

"Therefore, M. Daguerre, deeming it important that everyone may be able to operate successfully after his instructions, has confided the manufacture of his apparatus to a capable house in order that the resources of its manufacture might completely attain the desired end.

"The Apparatus manufactured by MM. Alphonse GIROUX & CO., ARE THE ONLY ONES WHICH ARE EXECUTED UNDER THE IMMEDIATE DIRECTION OF M. DAGUERRE,

THE ONLY ONES CARRYING HIS SIGNATURE, and are guaranteed in all their details necessary to the perfect success of this operation."

After several recommendations concerning the other apparatus, the chemical agents, etc., the *note* ends with the announcement that "practical experiments are made in the presence of persons who buy an apparatus."

All these recommendations, all these announcements are easily understood; by virtue of agreements signed between manufacturers of his choice, Daguerre participated with them in the profits which would accrue from the sale of the apparatus and their accessories which were sold to amateurs.

But the fame which was unexpectedly achieved by his name and the honours of which he was the object, did not suffice Daguerre; he published several editions, printed in great numbers, of the brochure which we have analyzed and in which, as we have said, he criticized and deprecated the processes of Niépce. This unscrupulous conduct of Daguerre aroused the indignation of Isidore Niépce, who found himself by these proceedings compelled to defend the memory of his father, and he published his brochure *History of Discovery improperly named Daguerreotype* often quoted by us in this book.

But the following extract of a letter which Isidore Niépce wrote from Paris to his mother, on September 8, 1839, will explain better than we can the strange behaviour of Daguerre; this extract will also be a corollary of our analysis of the latter's brochure:

"Daguerre has just published a brochure containing, first, my father's process; second, the modifications which he had contributed; third, his process; and finally that of the Diorama. We have had for several days a most strenuous quarrel about this matter; I have confounded him! And like every man who has no appreciation of integrity, he has certainly turned about and, arrogant and furious as he was while he saw me calm, he became tractable and ingratiating, when he saw the irritation and indignation which his past and present conduct has caused me! But I assure you I do not know how to profit by my victory; in appearance we leave each other friendly enough, and the brochure in which he made notes and added letters of my father and from me, behind my back, is going to appear! He has shown me the

full measure of his iniquity and of his desire to disparage my father's glory! I am compelled to publish an article in order to make his conduct known and to correct the false impression produced by his notes criticizing my father's discovery. . . . "

Isidore Niépce published his brochure *Historique;* but printed in small numbers, distributed only to his friends and to those who were indifferent, it had little effect and changed the opinion of only a small number of people on the origin of Photography; and so, Daguerre could enjoy in peace his largely usurped glory and his immense publicity.

Daguerre died at Petit-Bry-sur-Marne—to which place he had retired—on July 10, 1851. More favored than Nicéphore Niépce, Daguerre has a monument which was erected to his memory by the *Société libre des Beaux-Arts,* of which he was a member, by means of a subscription; this monument was dedicated on November 4, 1852.

L'Etude which Arthur Chevalier has dedicated to the memory of his father contains the recital of the dedicatory address and a description of the monument.

"Daguerre's monument," it is stated there, "is of a simplicity or more precisely of a severity which does not exclude grandeur; the great men of ancient times are not more revered. An iron grille surmounted by torches surround a granite base, serving as a pedestal for a sepulchral pillar, on the upper part of which is sculptured a medallion representing the famous deceased. M. Rohault de Fleury was the architect of this mausoleum and the sculpture was the work of M. Husson.

"On one of the faces of the pedestal one reads:

To DAGUERRE

The Société Libre des Beaux-Arts

M DCCC LII

"On the other:

SCIENCES—FINE ARTS

"On the third:

DIORAMA—DAGUERREOTYPE

"And on the fourth side this inscription is engraved:

THE MUNICIPAL COUNCIL OF BRY

To LOUIS-JACQUES-MANDÉ DAGUERRE
Born at Cormeille-en-Parisis, November 18, 1787
Died at Bry, July 10, 1851

THIS GROUND IS DONATED GRATUITOUSLY
AND IN PERPETUITY
According to resolution of August 10, 1851." ([82])

But we were struck with astonishment when in the pompous discourse, full of exaggeration, pronounced by the general secretary of the *Société libre des Beaux-Arts* at the dedication of the monument, we read the following phrase:

" I have spoken only, gentlemen, of the great artist-inventor, I leave to the Biography which will be published by the Society the task of telling some of his private qualities. However, I cannot keep silent because they have spread everywhere, they are known to the whole world. I desire to mention the generosity, his unselfishness, virtues which at the same time proclaim the goodness of his heart, the grandeur of his soul and the neglect of his ego. His dealings with M. Niépce are a remarkable example of this. How many inventors would have so carefully guarded their discovery in order to reserve to themselves the glory and the profit?" ([83])

It is a real mockery to extol in such a pompous style the *generosity*, the *unselfishness, the grandeur of his soul*, the *forgetfulness of self* with which one endows Daguerre so liberally!

Those who have read attentively all that preceded this, know the brutal methods, the subterfuges employed by Daguerre for despoiling Nicéphore Niépce of the glory, acquired by more than twenty years of persevering and difficult researches, will deal justly and promptly with these eulogies and unmerited praises.

The rest of the discourse of the general secretary of the *Société libre des Beaux-Arts,* referring to Photography, is composed in the same pompous style and with the same exaggeration. But of course the orator must be excused, owing to his ignorance of the blameworthy and reprehensible conduct of Daguerre.

With the exception of a new street crossing the faubourg Saint-Come, on which there are only a few houses, the greater

part of which are of mean appearance, and which carries the name of Nicéphore Niépce, nothing at Chalon recalls the inventor of Photography. Excepting a few persons informed by us, the people of Chalon do not know where the house is situated in which our famous compatriot was born a century ago. On our solicitation, the present proprietor, Guichard-Potheret, promised us to affix to the wall of this house a plate commemorating the birth of Nicéphore Niépce.

Concerning the projected monument for which we have been waiting a dozen years, of which we have spoken in our preface, we have been assured that at a time, not yet fixed, it will be erected on one of the public places of Chalon. We sincerely hope that this time will not be too far distant.

In the meanwhile, the municipal administration of Chalon has brought together in show cases, at the Museum in our town, several objects which were used by Nicéphore Niépce in his heliographic experiments. These objects consist principally of several cameras of different sizes, more or less well constructed and of which we have informed the reader several times; of an intaglio printing press, which Nicéphore Niépce had bought secondhand with its accessories, and on which he printed his lithographic and heliographic proofs. The Museum also possesses retorts and other utensils used by Nicéphore in his compounds and chemical experiments, etchings covered with varnish, plates of pewter, glass and silvered (or plated) copper, etc., all of which we have spoken of elsewhere. ([84])

Among other relics of Nicéphore Niépce we have, written by his own hand, an *Introduction* to a work on *Heliography* and *Etching* which he intended to publish, and in which he explained with great lucidity the outline of his work. This introduction is not dated; but it was written after his return from England; because he mentions his dealings with several members of the *Royal Society of London;* there are three full quarto pages.

We also own several objects which belonged to our famous compatriot, particularly a heliographic print on paper, unfortunately almost effaced, dating back to 1816, this is, more than half a century, representing the *bird house* and the surrounding objects discussed in the letters of Nicéphore of May 5 and 28 and June 2 of that year. ([85])

We must also call attention to the country house at Gras, in which Nicéphore Niépce devoted himself for more than twenty years to his heliographic experiments and in which he suddenly died in 1833. Just as in that of the rue de l'Oratoire, nothing of this charming house reminds one of the inventor of Photography. Whatever still exists belongs to different persons. The family property of Niépce was acquired by Rocault. After the death of Claude and Nicéphore Niépce, the family was compelled to sell it with the meadows, the vineyards, farm and buildings, which surrounded it, as well as several parcels situated in the several parishes, in order to pay the debts contracted particularly to provide the considerable expenses of Claude Niépce for his machines, motors, the Pyreolophore, the hydraulic pumps and other mechanical inventions.

The residence at Gras, as well as the courts, gardens, grounds and buildings which comprise it, were bought by Briveaux, of Chalon. Seen from the street, which leads, along the highway running from Chalon to Lyons, to the railroad, the rear of this house presents a uniform appearance. But it is not the same on the side which looks out on the gardens. That part which comprised the property of the brothers Niépce, which is nearest to the highway, is higher and larger than that part which looks out on the former court and in which was the bird house and the other buildings of which we shall speak directly.

Briveaux, after he had bought this residence, divided it in three lots. The first lot comprised the living quarters, properly so called, and the gardens which extend along the highway, having been sold first to Mademoiselle Roy, sister of M. Roy-Combes, wholesale merchant at Chalon, were bought last by the present proprietor, Besson, son-in-law of Thiébaut of the commercial firm of Thiébaut and Brintet, of Chalon.

The other building, less important than the one just mentioned, constitutes the second lot, in which was included the court, the bird house, a portion of the garden, etc. After having lived there and having used it for several years, Briveaux sold it to Bon, the father, a grocer of Chalon. A wall and outbuildings were built in order to separate the two properties. This wall and the outhouse hide to a great extent the view of Bon's house; this gives to the house a disagreeable aspect; the weeds which overgrow the court, and the shutters, always closed, give it the ap-

pearance of an abandoned house. The gardens of the two prop-erties are separated by a wooden fence.

The third lot comprises farm buildings such as a barn, cow-shed, kennel, stable, etc. and a field which is enclosed by a hedge bordering on the railroad. This lot was bought from Briveaux by the present owner, Paillot-Dupuis. Paillot used a part of the buildings which face the railroad bed to build his house.

Bon has preserved the old large and small doors which give access to his house. But Besson has erected a beautiful iron grille leading to his yard, or better, to his gardens, which are designed and kept up with a great deal of taste and care and to which he adds every day many improvements.

It is this window of the garret or attic of Besson's house, facing the highway looking towards the inn, from which Nicé-phore made most of his trials and heliographic experiments. He also very often made them from one of the windows of what is now Bon's house, opposite the bird house, the bake house, the roof of the barn, etc., mentioned in the letters of May 5 and 28 and June 2, 1816. Aside from the *White-butter* pear tree, cut down lately, to make place for a flower bed, the orchard, the bird house, the barn, etc., so often described by Niépce in his letters, are still there.

In that part of the house which belongs to Bon, Nicéphore Niépce had established his chemical laboratory, as well as a machine shop in which there were made by the good *Langrois* both the apparatus conceived and described by Claude, or his own, of which he sometimes speaks in the course of his recital.

But if there remains no trace to remind one of the creator of Photography at the old residence of the Niépce family at Gras, we have some compensation for it—if it is a compensation at all, which personally we deny and we are not the only ones who think so: far from it—by a sort of monument recently erected at the extreme end of the field bordering on the right of way of the railroad line from Paris to Lyons, and which its author pompously qualifies by the name of *CIPPUS!*

This so-called monument is simply a large section of a wall, sixty centimeters thick, three meters high, and one meter sixty centimeters long; it is made up of three stones of the same size, unpolished, superimposed, one of which, set into the ground, projects three centimeters, engraved and bevelled, forming a

kind of pedestal; this is placed on the top and on its end is cut somewhat to a point and ornamented with an inscription to the memory of Nicéphore Niépce. The two other stones which are below this first one are completely bare.

From its flat shape and its sharp corners, this monument has not the slightest resemblance to a *Cippus* which is, as everybody knows, *a half-column without capital, and often without base.* Here is an exact copy of the inscription referred to, as well as the arrangement of the lines:

HOUSE WHERE
J. NICEPHre NIÉPCE
DISCOVERED
PHOTOGRAPHY
IN THE YEAR 1822

and then on a single line there is also this:

PROPTER VERITATEM ET POSTEROS INSCRIPSIT....
(Inscribed for truth and posterity....)

After this last word there is the title and name of the person who had engraved this sort of a sign; the name is followed by the date 1866, the date when this thing was erected. The whole is on a metal base painted in black, the letters are gilt.

Originally the author of the inscription had fixed the date of the *discovery* of Photography as the year 1829, in his ignorance of the facts concerning the heliographic work of Nicéphore Niépce. This author mistook the date of the act of Association *Niépce-Daguerre* for that of the *invention!* Desiring to exalt the name of Niépce, he took the place of the dangerous and ignorant friend of whom LaFontaine speaks, who, in showing thoughtless zeal, impetuously bruises your head with a paving stone! Perhaps it is not out of place to apply to this the word of the painter Apelles: *Ne sutor ultra crepidam!* (Cobbler stick to your last.)

However this may be, on Isidore Niépce's claim, who properly observed that this date of 1829 was one of the weapons used by the detractors of his father, who would hasten to use this against Nicéphore, 1829 was replaced by 1822—unfortunately this latter date, no more exact than the first, because before 1816, as we have seen, Niépce had already obtained fine prints of the images received in the camera obscura.

This kind of a monument has also other disadvantages. First of all, the speed of the trains on the railroad does not permit the traveller to read the inscription; one has hardly the time to note one word as one flies by. But, even supposing you could read the whole thing, the reader naturally keeps his eyes on the house which is in sight to which attention is drawn. But the house which one sees from the railroad was not the one in which Nicéphore Niépce resided. The buildings in sight are only the old *cowshed, stable* and *kennel* of Niépce's residence, which the present owner has adapted to his needs and in part of which he resides, as we have already said.

Those who come from the direction of Chalon and who know of the existence of the inscription mentioned are able to see perfectly the rear of the old Niépce house; but those who arrive from the direction of Lyons, whether they know of the inscription or not, will see only a part of this house, the rest of which is hidden by the trees until they are in plain sight of the old cowshed, stable, etc., transformed partly into a residence, with steep roofs and of a mean appearance.

The author of the monument which we have decried,—who calls himself a friend of Nicéphore Niépce: everybody is the friend of a famous man,—had an unfortunate inspiration when, on his own initiative, without consulting anyone, and what is more serious, without being authorized by the Imperial Government, he had the peculiar idea, or rather the strange fancy, to erect this anomalous monument, without legal sanction, at the risk of seeing it demolished by orders from above; and the inscription of which or rather the information,—which is two meters from the ground,—seems to look down from above on the roadbed which dominates all its height. The trains are incessantly passing on the rails.

The Mint in Paris had no happier thought when they struck, some months ago, a medal in honour of Photography.

This beautiful bronze medal, excellently engraved, is seventy-two millimeters in diameter. It bears on one side the profile of Emperor Napoleon III, without any other inscription than his name. In the center of the other side there is a figure of *Glory* or of *Fame, as you will,* surrounded by this legend: HOMINE DIRIGENTE SOL ARTIFEX (Sun, the master, directed by man) MDCCCXXXVIII 1866. (Sic!)

What was the object of the administration of the Mint in issuing this bronze? When they are asked this question, they invariably reply that it was for the purpose of commemorating the date of the invention of Photography. If this is the motive underlying the issue of the medal, the object is completely unattained, because the medal does not name anyone as the inventor of Photography; the date 1838 is also false, if it is meant to give that of the invention of this wonderful art. As a fact it does not apply to Nicéphore Niépce or to Daguerre, or to any other person who may be entitled to it.

A few more pages, devoted to the family Niépce, and we shall have completed the task which we have imposed upon ourselves.

FOURTH PART

· IV ·

The family Niépce, one of the oldest in Chalon-sur-Saône, belonged to the upper middle class of this town by its fortune, its place and position; they moved in the same circle as the aristocracy, to which they were often allied. At the end of the seventeenth century they were ennobled by an hereditary charge which then. conferred nobility. We are unable to reconstruct their genealogy before 1595, the date at which there was "the honourable" Jean Niépce, who lived at Saint-Desert at this period; the papers and documents of the family were burned during the difficult days during the Revolution of 1793, as we shall see later.

The above-mentioned Jean Niépce married *damoiselle* Jeanne Juillet, by which marriage he had two children:

1st) Charlotte Niépce, married to Pierre Burault;

2nd) Antoine Niépce, who was married to Christine Perrot; he died at his castle of Saint-Loup, about 1720; his fortune was large. Of his union with Christine Perrot, he had eleven children, among others the four following:

1st) Charles Niépce, who was the head of the branch Niépce of Tournus, extinct in 1814;

2nd) Claude Niépce, who was the head of the family Niépce of Saint-Ambreuil, also extinct;

3rd) Pierre Niépce, who was the head of Niépce of Senneceyle-Grand;

4th) Bernard Niépce, who was the youngest of the eleven children of Antoine, who was the head of the branch of Niépce of Chalon and of that of Niépce of Saint-Cyr. This Bernard Niépce is the same Bernard whom we saw buy on April 24, 1740 the house in the rue de l'Oratoire in which Nicéphore Niépce was born.

Three branches still exist today:

1st) The branch of Niépce de Chalon;
2nd) The branch of Niépce de Saint-Cyr;
3rd) The branch of Niépce de Sennecey-le-Grand.

We shall preserve this order and begin with

Branch of Niépce de Chalon

Having established above ([86]) the genealogy of this branch until the death of Claude and of Nicéphore Niépce, a few lines suffice to complete it.

From the union of Nicéphore with Madame Agnes-Reparade Romero ([87]) was born, as we have seen, M. Jacques-Marie-Joseph-Isidore Niépce. After his school days, M. Isidore Niépce entered the Gardes du Corps of Louis XVIII, Wagram Company, on June 16, 1814, he was discharged at Bethune with his company on March 25, 1815, after the return of Emperor Napoleon I. from Elba.

After the Hundred Days, on November 1, 1815, M. Isidore Niépce reentered the Gardes du Corps, Havré Company; he was in garrison sometimes at Versailles and sometimes at Paris. Dissatisfied with the military service, he asked for his discharge on March 29, 1821 and returned to the bosom of his family, which he never left after this.

Every year, during his service, he obtained a three months leave of absence which he passed usually at the country home of his father at Gras where he witnessed the heliographic work of Nicéphore. After he returned to private life and had established himself with his family, he became in a fashion his father's collaborator, or at least the earnest observer of most of his labours.

On January 22, 1825 he married Mademoiselle Barbe-Eugenie Gaucher de Champmartin, daughter of M. de Champmartin and of dame Marguerite Berzé de Pierreclos.

Four children were born to this marriage; only two survived:

1st. François-Alphonse Niépce, former sub-lieutenant in the second regiment of cuirassiers, at present a successful photographer at Paris; he is married and childless;

2nd. Eugene Niépce, former sub-officer in the seventh regiment of cuirrassiers; who at first, like his brother, devoted him-

self to photography but abandoned it in order to accept employment with a stockbroker in Paris.

These two young men had no other heritage than the famous name of their grandfather; for there was nothing left from their father's fortune than the annuity of four thousand francs which he received from the State.

After the loss of the family fortune, M. Isidore Niépce retired from the world; he established himself in a modest house at Givry-près-l'Orbize.

Branch of Niépce de Saint-Cyr.

This branch descends, the same as that of Chalon, from Bernard Niépce, youngest son of Antoine Niépce and of Christine Perrot. This Bernard is the same whom we have pointed out as having bought the house in the rue de l'Oratoire who had by his marriage with Anne Nodot a daughter married to Nicholas de Marcenay, Claude, father of Nicéphore, and another son, named Bernard like himself.

This third child, or rather the second son of Bernard, who, in order to distinguish himself from his father, signed himself Bernard cadet, was a Squire, paymaster in the wars at Chalon, a position which he had bought from his brother Claude, who had inherited it from his father, he being the elder. Bernard, cadet, received from his mother Anne Nodot, the property of Saint-Cyr, which her husband had left to her as tenant for life. Bernard married Claudine-Thérèse de Courteville, whom together with his godfather, the barrister, Joseph Betauld, we have seen holding Joseph Nicéphore Niépce over the baptismal font.

From this marriage were born several children, notably M. Laurent-Augustin Niépce, married to madame Elisabeth Pavin de Saint-Victor.

From this union was born at Saint-Cyr, on July 26, 1805, M. Abel Niépce de Saint-Victor.

His father, in order to distinguish himself from his brothers had added to his name that of his wife and naturally M. Abel signed himself: Niépce de Saint-Victor.

This explains that Abel Niépce de Saint-Victor is the second cousin of Nicéphore Niépce and not his nephew, as he undertook to qualify himself voluntarily. It is true that in Bourgogne, as well in other provinces of France, it is the custom as a mark

of deference and respect, to give the title of *uncle* to grand-cousins when aged; and this explains M. Niépce de Saint-Victor's relation to his famous relative.

However, M. Niépce de Saint-Victor has achieved by his own high intelligence and by his rare merit and his eminent talents, one of the first places in the scientific world.

M. Niépce de Saint-Victor devoted himself to the military service. He graduated in 1827 from the Cavalry School at Saumur with the grade of drill-sergeant-marshal. In 1842 he was admitted to the first regiment of dragoons with the grade of lieutenant.

From this time on, he occupied himself successfully with chemical experiments. We shall not follow him along the road which marked his admirable scientific works nor the wonderful improvements which he contributed to the invention of Nicé-phore Niépce; pens better trained than mine and more capable in these matters have ably performed this task long ago.

On April 13, 1845 M. Niépce de Saint-Victor entered the municipal guard of Paris with the rank of lieutenant; he was lodged in the barracks of faubourg Saint-Martin. The discipline, proper and at the same time severe, which reigned in this select corps and the fine conduct of the men who composed it, left the guardroom unused. With the permission of his chiefs, M. Niépce de Saint-Victor established in it a chemical laboratory, in which he devoted himself to his scientific researches.

During the Revolution of February 1848, a band of insur-gents invaded the barracks and burned them. M. Niépce de Saint-Victor lost everything, in one day, his furniture, his laboratory, the fruits of several years of difficult labour, the results of his scientific experiments. This loss, it is readily seen, was exceed-ingly painful to the diligent officer but did not discourage him and as soon as circumstances permitted he again devoted himself with great success to the works of his choice.

Appointed lieutenant in the regiment of the tenth dragoons in July 1848, he left Paris in order to join his regiment. On No-vember 11th of the same year, he was promoted to the rank of: captain. Six months later in April 1849 he returned to Paris, having been appointed with the same rank to the Republican Guard garrisoned in the rue Mouffetard. There he lost no time in transferring his room into a laboratory where he continued

his experiments.

On the following December 10, M. Niépce de Saint-Victor was appointed chevalier of the Legion of Honour for his scientific work which brought him besides a gold medal valued at two thousand francs from the Société d'Encouragement.

Promoted to chief of squadron on February 3, 1854, Napoleon III appointed him commandant of the Louvre on the 19th of the same month as a just recompense for his continued work and which permitted him to devote himself with more liberty to his experiments. In accepting this confidential post, M. Niépce de Saint-Victor had to renounce further advancement in the army and a considerable part of his emolument, owing to a recent decision of the Minister of War who ordered that the commandants of imperial residences could only enter upon functions if they had been placed on a non-active list.

The new functions of M. Niépce de Saint-Victor permitted him to occupy himself more with his exceptional leanings towards science to which he devoted himself during his creditable existence with the most complete self denial; although he had no other income than his emoluments, he never cared to draw profit from his numerous and admirable discoveries.

Branch of Niépce de Sennecey-le-Grand

Pierre Niépce, second son of Nicolas and Christine Perrot, is the head of this branch, he was a squire, King's counsellor, special comptroller for war, at Chalon. In the Summer, he resided at his estates at Sens and Sennecey; but in the winter he lived at Paris with his brother-in-law, M. Advenat, deputy governor of the Enfants de France. Pierre died at his residence Sennecey-le-Grand.

He married at first Laurence Dommartin, and later Marguerite Advenat. From this marriage sprang thirteen children, among others:

Anne-Valerienne Niépce, the eldest of this numerous line, who married on November 21, 1734, Claude Arnoux, squire and lord of Ronfand;

Marguerite Niépce, a member of the Benedictine order at Tournus;

Bernard Niépce, regular canon of the order of Saint-Antoine;

Marie-Anne Niépce, married to Pierre Benoist, a squire, controller for the wars, at Chalon;

And Laurent Niépce who follows.

This Laurent Niépce, born at Sennecey, April 26, 1723, was a squire, King's counsellor, ordinary controller for the wars, King's deputy and administrator for streams and forests; he succeeded his father in these positions.

Laurent Niépce lived at Chalon when the Revolution broke out and vacated his offices. Insulted and menaced by the fanatics of this period, he retired to his property at Sennecey; but he was no more secure there than in town: he soon had a sad experience.

One day a band from Marseille, marching to Paris, plunged through Sennecey, and noticed the weather cocks surrounded by fleur-de-lises, denoting the sign of a feudal seat, on the outbuildings of Niépce's estate, as well as the formal coat-of-arms sculptured above the principal entry gates. These emblems of feudalism incited the furor of this band; they overran the house and gave themselves over to all kinds of excesses. Laurent Niépce, insulted, menaced by these madmen, and frightened by their violence, threw all his documents and family papers into the fire. However, the violent band did not take their leave until they had turned the weather cocks upside down and broken by gunshot the coat-of-arms which had scandalized them so and until they had numerous and copious libations exacted under the form of requests. These vile scenes were the death knell of Laurent Niépce; he contracted a serious malady from which he never recovered; he died on July 13, 1793.

He had married Claudine Benoist, daughter of Etienne Benoist, a squire and controller of wars at Chalon. From this union were born:

Pierrette Niépce, married to Jean-Baptiste Prieur, receiver of salt tax at Seurre;

Marie-Anne Niépce, who married first Jacques de Vercy, and later François Ligeret, sub-prefect of Tonnerre;

Pierre Niépce, of whom we know nothing;

And Etienne-Laurent Niépce, who was procurator of the King as administrator for streams and forests at Chalon and later conservator in the same administration at Moulins.

He lived at Chalon where his life was threatened by the same people who had persecuted his father Laurent Niépce. In order to avoid being arrested as a suspect, he entered the lists of the national guard in one of the army corps which beseiged Lyons

and whose general staff headquarters were at Macon. He died at Sennecey-le-Grand, July 5, 1827.

Etienne-Pierre-Laurent Niépce married Therese Reynard de Bassieux and they had two children:

1st. David-François-Etienne-Pierre-Laurent Niépce, born at Chalon-sur-Saône, September 12, 1781;

2nd. Augustin-Laurent Niépce, also born at Chalon on January 15, 1784.

Although David-François was born before his brother Augustin-Laurent, we will relate first what concerns him so that we can devote ourselves after this to his elder brother and family.

M. Augustin-Laurent Niépce was the conservator of streams and forests at Macon, chevalier of the Legion of Honour; he died in this town on November 7, 1864; he was married to Louise de Guinet of Nevers; from this union were born:

M. Stephane Niépce, inspector of forests;

Madame Anaïs Niépce, married to M. Charles Pellorce, vice-president of the council prefecture at Macon, chevalier of the Legion of Honour, officer of the Academy;

Madame Laurence Niépce, who married M. Edouard Dombey, mayor of Pont-de-Veyle.

M. David-François-Etienne-Pierre-Laurent Niépce, elder son of Etienne-Pierre-Laurent,—and whom from now on we shall call by the title and name of Col. Niépce,—commenced his studies in the College of Chalon, directed by the Josephistes. When the Revolution removed in its vortex the religious orders, the Josephistes had to leave this College and the pupils were sent home to their parents. Then young Niépce was put in charge of a preceptor in order to complete his education.

But after he attained the age of seventeen, he gave up latin and greek and entered the ranks under the flag as a common volunteer soldier in the 19th regiment of the line on the 1st germinal, year VII (1798).

Endowed with well-tried courage, Col. Niépce conquered all the grades to the rank of officer, shedding his blood on the battlefield! And thus the plain volunteer of germinal 1, year VII, became sub-lieutenant in the 4th infantry on prairial 13, year VIII; transferred with the same grade to the 18th infantry on thermidor 4, year X, was nominated lieutenant in the same regiment, year XII; captain of the 6th hussars in thermidor of the

same year; then he became adjutant to the staff of the Prince de Neufchatel on June 17, 1806; after that, aide-de-camp to the lieutenant general Hedouville, November 30 of the same year.

In the following year, December 17, 1807, he entered the service of the King of Westphalia, under orders from Emperor Napoleon. Two and a half months later, on March 4, 1808, King Jerome Bonaparte appointed him officer of ordinance. On June 2nd following he was promoted to the rank of chief of squadron in the guard du corps (cuirassiers of the guard).

Appointed by the King, president of the Commisison instituted by the Minister of War, for the examination of cavalry officers who applied for admission to the service of the King, he organized the 2nd regiment of Westphalian cuirassiers.

Col. Niépce was in succession colonel of the guards on January 8, 1812; colonel of the 2nd hussars on March 12, 1813; commanding-colonel of the guardes du corps, from August 13th of the same year to April 17, 1814; and finally colonel of the 4th regiment of dragoons, November 9, 1814.

Under the Restoration, Col. Niépce was appointed by King Charles X, in the beginning of 1826, commandant of the Ile de Ré; and later, by King Louis Phillipe, on July 15, 1831 Mayor of Lyons. He retired on his application on January 7, 1834.

Col. Niépce achieved all his ranks in the Italian, Austrian, Prussian, Russian and French campaigns during which he received several wounds from gunfire, bayonets and sabres, in his head, left shoulder and thigh.

Let us quote some of his feats of arms.

On thermidor 18, year VIII, he was sent with fifty infantrymen in pursuit of some *Barbets* who infested the mountains at Genoa; he took a redoubt defended by two hundred men and captured two pieces of cannon from them.

On the same day, he saved the life of his captain, killing by a shot of his carabine and two bayonet thrusts, two *Barbets* and an Austrian who made him prisoner.

. Wounded on the same day, after having his sabre broken in his hands, sub-lieutenant Niépce was himself made prisoner, bound hand and foot, by a detachment of *Barbets*. Delivered after eight hours captivity from the midst of these brigands, forgetting his wounds, he returned to the battle and killed two enemies who refused to lay down their weapons.

Another time he swam across the torrent of the *Doria* under

the fire of the fort and made an assault on the garrison of the place. This action gained for him the grade of lieutenant.

Col. Niépce was appointed chevalier of the Legion of Honour at the time of the creation of the Order, having previously received an honorary sabre. He was made chevalier of the order of the crown of Bavaria after the Prussian campaign in 1807; chevalier, first class, of the order of the crown of Westphalia on February 5, 1810; chevalier of Saint-Louis, March 17, 1815; officer of the Legion of Honour, October 30, 1825, and commander of the same order, December 5, 1831; medal of Sainte-Helene.

After he had withdrawn to private life, Col. Niépce had several honorary titles bestowed upon him; thus since 1852 he is a member of the general council of Saône-et-Loire for the canton of Sennecey-le-Grand; member of the departmental council of primary education; cantonal delegate for public instruction; officer of public instruction; president of the departmental commission of meteorology.

When Col. Niépce was only a captain, he married at Augsburg, in Bavaria, on August 19, 1807, mademoiselle Marie-Anne-Josephine-Louise-Alexandrine, baroness of Zandt, born at Dusseldorf, January 11, 1788; daughter of Jean-Frederic, baron of Zandt, of Loche Wenchelhausen, field marshal general of the armies of the King of Bavaria and of the Palatinate, officer of the Legion of Honour;

And of madame Anne-Thérèse-Marie-Julie, baroness of Willinghof, de Schellemberg, canoness of Stokemberg and Klaremberg.

It was during a truce in the German war and while the French-Bavarian army occupied Ulm, after the surrender of this important place, that Capt. Niépce made the acquaintance of Gen. Zandt, and came to appreciate the rare merit and excellent qualities of the young baroness.

Gen. Zandt came from one of the most aristocratic families of the Palatinate. One of the members of this family, Goetz von Berlichingen, was the hero of one of Schiller's finest tragedies.

From his union with the baroness of Willinghof, Gen. Zandt had five children, two sons and three daughters. The elder of the sons became lieutenant-general, grand-cross of several military orders; the second son, also a general, was commandant of the

royal guard of Bavaria. The eldest of the Misses Zandt became canoness of the aristocratic chapter of Wittemarchen; the second was canoness of the noble chapter of Munich; and the third married, as we have seen, Col. Niépce, who was then only a captain. Mme. Niépce's father, Gen. Zandt, was killed in April 1809, before Landshut, by the Austrians, who defended the bridge.

Eight children were born to the marriage of Col. Niépce with Baroness Zandt of whom four only are living:

1st. M. Etienne-Pierre-Laurent-Ferdinand Niépce, born at Cassel (Westphalia) November 27, 1809, who, like his father, followed a military career, having entered the military school of Saint-Cyr, November 12, 1828, he was appointed sub-lieutenant in the 1st regiment of the light infantry on October 1st, 1830.

Lieutenant in the same corps on February 11, 1835;—transferred with the same grade to the 7th battalion of infantry on October 24, 1840;—captain in the same corps January 17, 1841; —captain-adjutant-major in the 2nd battalion of infantry, August 18, 1842;—chief of battalion, 32nd regiment of infantry of the line on April 30, 1853;—transferred with the same grade to the command of the 11th battalion of infantry, December 25th of the same year;—lieutenant-colonel of the 63rd regiment of the line, August 12, 1857;—appointed mayor of Saint-Omer, April 1864.

Lt. Col. Niépce took part in the Italian campaign from 1849 to 1851; the African campaign from 1851 to 1853 (expedition into Eastern Kabylia,—expedition of Collo,—expedition against the insurgents of Bone); from 1856 to 1857 (expedition to Great Kabylia); from 1862 to 1864 (expedition against the Tunisian tribes).

Appointed chevalier of the Legion of Honour on August 18, 1849, for having distinguished himself in the attack on Rome;— chevalier of the order of Pius IX, second class, March 21, 1851; officer of the Legion of Honour, March 21, 1863.

2nd. M. Maximilien-François-Louis-Etienne Niépce, also born at Cassel, June 22, 1812, just as his father and elder brother, he followed a military career.

Admitted to the military school at Saint-Cyr on December 2, 1830;—sub-lieutenant in the 5th regiment of the line, October 1, 1832;—lieutenant on April 6, 1840;—captain on January 26,

1845;—captain of grenadiers, June 29, 1847;—captain-adjutant-major, May 13, 1850;—battalion chief in the 2nd regiment of the Zouaves, December 26, 1853; battalion chief of the 85th regiment of the line, December 16, 1856;—lieutenant-colonel of the 67th regiment of the line, November 6, 1858;—retired on his request January 10, 1863, chevalier of the Legion of Honour, December 28, 1858.

Lt.-Col. Maximilien Niépce participated in the African campaigns from 1845 to 1850, and from 1854 to 1856; he was cited in the order of the day by Gen. Pelissier, for his splendid conduct in the expedition against the Arabs in 1849 and on account of this was also promoted to the rank of battalion chief.

3rd. M. Leopold-Antoine-Joseph-Etienne Niépce, born like the two predecessors at Cassel, December 3, 1813.

Destined for the judiciary, the education of M. Leopold Niépce naturally followed this line of study. Having become advocate on November 23, 1839, he was appointed auxiliary justice to the tribunal of the first instance at Chalon, on March 23, 1842;—substitute procurator of the republic, at Draguignan, August 1, 1851;—procurator of the republic at Brignoles on June 21, 1852; —imperial procurator at Tarascon, October 28, 1854;—to the same functions at the bench of Rennes, July 18, 1860:—chevalier of the Legion of Honour, August 15, 1866.

Blood will tell. Son and brother of valiant military men, M. Leopold Niépce had proved that courage and devotion are also the qualities of a judge as well as that of a military man. But, as far as this is concerned, the following documents speak more eloquently than we can.

"M. the imperial procurator, the Government of the Emperor has learned with great appreciation the generous conduct which you have shown during the duration of the cholera epidemic in your home town at Brignoles, and I am happy to thank you in his name. Receive. etc. the Minister of public works, etc."

"Extract from the verbal proceedings of the deliberations of the Municipal Council of Tarascon, June 6, 1856. The mayor speaks: In the midst of the terrible conditions through which we passed and the cruel happenings of a disastrous flood, all of us can testify to the zeal and indefatigable activity of M. Leopold Niépce, imperial procurator of our town tribunal.

"The abnegation and devotion of this magistrate was shown in

every instance. He never ceased from the first instant of our disasters to run his boat from the inundated streets and territory, distribute bread, organizing measures for safety and carrying help and words of consolation into the country.

"The government in its solicitude will hasten, gentlemen, to publish the meritorious actions and to pay him for his acts of devotion.

"As far as we are concerned, we cannot fail, at the risk of being ungrateful, to testify from now on our appreciation to M. Niépce and this must precede your desires to propose a vote of thanks to him.

"The Council, M. the Mayor, in his recital, unanimously expresses by a vote of thanks, its sentiments of appreciation and gratitude to M. Niépce, imperial procurator, for the zeal, abnegation and indefatigable devotion which he has shown during the inundation."

The Minister of Justice, on his part, wrote the following letter to M. Leopold Niépce, June 20, 1856:

"M. the Imperial Procurator: I am informed by the Procurator General of Aix of the devotion and courage of which you have given proofs during the days of May 1st and June 1, 2, 3, 4 and 5th, either in alleviating the overflow of the Rhone at Tarascon, or by rescuing the unfortunate inhabitants in peril, after it was necessary to give up the battle against the flood.

"I am happy to be able to join in my expression of the public appreciation which you have so deservedly merited my personal congratulations for your noble conduct under these disastrous conditions. Receive, etc., The Minister of Justice.

"ABATUCCI"

Let us complete this testimony of appreciation so honourable to him who was the object of it by the speech of the first president of the court of Rennes in presenting to M. Leopold Niépce the cross of the Legion of Honour on November 4, 1866, before a solemn audience gathered at the court.

". . . Referring to you, M. the Imperial Procurator, it is at the courtesy of your present chief that your old chief has the honour to present you with the decoration.

"You have merited it by the firm and sagacious practice of all your judiciary duties,—but it was also due you as well for your

devotion and zeal which were proven during the inundation and the epidemics which have flooded the south of France.

"The recompense for these acts which I do not qualify because I do not want to hurt your modesty and of which with rare discretion you have kept me ignorant while I was at the head of the board, we must wait . . ."

While living in Chalon, M. Leopold Niépce was a member of the local committee of primary education (May 17, 1844) ;—of the consulting committee of boroughs (December 4, 1844) ;— President of the Historical and Archaeological Society of Chalon, of which he was one of the most fervent founders;—correspondant of the Society d'Emulation du Jura (June 30, 1846) ; of the French Society for the Conservation of Historical Monuments (August 20, 1846) ;—of the Institute of French Provinces (October 24, 1846) ;—Correspondant of the Historical Committees of the department of public instruction (1849).

We owe to M. Leopold Niépce: 1st) a Report of the work of the Historical and Archeological Society of Chalon; 2nd) Researches of the old and modern fortifications of Chalon; 3rd) Note on the old City Hall of Chalon; 4th) Researches on the privileges and franchises of Chalon; 5th) History of the town of Tarasconsur-Rhone; 6th) Parliament of Brittany; 7th) History of Sennecey-le-Grand and its proprietors; 8th) History of the canton of Sennecey-le-Grand and its seigniorial houses.

4th. M. Bernard-Etienne Niépce, born at Moulins, May 11, 1815, is a physician and, the same as his elders, he knew how to achieve by his own merit an honourable position in the world; at twenty-five years of age he received his degree of doctor of medicine from the Faculty of Paris on May 25, 1840. Dr. Niépce was appointed on May 20, 1848 medical inspector at the Thermal Springs at Allevard. He is a member of the Medical Society of Lyons (May 4, 1850) ;—of the Statistical Society of Isère (December 10, 1850) ;—of the Society for vaccination in France (March 25, 1851) ;—received the prize Monthyor of the Académie des Sciences: Institut de France (December 17, 1852) ;—the prize of the Imperial Academy of Medicine (November 10, 1853) ;—the gold medal of the Medico-Psychological Society of Paris (January 25, 1858) ;—member of the Society of Sciences of the Alpes-Maritimes (February 12, 1865) ;—and another prize of the Imperial Academy of Medicine (December 11, 1866).

Chevalier of the order of Saint-Gregoire-le-Grand, July 20, 1853; chevalier of the Legion of Honour September 29, 1860.

Dr. Niépce wrote and published: Treatise on goiter and cretinism, which brought him a prize from the Institut;—Treatise on chronic diseases, for which he was awarded a prize by the Imperial Academy of Medicine; Researches on the diseases of the larynx, for which he was awarded a prize by the same academy; —Treatise on the sulphurous springs of Allevard.

The family of Col. Niépce religiously preserves the souvenirs showing the marks of interest and graciousness which the Emperor Napoleon I has shown to several of its members.

We have seen that Madame Pierrette Niépce, daughter of Laurent Niépce, had married Jean-Baptiste Prieur, receiver of salt taxes at Seurre. The riot caused by the high price of bread, suddenly broke out in this town; artillery was sent from Auxonne in order to establish order. Among the officers commanding, there was the young lieutenant Bonaparte, who was received like his comrades, under the hospitable roof of M. Prieur. Madame Prieur, a superior woman of rare merit, did the honours of the house with as much grace as distinction. Young Bonaparte, who distinguished himself by his reserved demeanor and his affectionate character, received from his hosts a particularly kind reception for which he preserved the most vivid gratitude for the rest of his life, which he showed to the family Niépce particularly under three circumstances which became for them memorable events.

Madame Prieur having lost her husband, retired then to the house of her aged and venerable mother at Sennecey. General Bonaparte, returning from Egypt, learned in passing through Sennecey that Madame Prieur lived in this borough. Accompanied by Vincent Denon, he directed his steps to the house of this lady, where he received the most welcome reception. The general and his companion accepted an invitation to dine which was extended to them with the greatest of cordiality. Among other objects of art which ornamented the salon, the visitors of Madame Prieur admired reduced copies from several works of the celebrated painter Lebrun, representing the battles of Alexander, which the great-great-grandfather of Col. Niépce, Pierre Niépce, a very distinguished amateur in the fine arts, had copied by a clever painter under the direction of Lebrun himself. These copies even today adorn the salon of Col. Niépce.

In 1805, Emperor Napoleon, accompanied by Empress Joseph-
ine, traveled to Milan where he was to be invested with the iron
crown of the Kings of Lombardy; after remaining twenty-four
hours at Chalon, their majesties arrived at Sennecey April 7th
and, just as he had done on his return from Egypt, Napoleon
visited Madame Prieur; he offered to attach this lady to the house-
hold of his mother, Madame Laetitia Bonaparte: which she de-
clined. The Emperor kindly inquired about Madame Prieur's
nephew, the future Col. Niépce, at that time captain of the 6th
hussars.

On his return from the Island of Elba in 1815, Emperor Na-
poleon, on his passage through Sennecey, notwithstanding his
grave preoccupations, desired once more to see Madame Prieur;
he again insisted that she would accept a high position at the
court; but again she declined, owing to her advanced age, and on
account of her modesty and, above all, her independent and self-
sacrificing character. Death suddenly disrupted, several months
before, Col. Niépce and his family. Madame Niépce, née Baron-
ess de Zandt, died at Sennecey-le-Grand, July 7, 1866. The
entire population of the borough, as well as that of the surround-
ing towns, followed with profound reverence her funeral; the
grief of those•present and the tears shed by most of them, testi-
fied eloquently to the great regard felt by them for the dignified
wife of the colonel, for this saintly lady, whose entire life was
given over to the relief of the unfortunate, for her sympathy
and incessant devotion to all those who suffered, while all the time
raising with tenderness and distinction her own numerous family.

Col. Niépce, owing to the greatness of his tastes, belongs to that
indefatigable class of investigators and artists, endowed as he is
with a taste for the beautiful, with a rare aptitude for the arts,
with an unlimited perseverance; no obstacle prevents him, not
even his eighty-six years!

Nothing is more admirable or more wonderful than the objects
in ivory, in alabaster, in boxwood, in copper, which he has con-
ceived, constructed and sculptured; nothing can equal the fineness,
the delicacy of the arabesque of the garlands of flowers of an
infinite variety of ornaments from the chisel or engraving tool of
the colonel.

We admit our inability to describe the Gothic and Chinese
temples, populated by figures and Lilliputian animals, the vases,

urns, amphorae, the columns of the different types of architecture, the clocks with figures, the pictures worked in leather, constructed and sculptured by Col. Niépce which ornament his salon and in which in addition to numerous specimens of paintings there is one precious glass case enclosing the relics which belonged or were used by Napoleon I. Col. Niépce's house is a veritable museum. In it there is a great glass showcase in which are grouped artistically the different arms, insignia and decorations of the colonel. On each side of this case there are trophies or more groups of Arabic arms and utensils acquired and brought from Africa by the two lieutenant colonels, Laurent and Maximilien Niépce. Facing this group of arms and among other objects of art, there is another glass case enclosing the results of the archaeological researches of M. Leopold Niépce; then there are cases containing the medals, pieces of money, gilt and silvered by Col. Niépce, by the galvanoplastic process. Another piece is filled on all sides with large glass cases in which are classified a magnificent collection of birds, mostly from Africa, the result of hunting expeditions of MM. Laurent and Maximilien Niépce, brought over and stuffed by them; for these gentlemen are clever ornithologists as well as sculptors and very distinguished archaeologists. The greatest part of the house is occupied by studios, by relief maps of theatres of war, public edifices, famous houses, as well as the horrible house Bancal at Rhodez constructed on the spot by Col. Niépce. It would require a volume to enumerate and describe all the marvelous things constructed, sculptured and treated by MM. Niépce, father and sons, and with which their residence is filled.

Col. Niépce's physical appearance seems to be hewn from a block of granite; and notwithstanding his eighty-six years, he has all the knowledge, figure and intelligence of a virile man; and it can only be hoped that long years are reserved for him, venerated as he is by his family and many friends.

FINIS

Chalon-sur-Saône, Sordat-Montalan, Printers.

NOTES

1. Before the last revision of numbers, this house was numbered One in the rue de l'Oratoire.
2. It is to Pierre d'Hoges that the people of Chalon owe the establishment in their town of the first printshop which he started there.
3. M. Barrault, maternal grandfather of Nicéphore Niépce was an advocate and King's Councilor. Besides his eldest daughter, married to Claude Niépce, he had two other daughters, one of whom married M. Dubard de Ternant of Dijon. They had three sons, the first M. Dubard de Ternant, having the same name as his father, was a Captain of Engineers during the Empire and Colonel under the Restoration; the second, M. Dubard de Chazant, Captain of Artillery, later Commander of Fort Griffon at Besançon, who married a Mlle. Brachet of Dijon; the third, M. Dubard de Curley, who married Mlle. d'Anthès. All these people are cousins of different degrees of the branch of the Niépce family at Chalon.

M. Barrault was very well-known as a lover of arts and possessed a very fine collection of paintings. One of his contemporaries and fellow-citizens was a small manufacturer of nails by the name of M. Boichot, who lived in the rue des Cloutiers. This M. Boichot had a son who, like his father, made nails in his forge, and covered the shutters of his father's shop by drawing figures on them with chalk. M. Barrault, having seen these drawings, recognized a great talent for art in this boy and urged the nailmaker to have his son take lessons, but father Boichot refused. Whereupon M. Barrault had the boy taught drawing at his own expense, and young Boichot became the famous artist to whom is due the beautiful group of angels, sculptured in one piece, which ornaments the sanctuary of the Church at Saint-Marcel-lès-Chalon.

M. Jules Guillemin, secretary of the Société d'histoire d'archéologie at Chalon, who made a study of Boichot, has assured us that, in the documents concerning the family of the celebrated artist, his father is described under the title of a cutler; the street in which he lived was mostly inhabited by nail merchants and it is their profession which has given the street its name which it still bears today.
4. This church was destroyed by fire during the night of June 18, 1839.
5. The Oratorians established themselves at Chalon in 1624. Their house, in which Jean de Maupou, archbishop of this town, founded his seminary in 1675, is used today as barracks for the Gendarmerie.
6. Extract from the civil registry of the town of Nice. Agnès was not the only name of Madame Niépce; she was also called Antoinette-Marie-Catherine-Réparade.
7. Extract from the register deposited in the archives of the city of Nice.
8. *Sciences physiques,* 1st half, 1807, p. 146.

9. *Lycopodium,* is a cryptogamous plant, of the moss family. The pods are abundantly filled with pollen which burns like resin. They are highly inflammable.

10. This society was founded September 1, 1805 under the title of *"Société d'Encouragement".* It was recognized by royal ordinance, July 11, 1829. Its motto is *"Discimus, non docemus."*

11. *Isatis tinctoria* is known under the common name of *Pastel, Guéde, Vouéde,* and belongs to the family of Crucifer, a straight, smooth stalk, branching out towards the top, it grows about a meter high, its leaves are lance-shape, full, one above the other; the flowers are yellow, small, and arranged in clusters or in bunches. *Pastel* grows annually or bi-annually, according to the species. It gives a strong blue starch which is a substitute for indigo and is used especially for the dyeing of wool.

12. This subsidy consisted of five, or four, or three francs per kilogram, according to the quality of the product but no one was entitled to or received the bonus unless he had produced at least fifty kilograms of the blue starch per year.

13. A species of gourd which bears an edible fruit and from which some kind of starch can be extracted.

14. Born at Prague in 1771, son of an actor. At first he studied law, became a comedian like his father, and a very mediocre dramatic author; finally, after numerous and fruitless attempts, he devoted himself to the lithographic art, of which he was the inventor. He died at Munich in 1834.

15. Born at Brives-la-Gaillarde November 4, 1759, died in 1849. He was one of the most distinguished agriculturists of France, and son-in-law of General La Fayette.

16. This letter, as all those which Nicéphore wrote to Claude during the latter's stay in Paris, bears this address: "To Monsieur Niépce Sr., in care of M. Barrat, formerly Hotel de Boulogne, rue du Bacq. (sic), No. 42, faubourg Saint-Germain, Paris." We are obliged to state here that *all the extracts* which we have used either in the voluminous *unpublished correspondence* or the other *documents* which we were entrusted with, have been *copied rigorously* and *literally;* that the words which are *underlined,* we shall also *underline;* and that we shall do the same with those that are reproduced in their entirety.

17. This box contained a lithographic stone from the quarries of Chagny, which Nicéphore had sent gratuitously as a sample to the *Société d'Encouragement pour l'Industrie nationale,* after having it polished by a marble-cutter.

18. Letter from Nicèphore to his brother Claude, October 8, 1816.

19. A hamlet situated eight kilometers (5 miles) south of Chalon, on the imperial road to Lyons, and part of the borough of Saint-Loup-de-Varennes.

20. One of these camera obscura is deposited in the Museum of Chalon-sur-Saône.

21. Abbé J. Antoine Nollet, physicist, member of the Académie des Sciences, born at Pimpré, Picardie in 1700, died in 1770. He devoted himself particularly to electricity; his great talent for teaching and prac-

ticing the physical sciences contributed greatly to making him popular. His principal work was entitled: *Leçons de physique expérimentale,* 6 volumes, duodecimo, published in 1743.

22. At this time Saint-Loup had a population of only about 350 inhabitants.

23. Martin Heinrich Klaproth, born at Berlin, December 1, 1743, died at the same city January 1, 1817. Celebrated chemist and mineralogist, professor of chemistry, member of the Academy of Sciences of Berlin; he was counted among the most distinguished scientists of the century owing to his numerous discoveries in mineralogy, notably *Titane* or *Titanium,* a yellowish red metal, one of the most unfusible; *Urane* or *Uranium,* a metal, one of the chemical elements, discovered in 1789. *Tellurium,* a solid metal, bluish-white, and very brilliant, discovered in 1797. We owe to Klaproth several works on chemistry and mineralogy, among them the *Dictionary of Chemistry,* in collaboration with Wolf, translated into French by Vogel and Bouillon-Lagrange, published in 1810 in four volumes, octavo.

24. Wilhelm August Lampadius, one of the most distinguished and most famous German chemists, was born at Stehlen, duchy of Brunswick, in August 1772; Professor of chemistry at Freiberg from 1794; he is the author of a large number of famous works, disseminated among the German scientific journals.

25. We have seen from *note* 3 above that Colonel Ternant was a maternal relative of Claude and Nicéphore Niépce.

26. Letter from Nicéphore to Claude, July 11, 1817, cited before.

27. These letters of Claude all carry the postmark of Hammersmith, an English town, County of Middlesex, on the Thames, six kilometers (3¾ miles) west of London. Population: 10,000; a fine suspension bridge; there is an old convent and the palace of Brandenburg House, which became the property of the Margravine of Anspach in 1792, and later of Queen Caroline of Brunswick, wife of George IV, King of England, and who died there on August 7, 1821.

28. He refers here to the renewal of loans, more or less considerable, contracted mostly to meet the excessive expenses of Claude, necessitated by his mechanical work. Most of the letters of the two brothers make mention of these loans and of the embarrassment which they caused Nicéphore in renewing them when they became due.

29. See page 25 and the following pages.

30. This good Langrois was a mechanic who had the confidence of the brothers Niépce. Ignorant of the value and proper significance of certain terms which he readily employed, he parodied the word *inertie* (inertia) with *ineptie* (ineptitude), without disturbing himself whether he used the word in its proper place or not.

31. This refers to contracting a new loan of *Five thousand francs* from MM. Coste, to be used for improvements on the *Pyreolophore.*

32. The Meniscus prism is an optical instrument consisting of a concave glass on one side and a convex one on the other, which serves to disperse the light.

33. *Etude sur la Vie et les Travaux scientifiques de Charles Chevalier, Ingénieur-Opticien.* (Study on the life and scientific works of Charles

Chevalier, optical-engineer) by Arthur Chevalier, his son. 1 vol. grand octavo, Paris 1862, pp. 18 and 19.

34. *Idem*, p. 142.

35. *Idem*, p. 143.

36. *Idem*, p. 144.

37. J. Conrad Dippel, German theologian and chemist, born in 1673, died in 1754. Although a Protestant, he wrote against his coreligionists, and made many enemies. He abandoned theology, and devoted himself to medicine and chemistry. He discovered the animal oil which bears his name, and Prussian blue.

38. This letter, as well as other letters from Lemaître and Nicéphore Niépce, which we shall reproduce either in their entirety or only in part, were published by the journal *La Lumiére,* in Nos. 1 to 6, and 8 (from February 9 to March 30, 1851).

39. Champmartin was the father-in-law of Isidore Niépce, son of Nicéphore.

40. In expressing himself thus, Nicéphore is not in accord with Charles Chevalier. Charles Chevalier, in his *Souvenirs historiques,* affirms with great satisfaction that it was he who put Daguerre in contact with Niépce; he uses the same language in the letter that he wrote to the widow Daguerre; Arthur Chevalier says the same thing in his *Etude* on his father: this is exaggerated. This *putting* (mise) them in contact consisted only, as far as Charles Chevalier is concerned, in his imparting (remise) to Daguerre, Nicéphore Niépce's address; this is evident, for more than a year after this "imparting" (remise) Niépce wrote to Lemaître that he *was not quite sure how* Daguerre *knew of the object of his researches . . .*

41. An instrument which serves to enlarge objects; it is used to observe *opaque* matter that cannot be seen through the *microscope.*

42. Historique de la Découverte improprement nommée Daguerréotype. Preceded by a notice on the real inventor, the late M. Joseph-Nicéphore Niépce, of Chalon-sur-Saône, by his son, Isidore Niépce, Paris, Astier, August 1841, octavo, p. 21.

43. Sée page 63.

44. Kew-Green is an English village in the County of Surrey; it is situated on the Thames, about ten kilometers (6¼ miles) west of London. There are a beautiful royal residence and a magnificent botanical garden at Kew.

45. "I believe I may be allowed to give this name to the object of my researches, until a more exact term may be found." (Note by Nicéphore Niépce).

46. An optical glass of which one surface is plane or concave, and the other convex. The camera obscura perfected by Wollaston is equipped with *Periscopic* lenses.

47. Arthur Chevalier. Etude sur Charles Chevalier, etc., p. 20.

48. *Achromatic Lenses* permit the images of coloured objects to be seen exactly as the objects themselves, without interference of unrelated colours.

49. *Biconvex*: A lens with two convex surfaces opposed, that is, spherically curved.

50. In addition to this printed text, we reproduce this Contract of Partnership, practically as it is in four folio pages, by the *Photographic* process, in order that it may be included in this volume, and to thoroughly convince the incredulous that this document is not a *Myth,* as several writers aver, but that it is an authentic document really existing. (The photographic reproduction is omitted in this translation. T.N.)

51. As in the case of the *Preliminary Agreement* of December 14, 1829, we reproduce separately—*by the Photographic process*—and in addition to the text printed above, the last page of this *Notice sur l'Héliographie,* because of the receipt given by Daguerre to Niépce at the foot of this page, so that the reader will be fully convinced that Daguerre had in his possession the principles of the heliographic processes of Nicéphore, in accordance with article *three* of the aforesaid *Agreement* of December 14, 1829. (The photographic reproduction is omitted in this translation. T.N.)

52. We intended at first to give here the copy of these four pages of Nicéphore's expenses; but, on reflection, we feared that we would bore the reader with the details of his household expenses. We merely add: the items they represent for nearly nine months amount to the modest sum of *eleven hundred sixty-eight livres eleven sols.* (Less than $240.)

53. See on pp. 62 and 63 for the extensive quotations which we have made from the book by Arthur Chevalier.

54. See this interesting letter pp. 74 and 75.

55. Daguerre. Historique et description des procédés du Daguerréotype, etc., Paris, 1839, p. 37.

56. Isidore Niépce, Historique de la Découverte improprement nommée Daguerréotype, etc., pp. 26, 27.

57. Charles Chevalier. Notice sur l'Usage des Chambres obscures et des Chambres claires, Paris, 1829.

58. Isidore Niépce, Historique de la Découverte, etc., pp. 39, 40, 41.

59. *Idem,* pp. 22, 45.

60. Arthur Chevalier, Etude sur Charles Chevalier, etc., pp. 145, 146.

61. Isidore Niépce, Historique de la Découverte, etc., pp. 49, 50.

62. *Idem,* pp. 50, 51.

63. *Idem,* p. 51.

64. *Idem,* pp. 51, 52, 54, 55, 56.

65. M. Clerc writes to the translator: "There is evidently no relation between the dissolution of not lighted bitumen and the 'development' (in its actual sense) of a *latent* image on silver iodide!" T.N.

66. Louis Figuier. Exposition et Histoire des principales Découvertes scientifiques modernes, 1st edition, vol. 1, p. 15.

67. M. Clerc writes: "In Niépce's process, silvered plates acted only as a support, and in Daguerre's process the silver was a constituent of the sensitive substance!" T.N.

68. *Iodine* is a substance found in the saline mother-liquor, combined with potassium; iodine is bluish grey and of metallic brilliance, volatile at a slightly raised temperature, when heated, gives off a violet vapor. Iodine was discovered, in 1811, by a manufacturer of saltpeter named Courtois; held a secret until the end of 1813; the chemists Clément and Désormes made its various properties known to the Institute the follow-

ing year. Gay-Lussac published a very remarkable memoir on this substance. Doctors Coindet of Geneva and Lugol of Paris were the first to use iodine as a therapeutic medium.

69. Isidore Niépce, Historique de la Découverte, etc. pp. 58, 59.

70. *Idem*, p. 57.

71. *Idem*, p. 56.

72. M. Clerc writes: "A facsimile of a prospectus for this subscription has been recently (1935) published in the *Bulletin de la Société Française de Photographie* by M. Cromer. T.N.

73. We stated on page 82 that Nicéphore left England during January 1828; that Claude died on February 10th following and was buried the next day, the 11th, by the curate of Saint-Anne's parish; we own the certificate of burial signed by this ecclesiastic, dated February 11, 1828.

74. This letter is an extract from the pamphlet by Isidore Niépce, entitled *Historique de la Découverte improprement nommée Daguerréotype*, pp. 61 to 67; it was also published in the journal *La Lumière*, February 9, 1851.

75. Arthur Chevalier, Etude sur Charles Chevalier, etc., p. 146.

76. This pamphlet which we have already quoted, contains seventy-six pages, printed in brevier; it is entitled: *Historique et Description des Procédés du Daguerreotype et du Diorama, par Daguerre, etc.*, octavo, Paris, 1839.

77. Daguerre, Historique et Description, etc., p. 51.

78. See page 108.

79. Daguerre, Historique et Description, etc., p. 51.

80. *Idem*, p. 57.

81. *Idem*, p. 69.

82. Arthur Chevalier, Etude sur Charles Chevalier, etc., p. 159.

83. *Idem*, pp. 156, 157.

84. Concerning the heliographic relics of Nicéphore Niépce, a trustworthy person informed us recently that it was intended to engrave more deeply, than it is, the design on the pewter plate representing *Christ carrying His Cross*, of which we spoke on page 60, and to pull proofs from it. One can imagine how such an announcement has shocked us. Is it necessary to say that such an action would be a monstrous profanation! We hope that this will not happen, and that this precious plate will be respected.

85. See these interesting letters, pp. 30 and ff.

86. pp. 7 and ff.

87. Madame Antoinette-Marie - Catherine - Agnés - Réparade Roméro widow of Nicéphore Niépce, died at Chalon, July 26, 1855.

THE LITERATURE OF PHOTOGRAPHY
AN ARNO PRESS COLLECTION

Anderson, A. J. **The Artistic Side of Photography in Theory and Practice.** London, 1910

Anderson, Paul L. **The Fine Art of Photography.** Philadelphia and London, 1919

Beck, Otto Walter. **Art Principles in Portrait Photography.** New York, 1907

Bingham, Robert J. **Photogenic Manipulation.** Part I, 9th edition; Part II, 5th edition. London, 1852

Bisbee, A. **The History and Practice of Daguerreotype.** Dayton, Ohio, 1853

Boord, W. Arthur, editor. **Sun Artists** (Original Series). Nos. I-VIII. London, 1891

Burbank, W. H. **Photographic Printing Methods.** 3rd edition. New York, 1891

Burgess, N. G. **The Photograph Manual.** 8th edition. New York, 1863

Coates, James. **Photographing the Invisible.** Chicago and London, 1911

The Collodion Process and the Ferrotype: Three Accounts, 1854-1872. New York, 1973

Croucher, J. H. and Gustave Le Gray. **Plain Directions for Obtaining Photographic Pictures.** Parts I, II, & III. Philadelphia, 1853

The Daguerreotype Process: Three Treatises, 1840-1849. New York, 1973

Delamotte, Philip H. **The Practice of Photography.** 2nd edition. London, 1855

Draper, John William. **Scientific Memoirs.** London, 1878

Emerson, Peter Henry. **Naturalistic Photography for Students of the Art.** 1st edition. London, 1889

*Emerson, Peter Henry. **Naturalistic Photography for Students of the Art.** 3rd edition. *Including* The Death of Naturalistic Photography, London, 1891. New York, 1899

Fenton, Roger. **Roger Fenton, Photographer of the Crimean War.** With an Essay on his Life and Work by Helmut and Alison Gernsheim. London, 1954

Fouque, Victor. **The Truth Concerning the Invention of Photography:** Nicéphore Niépce—His Life, Letters and Works. Translated by Edward Epstean from the original French edition, Paris, 1867. New York, 1935

Fraprie, Frank R. and Walter E. Woodbury. **Photographic Amusements Including Tricks and Unusual or Novel Effects Obtainable with the Camera.** 10th edition. Boston, 1931

Gillies, John Wallace. **Principles of Pictorial Photography.** New York, 1923

Gower, H. D., L. Stanley Jast, & W. W. Topley. **The Camera As Historian.** London, 1916

Guest, Antony. **Art and the Camera.** London, 1907

Harrison, W. Jerome. **A History of Photography Written As a Practical Guide and an Introduction to Its Latest Developments.** New York, 1887

Hartmann, Sadakichi (Sidney Allan). **Composition in Portraiture.** New York, 1909

Hartmann, Sadakichi (Sidney Allan). **Landscape and Figure Composition.** New York, 1910

Hepworth, T. C. **Evening Work for Amateur Photographers.** London, 1890

*Hicks, Wilson. **Words and Pictures.** New York, 1952

Hill, Levi L. and W. McCartey, Jr. **A Treatise on Daguerreotype.** Parts I, II, III, & IV. Lexington, N.Y., 1850

Humphrey, S. D. **American Hand Book of the Daguerreotype.** 5th edition. New York, 1858

Hunt, Robert. **A Manual of Photography.** 3rd edition. London, 1853

Hunt, Robert. **Researches on Light.** London, 1844

Jones, Bernard E., editor. **Cassell's Cyclopaedia of Photography.**
London, 1911

Lerebours, N. P. **A Treatise on Photography.** London, 1843

Litchfield, R. B. **Tom Wedgwood, The First Photographer.**
London, 1903

Maclean, Hector. **Photography for Artists.** London, 1896

Martin, Paul. **Victorian Snapshots.** London, 1939

Mortensen, William. **Monsters and Madonnas.**
San Francisco, 1936

*****Nonsilver Printing Processes:** Four Selections, 1886-1927.
New York, 1973

Ourdan, J. P. **The Art of Retouching by Burrows & Colton.**
Revised by the author. 1st American edition. New York, 1880

Potonniée, Georges. **The History of the Discovery of
Photography.** New York, 1936

Price, [William] Lake. **A Manual of Photographic Manipulation.**
2nd edition. London, 1868

Pritchard, H. Baden. **About Photography and Photographers.**
New York, 1883

Pritchard, H. Baden. **The Photographic Studios of Europe.**
London, 1882

Robinson, H[enry] P[each] and Capt. [W. de W.] Abney.
The Art and Practice of Silver Printing. The American edition.
New York, 1881

Robinson, H[enry] P[each]. **The Elements of a Pictorial
Photograph.** Bradford, 1898

Robinson, H[enry] P[each]. **Letters on Landscape Photography.**
New York, 1888

Robinson, H[enry] P[each]. **Picture-Making by Photography.**
5th edition. London, 1897

Robinson, H[enry] P[each]. **The Studio, and What to Do in It.**
London, 1891

Rodgers, H. J. **Twenty-three Years under a Sky-light,** or Life and
Experiences of a Photographer. Hartford, Conn., 1872

Roh, Franz and Jan Tschichold, editors. **Foto-auge, Oeil et
Photo, Photo-eye.** 76 Photos of the Period. Stuttgart, Ger.,
1929

Ryder, James F. **Voigtländer and I:** In Pursuit of Shadow Catching. Cleveland, 1902

Society for Promoting Christian Knowledge. **The Wonders of Light and Shadow.** London, 1851

Sparling, W. **Theory and Practice of the Photographic Art.** London, 1856

Tissandier, Gaston. **A History and Handbook of Photography.** Edited by J. Thomson. 2nd edition. London, 1878

University of Pennsylvania. **Animal Locomotion. The Muybridge Work at the University of Pennsylvania.** Philadelphia, 1888

Vitray, Laura, John Mills, Jr., and Roscoe Ellard. **Pictorial Journalism.** New York and London, 1939

Vogel, Hermann. **The Chemistry of Light and Photography.** New York, 1875

Wall, A. H. **Artistic Landscape Photography.** London, [1896]

Wall, Alfred H. **A Manual of Artistic Colouring, As Applied to Photographs.** London, 1861

Werge, John. **The Evolution of Photography.** London, 1890

Wilson, Edward L. **The American Carbon Manual.** New York, 1868

Wilson, Edward L. **Wilson's Photographics.** New York, 1881

All of the books in the collection are clothbound. An asterisk indicates that the book is also available paperbound.